Exploring Color

About the Author

Nita Leland is a graduate of Otterbein College and has studied with many prominent artists. Since 1975, she has taught workshops in watercolor, multimedia, creativity and color at Riverbend Art Center in Dayton, Ohio, and across the country. She is also an active judge for local art exhibits. She has won more than 30 awards, including the President's Award of the Western Ohio Watercolor Society. Her paintings are included in numerous corporate and private art collections, and she is a member of the Western Ohio Watercolor Society, the Dayton Society of Painters and Sculpters, and The Riverbend Arts Council Board. Nita is also the author of *The Creative Artist*.

Exploring Color

Nita Leland

North Light Publishers

Published by North Light Books, an imprint of F&W Publications, Inc., 1507 Dana Avenue, Cincinnati, Ohio 45207. First Edition. First paperback printing 1990.

94 93 4 3

Library of Congress Cataloging in Publication Data

Leland, Nita.
 Exploring color.
 Includes index
 Bibliography: p.
 1. Color in art. I. Title.
ND1488.L44 1985 752 85-3101
ISBN 0-89134-363-6

This book is dedicated
to my family,
and especially to R. G. L.

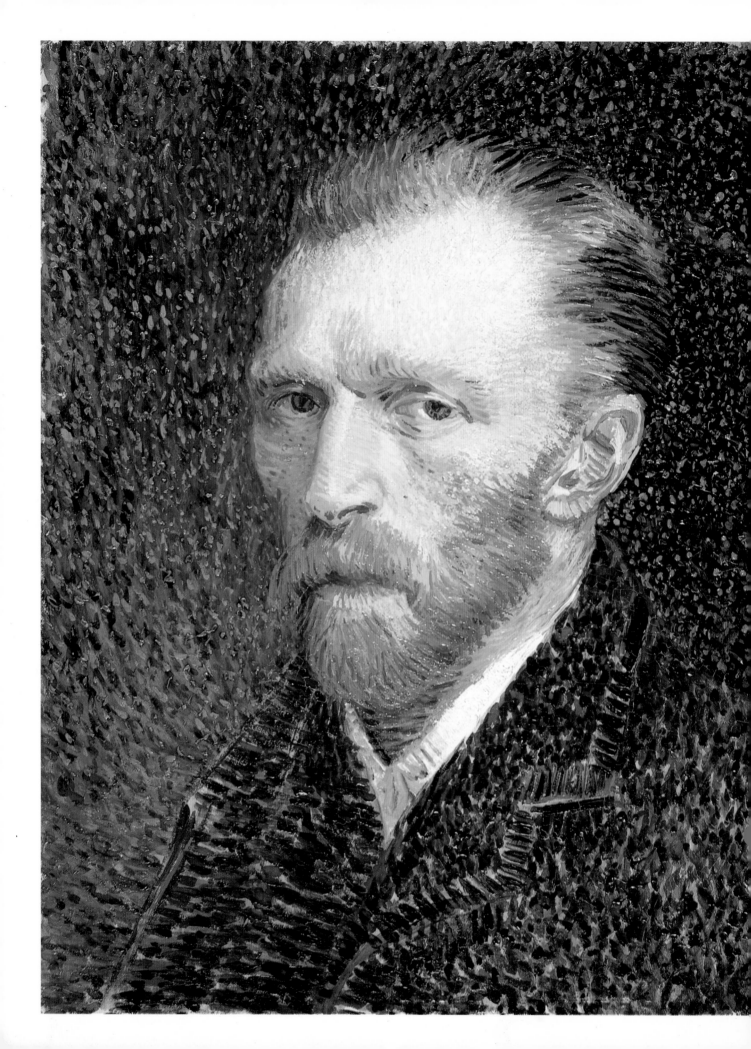

Preface

This book is based on a five-day workshop that began in 1980 at Riverbend Art Center in Dayton, Ohio. I organized the course because there didn't seem to be enough useful information on color available to my students. Through the years I have become convinced that beginning students and accomplished artists, as well, benefit from studying the history, science and art of color, along with first-hand exploration of pigments, thereby developing an appreciation for color that enables them to use it successfully in their paintings.

Most books on color for artists give good basic information, but they usually list and describe the pigments to use without showing the student how to experience, organize and individualize color as a means of personal expression. The books don't encourage the artist to incorporate personal choices into the palette. This book deals with these specific needs and also teaches the elements and principles of design as they apply to color.

In 1972 I heard Edgar A. Whitney, often described as the dean of American watercolor, thunder into a microphone: "Art is rational!" Prior to that, I had been told frequently that art is wholly personal, intuitive and subjective. I believed that art required "talent" and could not be learned. Whitney's bold assertion was a revelation to me: a determined student *could* unlock the mysteries of art and become an expressive artist. I applied this approach to teaching watercolor and eventually to color in art.

Personal selection of pigments and color schemes, consciously directed by awareness of an underlying rational order of colors, can overcome bad habits that interfere with artistic growth. The subject of color is fascinating in myriad aspects. Although the ex-

ercises in this book are described in watercolor, the artist in any chromatic medium can adapt most of them and benefit from the practical experiences of color contained in the book. The book is amply illustrated with the work of artists in several media, so you can enlarge your understanding and appreciation of how color can be used.

Vincent van Gogh said, "I am always in hope of making a discovery there (in the study of color), to express the love of two lovers by a marriage of two complementary colors, their mingling and their opposition, the mysterious vibrations of kindred tones." If you share Vincent's hope of beautiful color in your paintings, this book is for you. *(Fig. P-1)*

The artists whose work appears here have almost overwhelmed me with their generosity and good wishes. I extend my heartfelt thanks to all of them. My students, from whom I have learned much, deserve special mention. Joyce Engel, Dr. Harvey Engel, Ed Hunter, Larry Steinke at Patterson-Chase, Riverbend Art Center, the Brown Baggers, Ruth Coleman, Stephanie Kolman, Janet Zack of the Cincinnati Art Museum, the National Gallery, the Art Institute of Chicago, and Fritz Henning of North Light have all contributed friendship, inspiration, or assistance during the writing of this book. Diane Coyle was particularly helpful. My parents, Carl and Martha Shannon, encouraged intellectual curiosity, and for that I am profoundly grateful. My husband Bob and my children, Kurt, Carl, Wes and Kathleen—the "go-for-it gang"—have been my most ardent supporters. Everyone who has touched my life is, in some way, a part of this book. Thank you—all of you.

Contents

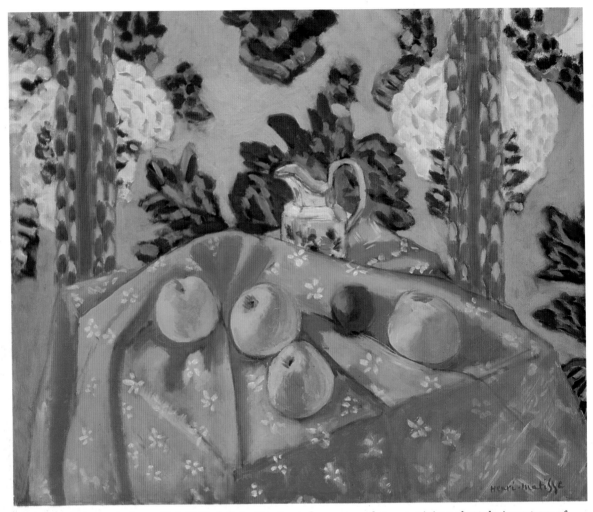

Fig. IN-1. Still Life: Apples on Pink Tablecloth *by Henri Matisse. (ca. 1922). Oil on canvas. 23¾″ × 28¾″. Matisse was drawn to the sensual nature of color, but he neverthe-* *less expressed strong opinions about the importance of organization of color and color relationships.*
Chester Dale Collection. The National Gallery of Art, Washington, D.C.

Introduction

"The use of expressive colors is felt to be one of the basic elements of the modern mentality, an historical necessity, beyond choice."—Henri Matisse

Color, as a means of expressing an artist's individuality, is unparalleled by any other element of design. Much contemporary art places emphasis on shape and value, disregarding the importance of color. Considering the revolutionary advances in color that have occurred during the nineteenth and twentieth centuries, this neglect seems strange. In *The Art of Color* Johannes Itten wrote, "However painting may evolve, color will remain its prime material." While you may acknowledge the significance of line, value, and shape, you should also recognize *color* as a fundamental ingredient, your most direct avenue of communication. *(Fig. IN-1)* Shapes make contact with the intellect. Color touches the heart.

If your purpose is to express yourself and to touch your viewer's emotions, then color is the way.

To paint is simply to color a surface. There is no great mystery about the use of color, but learning to use color well requires your conscious effort. Unfortunately, many search for an easy way to do this: how to mix "tree color," "sky color," "flesh color." They do not attempt to understand color nor to appreciate the legacy inherited from great colorists of the past; nor do they develop sensitivity to color and personal color expression. Itten wrote, "Only those who love color are admitted to its beauty and immanent presence. It affords utility to all, but unveils its deeper mysteries only to its devotees."

Instructors of painting often avoid teaching color, suggesting that values are more important—that color is so personal it cannot be taught—or that colorists are "born" and not "made."

One of the great colorists in the history of art, Eugène Delacroix, said:

"The elements of color theory have been neither analyzed nor taught in our schools of art, because in France it is considered superfluous to study the laws of color, according to the saying, 'Draughtsmen may be made, but colorists are born.' Secrets of color theory? Why call those principles secrets which all artists must know and all should have been taught?"

J. M. W. Turner *(Fig. IN-2),* Eugène Delacroix, Paul Signac, Pierre Bonnard—among the acknowledged masters of color—studied color theory and science. Their fine color was no "happy accident." Itten, a highly regarded teacher of color, studied the master colorists closely and concluded that all of them possessed a science of color.

Why do so many neglect the study of color? Perhaps because the vast subject intimidates students and teachers alike. Possibly because the teacher doesn't really *know* color. Perhaps because the student wants formulas and quick results. However, color proficiency cannot be achieved that way.

How can you put all of these aspects of color into proper perspective, and where should this awesome task begin?

You, as an artist, can hope to achieve a great deal through a methodical and concentrated study of color. This book is the place to begin. The chapters that follow will help you to:

—develop appreciation of color science, history, and theory.

—explore pigments, learning their strengths, limitations and idiosyncracies.

—create expressive paintings by understanding color schemes and color design and by selecting and using intelligently a distinctive basic palette and versatile expanded palettes.

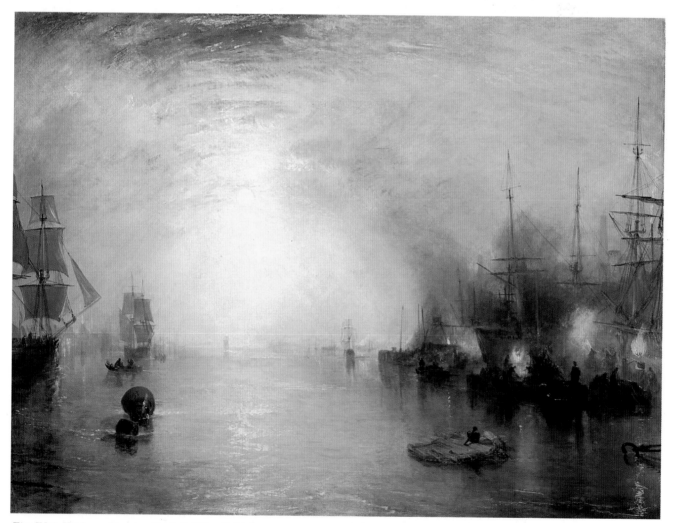

Fig. IN-2. Keelmen Heaving Coals by Moonlight *by J.M.W. Turner. (ca. 1835). Canvas. 36¼″ × 48¼″. Turner was one of the earliest of abstract colorists. Although a great deal of his work was done according to academic standards, his luminous, swirling landscapes are preferred today.*
Widener Collection. The National Gallery of Art, Washington, D.C.

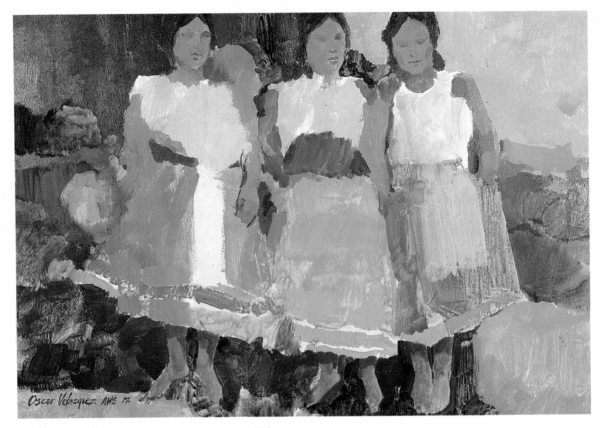

Fig. IN-3. Three Senoritas *by Oscar Velasquez, A.W.S. Casein. 20″ × 24″. Color principles apply to opaque media as well as transparent. Dominant blues and bluegreens are set off here by the warm, unsaturated hues surrounding them. The complementary red-orange trim on the skirt is an assertive color note.*

The study of color applies to all chromatic painting. An artist working in any medium can modify most of the watercolor experiments in this book. *(Fig. IN-3)* Painters in opaque materials, including oil, acrylic, egg tempera, casein and gouache, normally use white paint to lighten colors. Watercolorists require only water, which has little or no effect on the purity of the color itself.

Techniques of applying paint to the painting surface differ among the various media. The mingling of colors is easily accomplished in watercolor; watercolor is fluid and permits accidental effects. Oil paint is thick and requires manipulation with brush or knife. Painters using opaques often work from dark to light; the watercolorist reverses the order and works from light to dark, because of the lack of covering power of most of his pigments.

Many contemporary artists combine media such as opaque and transparent watercolor, inks and acrylics. Some incorporate collage and gritty textures in their paintings. *(Fig. IN-4)* These inventive methods can result in brilliantly creative works, particularly if sound color planning is a guiding force.

The painting support is paper in most watermedia. Canvas, Masonite and wood are used in oils and acrylics. A medium similar to transparent watercolor is acrylic, a water soluble medium that may be handled like oils or watercolor. Gouache, casein and egg tempera are water miscible, but opaque. Pastel is a dry medium and is handled differently from either watermedia or oils. Some pigments in the painting media vary in color permanence or chemical composition from those described for watercolor and some are not produced in every medium. An artist skilled in his own medium can adjust the exercises to suit his materials.

Personal investigation of color is the objective of this book. To a great extent the results you obtain will depend upon your motivation for learning about color, not so much upon the medium you choose. Formulas for mixtures are useless; your individual responses to colors and knowledge of pigments and color design are of great importance. Trying new pigments and color schemes is accomplished methodically here, giving you a fuller appreciation of the potential of color for artistic expression.

Exploring color isn't just a lot of hard work, however. A willing spirit and an attitude of eager anticipation of discoveries to come will contribute to the success of your studies as you experiment with color. The sketchbook-journal and the color exercises will help to develop your awareness and can serve as references while you expand your choices and your capability for lively artistic communication.

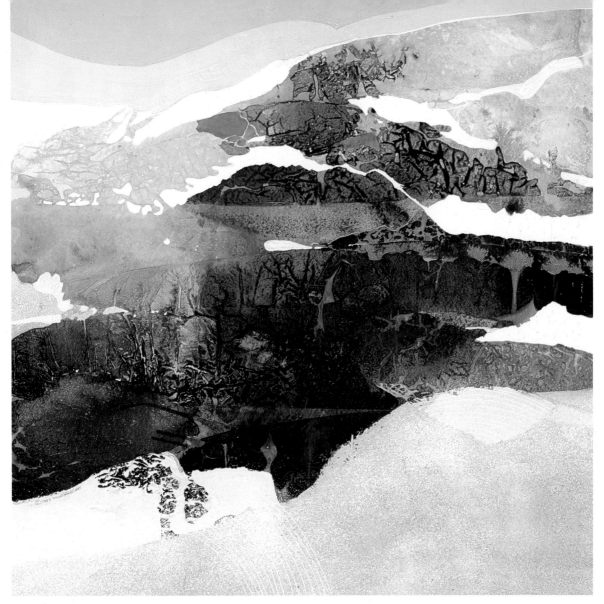

Fig. IN-4. World of Shadows *by Maxine Masterfield, A.W.S. Watermedia. 44" × 42". Masterfield's ink-pouring technique results in strong, expressive abstractions. The shapes are fluid and the colors are rich.*
Courtesy of C. G. Rein Galleries.

Fig. IN-5. Glacial Flow *by Edward Betts, N.A., A.W.S. Acrylic. 29¼" × 29¼". Dynamic shapes are made even more powerful by the vibrant quality of the color in this striking painting. The importance of the dominant blue is underlined by subtle neutrals and striking whites and opposed by a brilliant, smaller passage. This is indeed intelligent use of color.*
Courtesy of Midtown Galleries, New York.

Background in color theory will enable you to evaluate your first-hand experiences with color. Handling the pigments and observing their interaction should help you to develop a discerning eye. A structured exploration of color will lead to deepening awareness of how you can interpret your emotions in your art. Intelligent use of color calls for successful integration of the theoretical or academic aspects of color, of the perceptual grasp of real things to be interpreted in the painting, and of the conceptual visions existing only in the mind of the artist. *(Fig. IN-5)*

Fig. IN-6. Midsummer's Dream *by Robert Vickrey, A.W.S. Egg tempera. 35" × 46½". The complexity of this painting is awesome. There is a great deal going on, but it all works because of the successful interplay of small areas of intense color against larger areas of neutrals. The flickering whites create a captivating rhythmic movement.*

How do you respond to a painting?

When you first encounter a painting, you may react spontaneously to the arrangement of line, shape and value. The initial attraction is primarily visual. When you examine the work closely, you are likely to be touched more deeply by the provocative impact of the color than by any other element of design present in the work. This emotional content, irrespective of the subject of the painting, may be dynamic or subtle; yet, color is the factor that stimulates the deep response.

Finally, you, as an artist, may feel compelled to go beyond your emotional reaction to examine the technical process that achieved the expressive result. You can see that a painting lacking rich or delicate color harmonies may entertain visually, and still fail to move you emotionally. Color exploration will enable you to use this essential element confidently; your paintings will become more effective. *(Fig. IN-6)*

The mercurial Vincent van Gogh worked intensely with color. Van Gogh studied color theory and made serious efforts to apply this knowledge. His colorful, expressive paintings were not simply the fortunate results of casual methods. Freedom of expression is one of the rewards of dedicated scholarship.

Hans Hofmann wrote, "When the impulses which stir us to profound emotion are integrated with the medium of expression, every interview of the soul may become art. This is contingent upon the mastery of the medium." *(Fig. IN-7)*

Experience and organization are the keys to free expression in color. You select each color to which you have a strong affinity and combine it with others according to logical relationships of harmony until the expressive result is achieved, a beautiful accomplishment—a moving work of art.

As an artist, you paint not simply what you see but the underlying forces that energize your subject. The painting becomes a synthesis of nature, your medium and you. Color can be the force that unifies all of these elements.

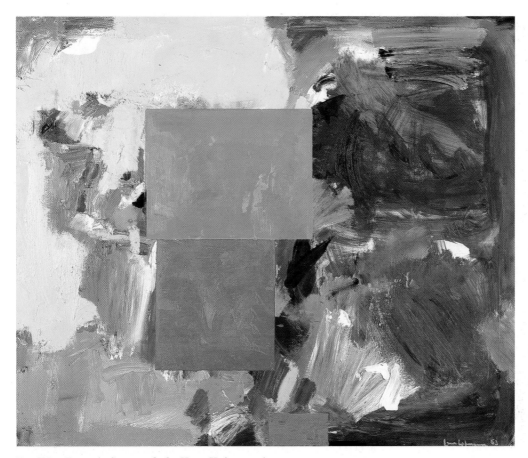

Fig. IN-7. Towards Crepuscule *by Hans Hofmann.*
(1963). Oil. 60" × 72". Pure hues, vividly contrasted, can
be a visual delight of themselves. The artist's impulses
and his control over those impulses are both necessary if
the painting is to be more than decorative.
The Edwin and Virginia Irwin Memorial. Cincinnati Art Museum.

Part One

Intuition is a highly desirable capability for an artist to possess. Intuition, coupled with knowledge and mastery of the craft, is better yet. Many believe that learning the basics of color theory and the fundamentals of mixing pigments is unnecessary, that color is entirely a personal matter. Yet some of the finest colorists in the history of painting studied both the art and the science of color. Turner, Delacroix, Monet, Seurat, van Gogh, Bonnard, all masters of color expression, possessed inquiring attitudes toward color theory; each used color to bring individual and vital expression to his work.

Even the inexperienced artist can achieve beautiful color. The colorist is not born with a special gift denied to ordinary mortals. If you are willing to devote time and effort to learning correct principles of color selection, you will be able to accomplish distinctive color in your paintings. When you have sound knowledge, you will be liberated from the commonplace in color.

Every journey must begin somewhere. Most also require a certain amount of preparation. Nicolai Fechin, a Russian artist who painted in the American southwest in the nineteenth century, believed that an artist working without training in materials and basic methods is like a traveler who has left home without his luggage; he will probably have to go back and get it if he wants to go very far. Begin your travels now in the world of color. You can go as far with color expression as you prepare yourself to go.

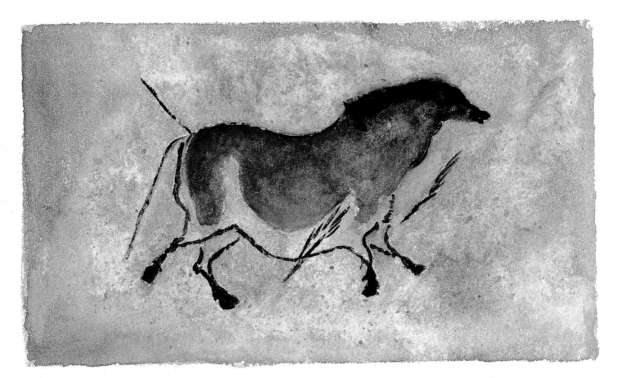

Fig. I-1. Horse Attacked by Arrows. *This is an artist's watercolor rendering of a cave painting at Lascaux, France. Prehistoric painters created remarkable compositions with simple materials.*

Chapter **I**

A Chromatic Odyssey: Color in Science

Standing in the great Hall of the Bulls at Lascaux, France, visitors admire the elegance of line and the sensitivity of color achieved by prehistoric artists more than 20,000 years ago. *(Fig. I-1)* Ever since the discovery of these caves, archaeologists and anthropologists have projected many theories on the purpose of the paintings and the meaning of the figures and the colors in the paintings. Disputes over the original purpose of the cave paintings are remote from today's artists, even though they are the spiritual heirs of the unknown, unschooled painters who decorated those ancient walls. The development of color in painting from the cave paintings to contemporary art *is* important, however, and intertwines with the history of man, from the simplicity of prehistoric paintings to the complexity of modern color science.

Color virtually shapes our world. Scientists have directed considerable attention to color. Physicists deal with light as the source of color, a measurable entity. Chemists concern themselves with pigments which reflect the color that we see. Physiologists regard the color sensation and how the eye perceives color. And, finally, psychologists delve into the mystery of how the brain interprets color. The color theorist and the artist, taking all of these things into account, study how colors affect each other in mixtures, in relationships and in painting.

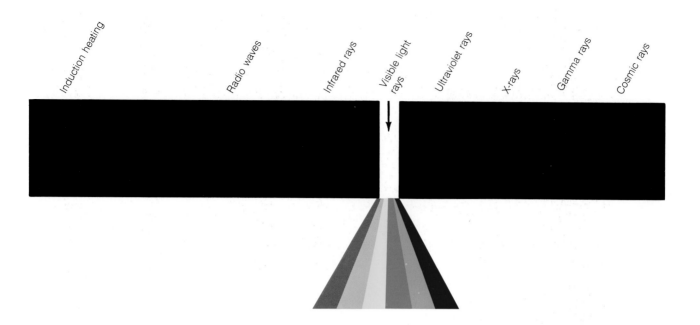

Induction heating · Radio waves · Infrared rays · Visible light rays · Ultraviolet rays · X-rays · Gamma rays · Cosmic rays

Fig. I-2. The Electromagnetic Spectrum. *Most electromagnetic energy is invisible. Visible light comprises a very small segment on the energy band. The color spectrum is found within this segment.*

Physical Properties of Light

The physicist researches the phenomenon of light: how light is reflected, transmitted, or absorbed. He measures the physical properties of light and characterizes its movement, speed, and color in precise scientific terms. He describes a long band of radiant energy that includes invisible heat and infrared rays at one end and x-rays and ultraviolet rays at the other extreme. The band also embraces a relatively short section of visible light rays. *(Fig. I-2)*

Within that visible portion of light rays Sir Isaac Newton discovered the color spectrum in the seventeenth century, observing that sunlight separated into a beautiful band of colors when projected through a prism. *(Fig. I-3)* By placing a second prism in the path of the spectrum emerging from the first, he found that the colors recombined into white light. Newton later overlapped the spectrum band at the ends, creating the color circle, which he illustrated with a black-and-white drawing. He enumerated seven fundamental colors in the spectrum, including indigo along with the six hues acknowledged today— red, orange, yellow, green, blue and violet—presumably because seven was a mystical number of

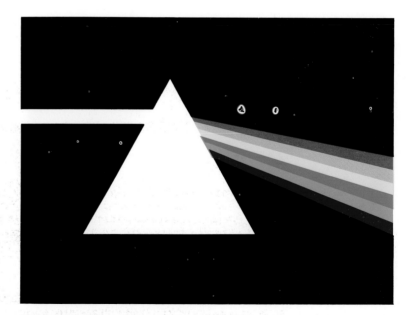

Fig. I-3. The Prism. *When sunlight is refracted as it passes through a prism, the colors contained in the light become visible. Newton recorded this phenomenon in 1666 and also noted that the spectrum would recombine when passed through a second prism in its path.*

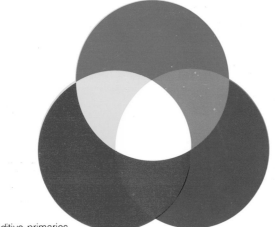

Physicists' additive primaries
and secondaries (light)

Physicists' subtractive primaries
and secondaries (transparent colorants)

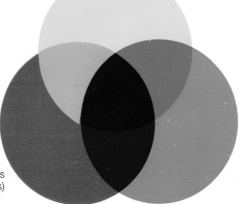

Artists' subtractive primaries
and secondaries (pigments)

Fig. I-5. Additive and Subtractive Color. *The additive primaries of light and the subtractive primaries of pigments are different. Artists' pigments also differ from physicists' pigments in the way the colors combine.*

great power in his time. *(Fig. I-4)* More than a century after Newton's discovery of the spectrum, Rumford showed that individual colored lights gathered together in correct proportions combine into white light when projected through the prism, a fact which Newton had overlooked.

Goethe sharply disagreed with Newton's theory of white light as the source of all color, believing that yellow came from light, blue originated in darkness, and all other colors were derived from mixtures of these two. Goethe was wrong, but he is credited with heightening awareness of the role of human perception in seeing color, a concept given little thought up to that time.

Fig. I-4. The First Color Circle. *Newton joined the opposite ends of the color spectrum and created the color circle. Purple became the link between red and violet. The color intervals were described as proportional to musical tones.*

Scientists after Newton determined that the local color of a pigmented object is produced when white light strikes its surface: some of the light rays are absorbed, while the color of the object is reflected. This discovery led to the definition of two distinct types of color: additive and subtractive. *(Fig. I-5)*

Additive colors are derived from light mixtures that reflect projected colors. The additive primaries of light are red, blue-violet and green. When colored lights are combined, they produce the following secondaries: red + green = yellow; red + blue = magenta; blue + green = cyan. A mixture of all three—red + blue + green—results in white; all colors are reflected and none are absorbed. Each additive mixture is lighter than the original colors combined to create it. When all of the colors are projected at the same time in equal intensity, white light results.

Subtractive colors are pigment mixtures that absorb (subtract) all colors but the color of the object, which is reflected and perceived by the eye. The subtractive primaries are magenta, yellow, and cyan.

When transparent colorants are mixed in printing and photography they produce the following secondaries: magenta + cyan = blue; magenta + yellow = red; yellow + cyan = green. Each subtractive mixture is darker than the original colors combined to create it. When all of the colors are mixed together, the result is black.

The primaries of artists' pigments differ slightly from the physicists' subtractive primaries. Ground pigments, which contain impurities and lack spectral clarity, are more opaque than dyes or lights. Red, yellow and blue pigment primaries produce the following secondaries: red + blue = violet (purple); red + yellow = orange; yellow + blue = green. All mixtures are darker than the colors combined to create them.

Perception of Color

Light is the stimulus on the retina that causes normal color sensation in the eye. *(Fig. I-6)* Even today little is understood about how color is perceived, beyond the knowledge that the rods in the retina react primarily to light and dark, and the cones respond to color, which is then interpreted by the brain. There is no way to determine whether or not different people see colors in the same way. What *is* known about color perception relates to such phenomena as simultaneous contrast (the effect resulting from placing two colors side by side); successive contrast (the complementary afterimage that appears after an object has been removed from view); accidental color (the result of injury, eye pressure, or drug use); and color constancy (the accommodation of the eye for changes in illumination). The eye may see a color the brain tells it to see—even when the color isn't there!

Color perception is far more complex than a stimulus/response effect. There are indications that the brain plays a much greater part in the way we see color than previously suspected.

Human Response to Color

In the fifteenth century Leonardo da Vinci described the fundamental primaries of vision, sometimes called the psychological primaries—red, yellow, green, blue, black and white—long before scientists recognized them. As the importance of the brain in the interpretation of color came to be recognized, the developing field of psychology took an interest in color.

Scientists believe that visual perception depends primarily upon the brain's interpretation of a stimulus received by the eye. Color is one way the eye and the brain work together to define the external world. Human beings have a better sense of vision, as well as greater color perception, than many other animals, pointing to the important part played by the highly developed brain of man in perceiving color.

The conflict of color versus shape has been closely studied by psychologists. Apparently, recognition of shape is a function of the intellect; color awareness is an intuitive process. Children, when told to select similar objects from assorted shapes and colors, nearly always relate the objects according to color.

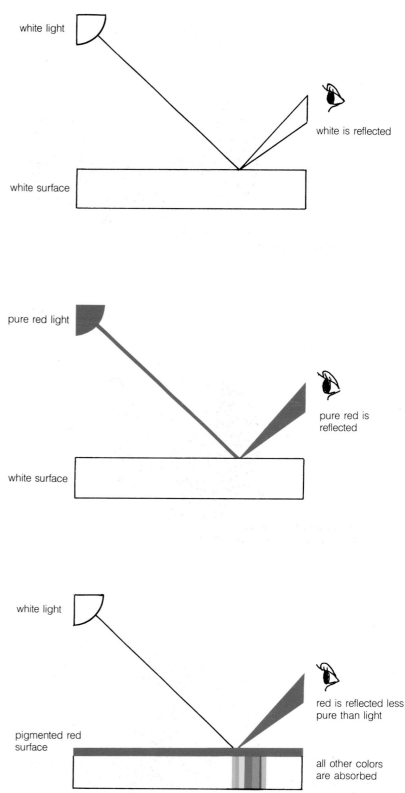

Fig. I-6. Reflected Color. *When light is reflected from a surface, the eye sees either the color of the light or the color of the pigmented surface. Colored light is pure and bright, but pigments contain impurities that reflect mixed rays and somewhat dull the colors.*

(*Fig. I-7*) Color is often symbolic in the drawings of children. In the adult world color is important in decoration and personal adornment. The colors you surround yourself with in your clothing and room decoration reflect your personality and affect your behavior.

Psychologists concern themselves with emotional responses to light and color and the symbolic meanings of color. Mystic interpretations appear in the earliest records of mankind, giving color remarkable powers in the hands of the tribal shaman. In the late nineteenth century Edwin D. Babbitt promoted healing with color. His fame spread throughout the world, as a result of his doctrine of creating harmony between the colors of human emanations and the colors in the atmosphere. More recently, the psychological effects of color are being exploited in schools, hospitals and industry, where specialists believe that appropriate color facilitates learning, hastens healing and increases production.

Numerous lists assign specific qualities to individual colors, for example:

red = excitement, courage
yellow = happiness, ebullience
blue = tranquility, serenity
green = fertility, pride
orange = tension, energy
violet = fantasy, magic

Such color associations differ from study to study. Our language is replete with color expressions: a yellow coward, blue Monday, green envy, purple passion. On a global scale, color has specific meanings that vary from one social sphere to another. Some northern civilizations have many words for white, a necessity where snow conditions, revealed by subtle changes in the coloration of the snow, are a matter of life or death. The strong psychological effects of color are universally accepted, but societies differ to a remarkable degree on the associative meanings of specific colors.

A blind person may sense coloristic qualities through touch, smell, and taste, using color words acquired from the people he depends upon to describe the world about him. He will usually assimilate the emotional connotations they give to colors. Color becomes extremely important to the extent that it affects others. Without color words, the world would be more difficult for him to comprehend. Those of us who are privileged with sight frequently take for granted our richly colored environment.

Color in the Laboratory

The chemistry of color, an exacting science, involves learning the structures of dyes and pigments, testing their permanence and interaction, and preparing paints from colorants. Chemists have made great progress in improving quality and performance in artists' paints. They have created many synthetic pigments of great strength and durability. Most fugitive colors, which fade or change color, have been replaced in recent years by reliable substitutes.

Chemists work continually to combat the harmful effects of contaminated air on paintings. Art conservation relies on chemical science in the restoration and preservation of art works. Microscopic

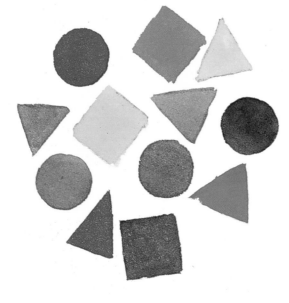

Fig. I-7. Colors vs. Shapes. *Most children, when asked to select similar objects from an assortment, will match the objects by color rather than by shape. As they grow older, they begin to recognize the shape relationships as well. Adults are more likely to sort objects by shape.*

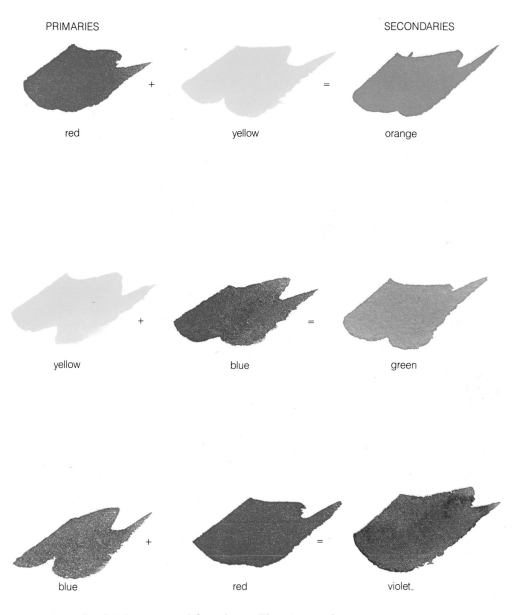

PRIMARIES

SECONDARIES

red + yellow = orange

yellow + blue = green

blue + red = violet

Fig. I-8. Primaries and Secondaries. *The primary colors—red, yellow and blue—cannot be mixed from other colors. Mixtures of any two primaries produce orange, green and violet—the secondary colors.*

examination of colors to determine chemical properties combines with the expertise of the physicist in analyzing visible and invisible rays, enabling conservators to replicate the colors in damaged paintings. Scientists have saved centuries-old paintings for future generations through the application of knowledge of the composition and permanence of pigments.

Color Theory

The theorist organizes the properties of color into a functional system. The accumulated discoveries of centuries established the foundation for these systems. In the fifteenth century Leonardo da Vinci, in his far-ranging quest for universal knowledge, touched upon color values and described the psychological primaries. Much later, Newton discovered the spectrum and devised the color circle. In 1756 J. C. Le Blon published a tract detailing his earlier obser-

vation of the primary nature of red, yellow and blue pigments and describing the hues that resulted from mixtures of these pigments. (*Fig. I-8*) Moses Harris, an engraver, published the first color circle in full color in 1766.

From beginnings such as these, numerous theorists developed systems to illustrate color relationships. In 1824, Michel Eugène Chevreul, an internationally respected chemist, was named Director of Dyes at the Gobelins tapestry works in Paris, the royal manufacturer of magnificent French tapestries and fabrics. Chevreul's job was to control the quality of the dyes used in the fabrics; his observations led to research into color effects that resulted in his great work, *The Laws of Simultaneous Contrast of Colors,* published in 1839.

The meticulous research of Chevreul touched on little-understood ideas of how the eye perceives color in myriad combinations. Chevreul concluded that

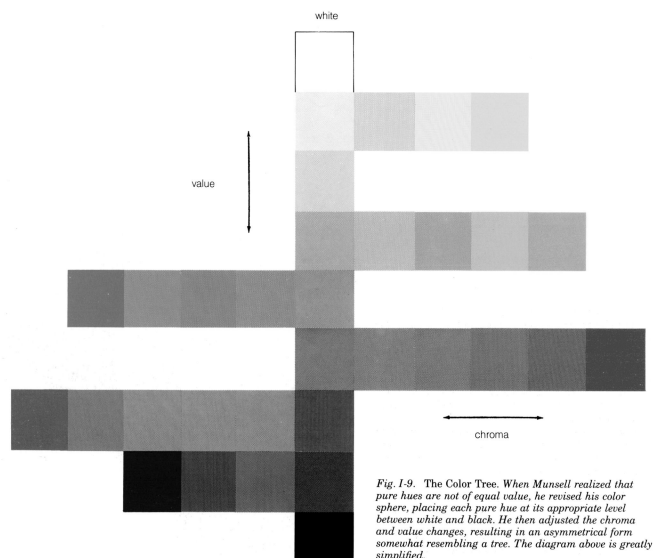

white

value

chroma

Fig. I-9. The Color Tree. *When Munsell realized that pure hues are not of equal value, he revised his color sphere, placing each pure hue at its appropriate level between white and black. He then adjusted the chroma and value changes, resulting in an asymmetrical form somewhat resembling a tree. The diagram above is greatly simplified.*

black

the more colors and objects that appeared in a composition, the more difficulty a viewer experienced in locating the focal point of the composition. Chevreul's experiments provided a basis for research in every branch of color science for a century-and-a-half and became the starting point—along with Ogden Rood's *Modern Chromatics*—for the explorations of the Impressionists and Neo-Impressionists in late nineteenth century painting.

Early theorists found Newton's color circle inadequate to represent the many aspects of color. They constructed a variety of three-dimensional forms, including spheres, pyramids, cones and double cones, to illustrate the changes of pure hues in brightness and in saturation. These color solids were intended to show all of the properties of colors—hue, value and intensity (or chroma)—in a single structure.

Beginning with five colors—red, yellow, green, blue and purple—Albert Munsell developed a solid color sphere containing sections of ten pure hues

around its perimeter, each hue further subdivided into ten variations of the pure hue. The vertical axis of the value scale from black to white stands in the center of the sphere. As the hues are mixed with white, they move up the scale, becoming "tints"; as they are mixed with increasing amounts of black, they move down the scale, becoming "shades." The hues also move horizontally toward the center, modified gradually in purity until they become a neutral gray.

Munsell revised his sphere when he saw that fully saturated hues are not of the same value; the resulting construction resembles a tree more than a sphere. *(Fig. I-9)* Each color chip on the Munsell solid is given a numerical notation, permitting a simple classification system for color still in use today. In fact, the Munsell system has been very nearly an international standard for many years, sometimes supplemented by newer, more precise systems of colorimetry when scientific accuracy is

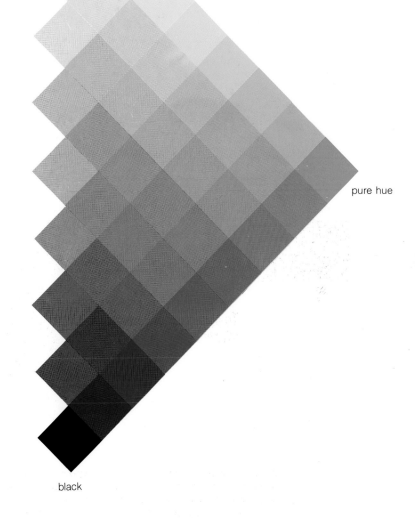

white

pure hue

black

required, as in the formulation of paints.

Wilhelm Ostwald constructed another sound color system: a solid based on triangles having pure hue, black, and white at the angles. *(Fig. I-10)* He devoted years of study to color science, culminating in the Ostwald system, in which the fundamental colors of vision—red, yellow, green and blue—are primaries, with orange, purple, turquoise and leaf green completing the circle.

Josef Albers, fleeing to the United States from Germany in 1933, brought with him the teaching methods of the Bauhaus: practice before theory. He believed that a color system alone is incapable of developing sensitivity to color in an individual. Albers trained his students to regard color as a relative factor in art and to learn color through *experience* with color.

Johannes Itten in *The Art of Color* formulated experiments to raise the student's awareness of the effects of color juxtaposition. Itten stressed scholarship. He said, "If you, unknowing, are able to create masterpieces in color, then unknowledge is your way. But if you are unable to create masterpieces in color out of your unknowledge, then you ought to look for knowledge." Color is more than a functional element. It reveals its beauty and mystery only to those who love it.

One of the great color theorists of the twentieth century is Faber Birren, who has devoted a lifetime to the study of color from its mystical beginnings to the mundane, but essential, color of walls in the work place. Comprehensive information on the science and uses of color are found in his many books and articles. Birren uses a color triangle to show the seven forms of color: pure hue, black, white, gray, tint, tone and shade. Students, artists and designers have found Birren a great source of useful information on color.

Many highly technical works have appeared in recent years, describing sophisticated methods of measuring color and testing color perception. Nevertheless, the most useful resources for artists continue to be the color systems based upon the remarkable scientific discoveries of the eighteenth and nineteenth centuries.

Fig. I-10. The Ostwald Color Solid. *The Ostwald system is based on eight "primaries" having a triangular relationship with a central core of values from black to white.*

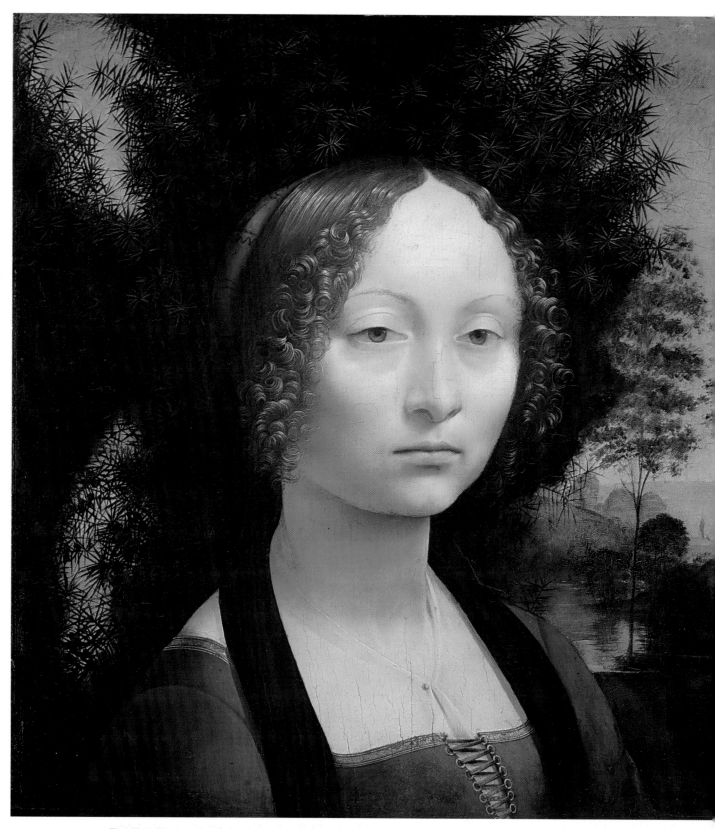

Fig. II-1. Ginevra de ´ Benci *by Leonardo da Vinci (ca. 1474). Oil on wood. 15″ × 14½″. Leonardo was more involved with the science of color than with color itself in his painting. He considered value relationships to be more important than color.*

Ailsa Mellon Bruce Fund. The National Gallery of Art, Washington, D.C.

"In fact, the whole world, as we experience it visually, comes to us through the mystic realm of color. Our entire being is nourished by it. This mystic quality of color should likewise find expression in a work of art."—Hans Hofmann

Chapter **II**

A Chromatic Odyssey: Color in Art

Evidence of the creative impulses of mankind exists from periods beyond the memory of man: how has color been used artistically to express man's feelings about himself and the world around him?

Pre-Renaissance color

The prehistoric cave painters used the simplest available substances. Clays, berries, animal substances and charred wood were probably mixed with water and applied to the walls. Dampness sealed the images into the rock; the lack of exposure to air and light preserved them. Whatever materials were available dictated the choice of colors. Nothing is known of the symbolic nature of the colors employed.

For centuries after the cave paintings, color served as decoration on functional ceramic objects, on tiles used in colorful mosaics, on the pages of illuminated manuscripts, and in the stained glass windows of medieval cathedrals. Fresco, a water-based paint applied to damp plaster, was a major medium. Color was usually flat, and more symbolic than descriptive. Subjects of a religious nature were common. The materials and methods did not lend themselves to three-dimensional modeling of form. Medieval art has a somewhat abstract flavor to it.

Renaissance color

During the Renaissance the humanistic goal of individual artistic expression emerged, along with the desire to paint an illusion of the real world. Local color of the subject was of great importance. Subject matter was more representational than in paintings by earlier artists. The portrait became significant as painting for private ownership increased. Improved materials for oil painting in the early fifteenth century encouraged the development of easel painting. Grünewald used color expressively and symbolically with the richness of a master colorist.

Many Renaissance painters used rather limited palettes, emphasizing value rather than color. The style known as "chiaroscuro" featured strong contrasts of light and dark values. Leonardo da Vinci favored this approach. *(Fig. II-1)*

Chiaroscuro was central in the art of Titian, Rubens and Caravaggio, but color also played an important part in their works. The masterful paintings of Rembrandt, in which faces glow with light, surrounded by the contrast of deeper values, exemplify the quality of illumination resulting from skillful control of values and color contrasts in the painting.

Vermeer and Velásquez continued the traditions of the early masters, emphasizing contrast rather

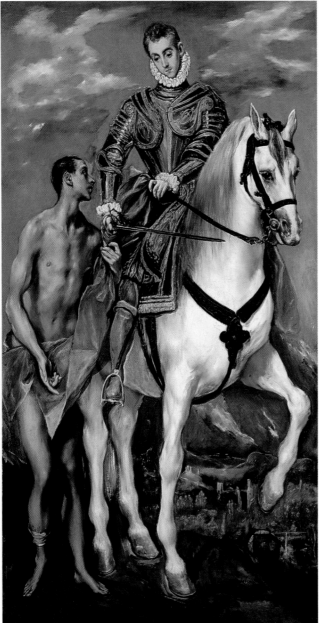

Fig. II-2. Saint Martin and the Beggar *by El Greco. (1597–1599). Oil on canvas. 76⅛″ × 40½″. El Greco used color more expressively than many of his contemporaries. Along with distortion of form, the brilliant colors reveal strong emotional content and seem to vibrate on the surface.*

Widener Collection. The National Gallery of Art, Washington, D.C.

than color. El Greco, a student of Titian, departed from custom with highly expressive use of color and a distinctive distortion of form. *(Fig. II-2)*

Much early painting was based on *grisaille,* a complete underpainting in umber or gray that established the forms through values. The color was applied in transparent glazes over this neutral underpainting and was generally representational or symbolic.

For centuries painters recorded naturalistic images or idealized settings of classical myths. Color expression was secondary to storytelling as the artist's objective. The strict control of the art academies prevented artists from exploring other avenues of expression. Fine craftsmanship, rather than expressive color, was the hallmark of classical art.

Nineteenth century developments

The later paintings of J. M. W. Turner showed a defiance of the classical and academic traditions. Turner heralded the beginning of the modern age of color. Color was about to come into its own as a vital, singularly expressive element in painting.

Artists began to acknowledge the advances of science in the study of color. The primary nature of red, yellow and blue pigments had been recognized for many years and the complementary relationships of colors opposite each other on the color circle became increasingly important to painters. Finally, the invention of photography spurred the artist to seek subject matter beyond the reach of the camera, within the eye and the mind of the artist himself.

Fig. II-3. Delacroix's Color Triangle. *Delacroix's notes contain references to a color triangle that had primaries at the angles and secondaries along the sides. This arrangement graphically illustrated complementary relationships, with each secondary color on the side directly opposite its primary counterpart.*

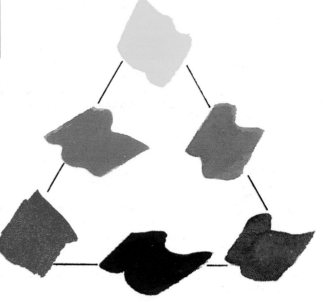

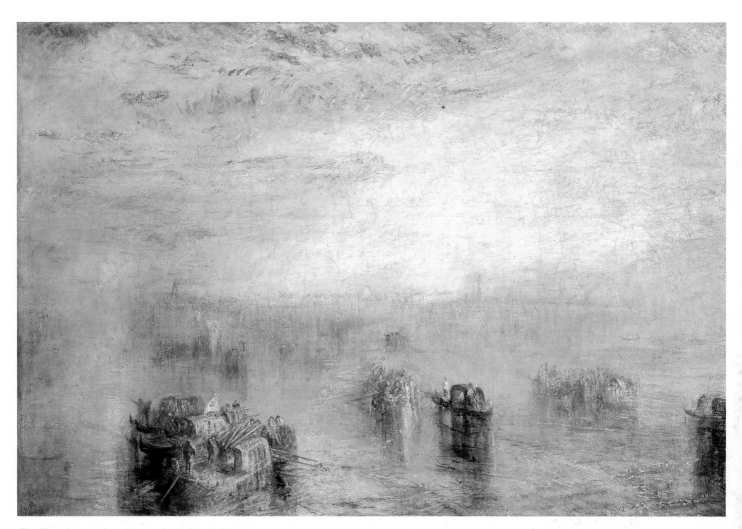

Fig. II-4. Approach to Venice *by J. M. W. Turner. (ca. 1843). Oil on canvas. 24½″ × 37″. The viewer becomes quickly engaged by the luminous glow of a Turner painting. It is only after the impression of color and light is absorbed that the subject is deciphered. Turner's color makes direct contact with the emotions.*
Andrew W. Mellon Collection. The National Gallery of Art, Washington, D.C.

At the turning point between the Classical and Romantic periods, Eugène Delacroix recorded in his journal many observations of color in nature, his analysis of the color of master paintings, and details of the colors used in his own works. He was enamored of color, yet he maintained an objective attitude about it, regarding color as a fundamental requirement of good painting, along with values, proportion, and perspective.

Delacroix's dissertations on several aspects of color, along with the writings of Chevreul and Rood, became a point of departure for Impressionist and Neo-Impressionist explorations into color as light. Delacroix diagrammed the primary relationship as triangular, with primaries at the angles and their complements on the opposite sides of the triangle, a simple, graphic illustration of basic color relationships. *(Fig. II-3)*

During the Romantic period painting became more expressive, but still adhered to strict academic standards that placed drawing and illustration of the subject before color. The subject was frequently historical or religious. Constable and Turner were both accepted by the Academy, but Turner rebelled, revealing unique color sensibility that was prescient of things to come. Turner was extremely popular and highly successful, in spite of his "mad" tendency to paint brilliant, luminous, very nearly abstract canvases and watercolors in which the narrative subject was little more than a speck in the composition! *(Fig. II-4)*

Near the end of the nineteenth century one of the greatest upheavals in the history of color began. Impressionist painters decided to ignore the academic rules and seek new avenues of expression. Many devoted themselves to depicting the effects of

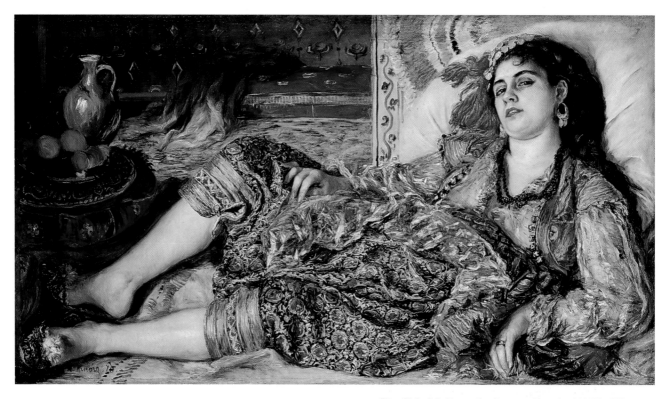

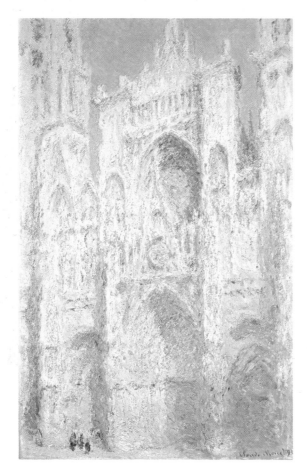

Fig. II-5. Odalisque *by Auguste Renoir. (1870). Oil on canvas. 27¼″ × 48¼″. Renoir's sumptuous color sparkles with the intensity of faceted gemstones. Unlike most of his fellow Impressionist painters, he concentrated on the figure rather than the landscape, using color in a painterly, rather than an academic, style.*
Chester Dale Collection. The National Gallery of Art, Washington, D.C.

Fig. II-6B. Rouen Cathedral, West Façade, Sunlight *by Claude Monet. Oil. (1894). 39½″ × 26″. Monet's on-location paintings are nearly color abstractions. The object painted seems to exist merely as a form on which to play the color and light effects he interpreted.*
Chester Dale Collection. The National Gallery of Art, Washington, D.C.

light and color on the subject. Having studied Chevreul's *The Laws of Simultaneous Contrast of Colors* and later, Ogden Rood's *Modern Chromatics,* along with Delacroix's journal, the Impressionists stepped out-of-doors to study and paint nature, using color theory to supplement their own observations of the effects of light and shadow.

Impressionist painters seemed to see color everywhere, bouncing off walls and reflecting from one object to another. Line became less important, while changing light and color effects were recorded on the spot. Impressionist painting depended heavily upon direct observation. Color appeared more luminous as value contrasts were modified. Broken color, flat color, color as description of form—each Impressionist painter placed a different emphasis, according to his own requirements, but the rallying point was color. *(Fig. II-5)*

Gustave Courbet, a forerunner of the Impressionists, was an outdoor painter and the spokesman for an influential new naturalism far removed from Classicism. Camille Pissarro followed Courbet's

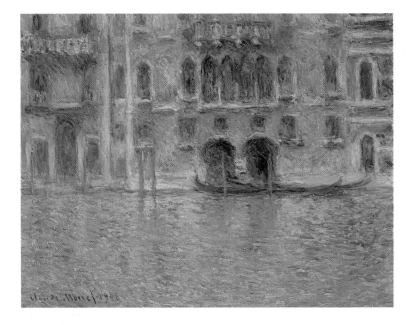

Fig. II-6A. Palazzo da Mula, Venice
by Claude Monet. (1908).
Oil on canvas. 24½″ × 31⅞″.
Chester Dale Collection.
The National Gallery of Art, Washington, D.C.

thought, eventually joining the Impressionists and participating in every aspect of the development of Impressionism, including Pointillism, which he later abandoned because it inhibited spontaneity.

In 1862 Monet, Renoir, Sisley and Bazille met in a studio in Paris. A spirit of rebellion against academic standards united the artists. It was only a matter of time until the "revolt" evolved into a quasi-movement aimed at freeing art from classical tradition. Although there were other aspects in-

volved in the Impressionist break with tradition, their new ideas seemed to be centered on color. Monet, Pissarro and Sisley, having seen the paintings of Turner in London, appear to have been influenced by his bold color expression.

Claude Monet, a highly disciplined craftsman, did several series of paintings of subjects at different times of the day, as the light changed before his eyes. *(Fig. II-6)* Monet and Renoir exhibited at the *Salon des Independants*, where the Impressionists

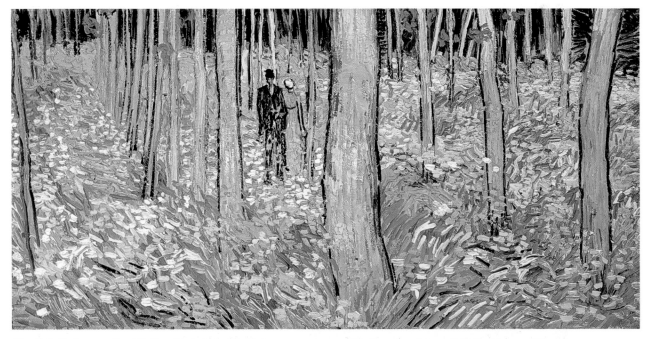

Fig. II-7. Undergrowth with Two Figures *by Vincent van Gogh. (1890). Oil. 19¾″ × 39½″. This haunting landscape, painted in the last year of his life, was described by van Gogh as violet tree trunks, perpendicular-like col-* *umns, with the ground beneath full of flowers. The color is uncharacteristically serene when compared to many of the artist's explosive canvases.*
Bequest of Mary E. Johnston. The Cincinnati Art Museum.

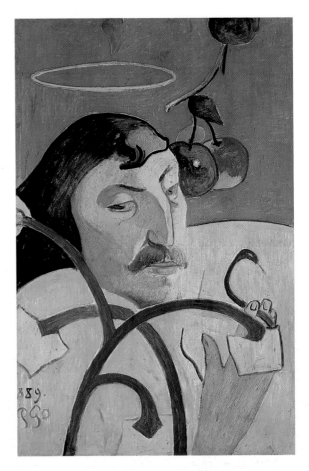

Fig. II-8. Self Portrait *by Paul Gauguin. (1889). Oil on wood. 31¼" × 20¼". Color is handled in a primitive manner in much of Gauguin's work. Areas of pure color are flat, with a minimal modeling of form. The color is more symbolic than representational.*
Chester Dale Collection. The National Gallery of Art, Washington, D.C.

were obliged to show their work when they were repeatedly rejected by the Academy. The Impressionists refused to return to academic ideals, despite the ridicule of much of the artistic community.

James McNeill Whistler, whose paintings reflected his European studies and his interest in Japanese art, had early encounters with the Impressionists, but he denied their influence on his art. Color was nevertheless a major element in his work. In later years the fellowship of Impressionists was scattered, but the central idea of color and light continued to be revealed in the work of Vuillard, Bonnard and Sickert.

The Neo-Impressionists, particularly Georges Seurat and Paul Signac, juxtaposed small dots of color on the painting surface; they reasoned that the pigments would reflect more brilliantly if they remained unmixed. The dots of paint were to be mixed by the eye, rather than on the palette.

Optical mixtures such as those found in Neo-Impressionist (sometimes called Pointillist or Divisionist) painting result when the pigments are not physically combined. Small bits of color are placed so the eye is unable to differentiate the individual colors. The eye perceives them as a mixture that is neither lighter nor darker than the component colors, but the average of the brightness of the colors. This characteristic created a distinctive beauty in the work, but the physical problem of covering enormous canvases with tens of thousands of tiny dots eventually led the Neo-Impressionists to abandon their tedious technique.

Vincent van Gogh was one of the great colorists of the Post-Impressionist period. *(Fig. II-7)* He knew the journal of Delacroix and used color for a powerful, personal expression. In his letters to his brother and to other painters he described in detail the effects he wished to achieve and the specific colors he intended to use.

The dazzling color of van Gogh began with scholarship and practice, but sometimes went out of control. Refined technique was never van Gogh's objective. "But what do these differences matter, when the great thing after all is to express oneself strongly?," Vincent wrote in a letter to Émile Ber-

nard. He recorded intense feeling with blazing color and violent brush strokes, frequently sacrificing color balance as he passionately applied the paint. The canvases of his friend Paul Gauguin were also brilliantly colored, the two painters being the nearest thing to precursors of the Expressionist movement. *(Fig. II-8)*

Paul Cézanne decried the loss of form that had evolved with Impressionist painting. He enlarged the brush stroke and used strokes of adjacent colors to move around forms and back into space through value and temperature changes. He remained faithful to the two-dimensional picture plane, letting color do the work of mechanical perspective. Naturalistic color was less important to Cézanne than the expression of limited space and volume. *(Fig. II-9)*

The twentieth century

At the turn of the twentieth century, the Fauves ("Wild Beasts") erupted with an uninhibited, jubilant, decorative use of flat color, pure and playful. The paintings of Dufy, Derain, Vlaminck and Matisse demonstrate this exuberance. *(Fig. II-10)* Their approach led the way to the more powerful Expressionist ideal of color as emotion and to the subsequent Orphist credo of color for it own sake.

The Expressionists painted impulsively, with passion and drama—no holds barred and no rules of color. Munch, Nolde, Chagall, Klee, and Marc exemplified the Expressionist ideal. *(Fig. II-11)* Many

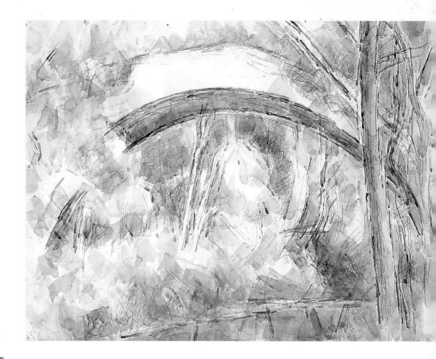

Fig. II-9. The Bridge of Trois Sautets *by Paul Cézanne (ca. 1906). Watercolor. 16¹/₁₆" x 21⁵/₁₆". Very little spatial recession is felt in this colorful watercolor. The eye moves around the painting following repetitions of delicate colors and rhythmic, colored forms and brushstrokes.*
Gift of John J. Emery. The Cincinnati Art Museum.

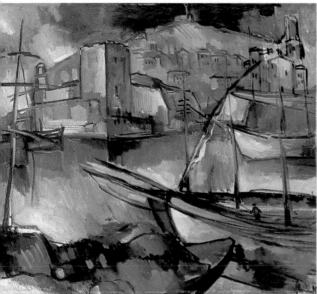

Fig. II-10. The Old Port of Marseilles *by Maurice de Vlaminck. (1913). Oil on canvas. 28¾" × 35⁵/₈". The exuberance of Fauvist color began to fade somewhat after 1907. Cézanne's ideas seemed to have a sobering influence on Vlaminck, whose work began to show more control over the color relationships.*
Chester Dale Collection. The National Galley of Art, Washington, D.C.

Fig. II-11. The Red Horses *by Franz Marc. (1911). Oil. 47⁵/₈" × 72". The emotional intensity of color is character-istic of Expressionist works. Marc used pure color freely— every color of the spectrum is vividly apparent in this stunning painting. The contrast of pure hues is successful through the use of a dominant color.*
Lent by Mrs. Paul E. Geier to the Cincinnati Art Museum and the Bush-Reisinger Museum, Harvard University. Courtesy of the Cincinnati Art Museum.

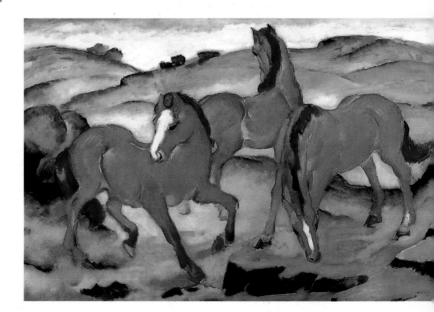

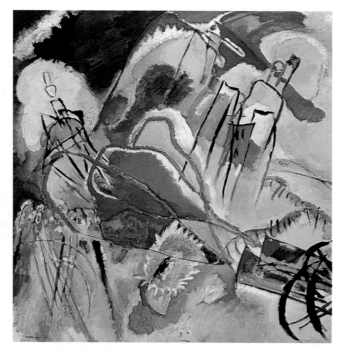

Fig. II-12. Improvisation No. 30 (Warlike Theme) *by Wassily Kandinsky. (1913). Oil on canvas. 43¼" × 43¾". Kandinsky described his* Improvisations *as spontaneous expressions of his inner self. The color must be dealt with on a purely emotional level, since no conscious effort has been made to integrate color relationships.*

Arthur Jerome Eddy Memorial Collection. Courtesy of the Art Institute of Chicago.

Expressionist painters admired van Gogh, but gave no credence to the theories that motivated his powerful use of color. Wassily Kandinsky spoke of the "inner necessity" of the artist to express himself freely, without the constraints of theories and rules to limit his expression. He affirmed that everything which springs from the inner spirit—whether harmonious or discordant—is beautiful. *(Fig. II-12)*

The Cubists, led by Picasso, Braque and Gris, had little interest in color expression. The planes of Cubist subjects, seen simultaneously from different sides, are mostly composed of contrasting values. Cubist paintings were often a negation of color; they represented the aspects of objects seen from several different viewpoints. Cubists de-emphasized volume and space in the development of the painting as a two-dimensional surface rather than an illusion of reality. Three-dimensional representation was considered detrimental to the integrity of the two-dimensional picture plane. A shallow illusion of space is sometimes suggested by gradation of tones. *(Fig. II-13)*

Other modern schools appeared that exalted color as the subject of the painting. Robert Delaunay, spokesman for the Orphists, announced that pure painting had at last been discovered. Disciplined use of color reigned. No longer were form, technique, representation or emotional expression of major importance. With color regarded as the fundamental material of the painter, only colors and their relationships to each other were of serious consequence. Color-field painting and optical art resulted from the efforts of such artists as Victor Vasarely and Frank Stella, whose paintings make color vibrate upon the walls.

Parallel to these developments glorifying color, opposing schools appeared in which movement, shape, materials and the revelation of the gesture involved in making the painting had significance. Conceptual and minimal art followed. Once again color was eclipsed.

Color in your art

Why not simply use formulas for color mixtures? Why bother with theory? What difference will practice and experience make?

Is color study worth your undivided attention?

You alone can answer these questions. If color is important to you, then you must come to understand the legacy of color that lies in the past; you must learn color "facts" to enable you to express yourself with conviction in color. Your artistic statement should be unique. Color is an effective and deeply satisfying way to communicate your message. *(Fig. II-14)*

Learning about color is a lot like learning perspective: first learn the rules; then break them if you must.

Perhaps you began your painting career as the student of a practicing artist. You probably use your mentor's palette, with minor changes and additions, to report what you see around you in a descriptive fashion. You might have copied your palette from a painting book. If you allow yourself to become comfortable with the choices of others, you will never know the thrill of inventing expressive color and making your own personal statements in painting.

On the other hand, you may have discovered a fortunate combination of colors that clearly distinguishes your work from the work of others; you have found a color "style." If you faithfully use these pigments throughout your career, restricting your subjects to those appropriate to "your" colors, your paintings may become stereotyped. You risk inhibiting your growth when you cease to experiment.

What other options have you, then? How can you increase your choices intelligently?

First, you should learn color theory and experience for yourself how pigments work. Then, and only then, can you use color with conviction. When you are confident that you *know* about color, you can trust your intuition to carry you forward to fine expression.

An inventive artist experiments with color. When you increase the range of available choices, you have greater variety in your painting vocabulary. You cannot accomplish that by guess work.

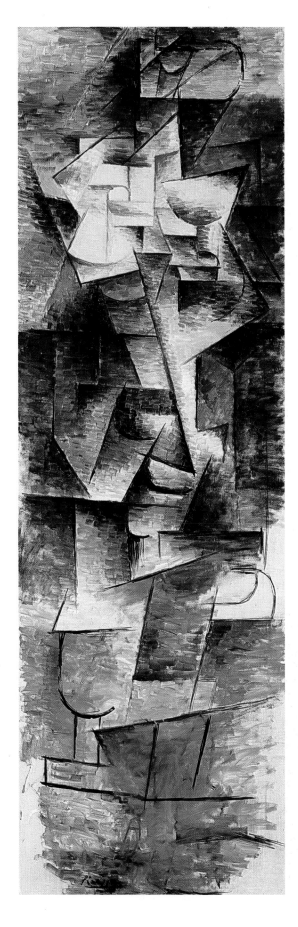

Fig. II-14. Gus *by Stephanie Kolman. Watercolor. 14″ × 20″. The language of painting requires your understanding of basic principles of color and design to reach its expressive potential.*

Exercise #1

What are you doing with color now?

Before beginning the exploration of color, complete this painting exercise for comparison with later paintings. Using the pigments you are familiar with, paint the four seasons, or abstractions of this subject. If you have a distinctive palette, use it as you are accustomed to doing. A less experienced painter should begin with a simple palette of three to five colors.

If you are a nonobjective painter, you need not refer to subject matter, although you might keep a seasonal motif in mind. If you are a representational painter, you will benefit if you include abstract and nonobjective paintings in your sketches occasionally, studying color relationships apart from subject matter.

Keep in mind that your sketches will be more revealing of color potential when you are flexible about subject and composition. Any of the exercise sketches may be realistic, abstract or nonobjective. Try to be as inventive as possible in your use of color.

Do not experiment yet with new pigments. These paintings are to be a record of how you now use color.

Your exercise sketches need not have the look of finished paintings. When you have seen what happens with the pigments and color effects you are exploring, each exercise has served its primary purpose. Keep them all for comparison with later exercises.

Fig. II-13. Nude Woman *by Pablo Picasso. (1910). Oil on canvas. 73¾″ × 24″. Color was of little importance in many Cubist paintings. Geometrical emphasis and shallow space were both inherited from Cézanne, but Cézanne's color thinking did not accompany them.*
Ailsa Mellon Bruce Fund. The National Gallery of Art, Washington, D.C.

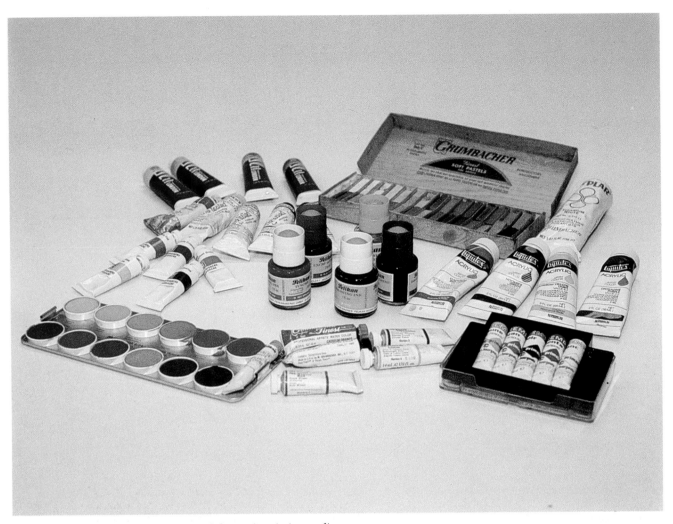

*Fig. III-1. Composition of chromatic painting media
varies somewhat, but any medium can be adapted to the
color exploration exercises. Theories of color relationships
apply to all media.*

Chapter **III**
Pigments

Exploration of pigments requires suitable supplies and systematic procedures. Fine materials give the best results. In the long run your investment in quality pigments for the color studies will be repaid by improved color in your paintings.

You have probably taken some classes and workshops. If so, each time you enrolled for a class, you were no doubt handed a list of supplies, including the colors needed for the workshop. You dutifully purchased the pigments listed. More often than not, the colors on the supply sheet were never used in the class. Even if they were, the instructor probably didn't explain why those particular colors were recommended. Over a period of time, you acquired exquisite pigments that you seldom use and a paint box heavy with unopened paint tubes. *(Fig. III-1)*

Here is still another list of pigments to add to your assortment. But don't despair! This time you will use them all. Some may become staples on your palette; others will fill special needs. Still others will appeal to only a few of you who explore them. You will test every pigment and accept or reject each on the basis of what you learn about it as the experiments progress. All of the tests and exercises can be applied to those unused paints from earlier classes and workshops.

Getting started

Purchase the finest paint you can afford. My personal preference is Winsor & Newton brand. Grumbacher Finest colors are excellent, also. These manufacturers classify their pigments by "series," according to the availability of the colorants and the cost of processing them. In Winsor & Newton colors, Series 1 pigments are the least expensive and Series 5 are the most costly.

London brand, student-grade paints by Winsor & Newton, are brilliant, clean colors. Liquitex and Grumbacher Academy are also dependable brands.

Pigment quality will affect the results in the exercises. Don't mix inferior paints with your best colors.

As you explore pigments, you will discover that some are more pleasing to you in one brand than in another. Coloration varies widely from brand to brand and, of course, personal tastes differ. You may use different brands of pigments of similar quality. Pigments are usually compatible between manufacturers. No "correct" brand of pigment exists. Chemical instability and incompatibility are rare today in fine paints, so you needn't concern yourself with this. Consult the manufacturer if you have questions regarding toxicity of pigments.

Artists of the past were forced to mix their own paints at every sitting, sometimes using animal bladders to contain the mixed paints. The development of the metal tube freed the artist of this time-consuming task, but like many improvements throughout history, this considerable gain was accompanied by a loss. Succeeding generations of painters have a diminished understanding of the materials they use.

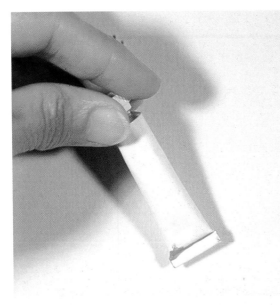

Fig. III-2. Leaky Tube. When a tube of paint is improperly crimped, the contents will ooze out. Sometimes ingredients necessary to the paint consistency are diminished, altering the handling characteristics of the paint. When you see paint or any other substance around the neck or bottom of a tube, select another tube!

When you purchase your paint, don't depend on manufacturers' color charts. Most are printed with inks that are not accurate representations of the colors. Charts produced with actual paint on paper swatches come closer to the true colors of pigments.

Check for leaks at both ends of the tube before you buy. *(Fig. III-2)* Avoid wrinkled tubes. Certain pigments have a shorter shelf life than others. Check the tubes as soon as you get home. If the contents are stiff and dry, return them to the dealer immediately. Some of the very costly metallic pigments dry out quickly.

A note of caution: try to keep the necks of the tubes clean, so the caps won't stick. But if one does stick, first use firm, gentle pressure with pliers. If the tube still resists opening, hold a lighted match to the neck or soak the tube to free the cap *(Fig. III-3)* Don't slit a tube at the bottom to get at stiff paint that won't squeeze from the tube. You risk permanent damage to your brushes if you scrub at the paint through the cut edges.

Paint is pigment suspended in liquid; the color forms a layer upon the painting surface. Substances dissolved (liquified) are called dyes and are absorbed into the surface. A palette of purely transparent pigments is feasible. When you have tested your colors, you will know which pigments meet your specifications.

A good pigment does not fade in normal light, but don't expose pigments or paintings to direct sunlight, even in tests. Bright, indirect light suffices to test for light resistance. Some cheap student colors fade even without exposure to light. Manufacturers have eliminated most fugitive colors. If you question the permanence of a color, paint a patch of it on a white support, cover half of it with masking tape and place it near a sunny window for several weeks. When you remove the tape you can judge the color loss. Most good paints show little fading after this exposure.

In 1892 the Winsor & Newton Company published a policy statement on permanency and composition of pigments. Artists sometimes requested pigments that the company considered to be "fugitive," or unstable under certain conditions. The company decided to continue to provide such colors; they devised a grading system, with AA for extremely permanent pigments, A for durable colors, B for moderately durable colors, and C for the fugitive colors. Only six fugitive colors are presently listed: carmine, chrome lemon, chrome yellow, mauve, rose carthame and Vandyke brown. The chrome colors are no longer available in the United States.

In *Notes on the Composition and Permanence of Artists' Colours* Winsor & Newton describes its present standards for testing colors and the materials used in the making of paint. The booklet further states:

"By the permanence of a Water Colour (transparent, opaque, gouache, or acrylic) we mean its durability when washed on the best quality water colour paper and, while under a glass frame in a dry room, freely exposed to ordinary daylight for a number of years, no special precaution (other than the usual pasting of the back of the frame) being taken to prevent the access of an ordinary town atmosphere. By an ordinary town atmosphere we

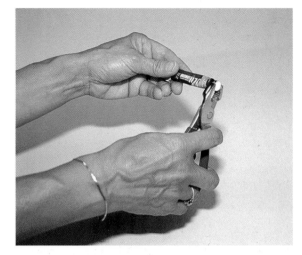

Fig. III-3A. Stuck Caps. *You may have to use pliers occasionally to open a tube of paint. Take care not to break a hole in the tube.*

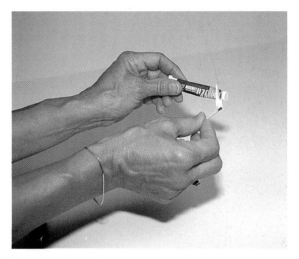

Fig. III-3B. A lighted match will usually soften the paint around the neck sufficiently to allow you to open the tube. After holding the match to the neck of the tube for a few seconds, use the pliers gently to remove the cap.

signify an atmosphere normally containing as the active change-producing constituents, oxygen, moisture, and a small percentage of carbonic acid, together with chronic traces of sulphur acids, spasmodic traces of sulphuretted hydrogen, and a certain amount of dust and organic matter in suspension. . . . Our colours are tested under conditions which are as nearly as possible the same as those which obtain in the ordinary practice of painting and exposing easel pictures. . . . It may be remarked in conclusion that, strictly speaking, there can be no such thing as absolute permanence."

Some pigments will react adversely to certain chemical fumes over a long period of time; the ultimate consequences of atmospheric pollution are as yet unknown.

The target of this book is to discover as much as possible about color, not only color theory, but also the idiosyncracies of the pigments that artists use. The transparency and opacity of so-called "transparent" pigments vary greatly. Good paints are relatively consistent: pigments that are transparent or opaque in a top quality brand generally have the same characteristic in another brand of similar quality. A few pigments that are transparent in "artists' finest" colors have an undesirable tendency toward opacity in students' colors, and some normally non-staining artists' pigments dye the fibers of the paper when students' pigments are used. Comparative testing will reveal these differences.

Generally speaking, the finer grades of paint contain a large quantity of pure pigment and few additives or fillers. The contrast with school paint box sets, which are often loaded with additives, is

apparent. *(Fig. III-4)* Cheap sets may look bright enough in the package, but it is nearly impossible to paint vivid colors with them. The best paints are brilliant and jewel-like when they are applied to the support.

Selection of paints becomes easier when you find a manufacturer whose product is pure, consistent and reliable. Inferior materials will invariably give disappointing results. The tests and exercises in this book will help you to make judgments between products available from different companies. *(Fig. III-5)*

Pigments for color exploration

Use the pigments on the first list below for the exercises described in Part One. The pigments on the second list are necessary for advanced work with expanded palettes in Part Two. Brief descriptions of some characteristics of the pigments follow the pigment names. Your medium or brand may differ. Color is subjective; appreciate that *your* reactions to color are more important than anything you find on a chart or list.

Some pigments formulated in the laboratory have proprietary names that do not always indicate the content of the pigment. "Winsor" colors are manufactured by the Winsor & Newton Company; "Phthalo" colors are the London brand, also by Winsor & Newton; "Thalo" is a Grumbacher designation. If the trade names are listed together on the recommended list below, the pigments are interchangeable, but not necessarily identical.

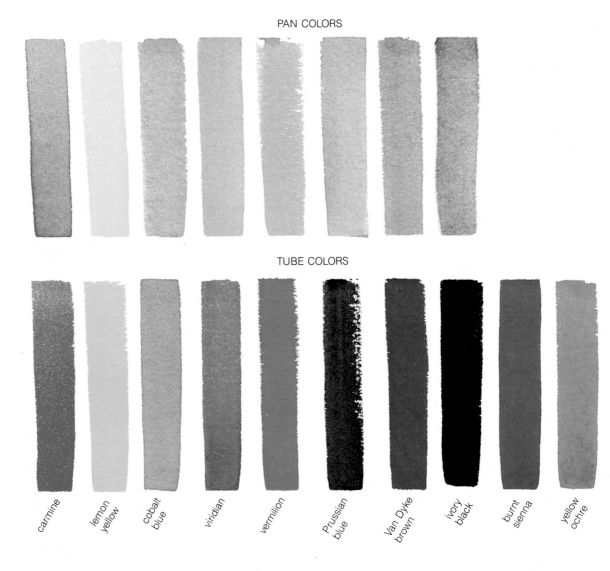

PAN COLORS

TUBE COLORS

carmine • lemon yellow • cobalt blue • viridian • vermilion • Prussian blue • Van Dyke brown • ivory black • burnt sienna • yellow ochre

Fig. III-4. No amount of scrubbing will coax more than this pale tint from the cakes of color in a cheap paint set (above). Inferior tube colors (below), considerably more intense than the pan colors, are very dense (probably because of fillers) and are not good representations of the colors for which they are named.

Recommended list for color exploration

BLUE
ultramarine blue (or French ultramarine)—warm, semi-transparent, brilliant; a dependable pigment found on many artists' palettes

phthalocyanine blue (Winsor blue or Thalo blue)—cool, transparent, intense and staining

indigo—cool, transparent

cerulean blue—very opaque, somewhat cool (brands vary greatly)

Antwerp blue (Winsor & Newton only)—cool, transparent; a gentle cousin to phthalo blue

cobalt blue (Winsor & Newton preferred)—warm, semi-transparent

GREEN
viridian—cool, transparent; less popular in watercolor than in oil

Hooker's green dark—cooler than Hooker's green light, but warmer than phthalo green; transparent

phthalocyanine green (Winsor green or Thalo green)—cool, transparent; intense and staining

YELLOW
cadmium yellow light or **cadmium lemon**—cool, opaque, as are all of the cadmiums; of unparalleled brilliance

cadmium yellow medium—warm, opaque and brilliant

new gamboge (Winsor & Newton only)—warm, transparent; extremely useful

aureolin (Winsor & Newton only)—cool, transparent; lovely in washes, which appear quite different from the paint straight from the tube

yellow ochre—cool, semi-transparent, grayed yellow

raw sienna—warm, transparent; a grayed yellow somewhat brighter than yellow ochre

Winsor yellow—cool, transparent

Naples yellow—warm, extremely opaque

RED

cadmium red light—warm, opaque and brilliant

cadmium red medium—warm, opaque and brilliant

Winsor red or **Grumbacher red**—cooler than the cadmium red light and more transparent; brilliant when wet, dries much lighter

alizarin crimson—cool, transparent; a lovely color in some brands

brown madder alizarin—warm, transparent

permanent rose or **rose madder genuine** (both in Winsor & Newton only)—cool, transparent; delicate

Indian red—cool, opaque; a powerful pigment

light red oxide—warm, very opaque and powerful

BROWN

burnt sienna—warm, transparent in some brands; one of the better browns

burnt umber—cooler than burnt sienna; transparent

GRAY

Payne's gray—cool, transparent; dries much lighter

ivory black or **neutral tint**—warmer than Payne's gray; transparent

WHITE

Purists do not use white paint, preferring to reserve the brilliant white of the paper. At one time transparent watercolors having white paint in them were summarily rejected from watercolor exhibitions. Now, white paint and opaques are used freely by many watercolorists. These uses have expanded the creative potential of the watercolor medium.

To simplify mixing procedures, white is not used in this book. If you wish to have a white pigment available, a liquid white, such as Luma, is recommended over Chinese white watercolor, because of its more consistent covering power. If you are adapting the exercises for a medium other than transparent watercolor, use your usual thinner.

Additional colors
for expanded palettes

BLUE

manganese blue—a cool, transparent blue-green; settling

cobalt turquoise—opaque, cool blue-green

GREEN

sap green—warm, transparent

Thalo yellow green—a bright, semi-transparent yellow-green

Hooker's green light—warm, transparent green

YELLOW

cadmium yellow deep—an opaque, yellow-orange

cadmium orange (Grumbacher)—an opaque, warm orange

RED

Thalo red—cool and transparent

cadmium scarlet—a warm, opaque red-orange

VIOLET

cobalt violet—cool, transparent

Winsor violet—warm, transparent

permanent magenta—warm, transparent red-violet

Thalo purple—transparent, cool violet

Thio violet—transparent, warm red-violet

Both lists include warm and cool hues, as well as transparent, semi-transparent and opaque pigments. Remember that "warm" and "cool" are subjective terms relative to the context of the color. Many characteristics of color are relative, rather than absolute.

If your favorites are not on this list, keep them handy anyway. Include them in the exercises and charts. Later you will be able to determine where they belong on your palette.

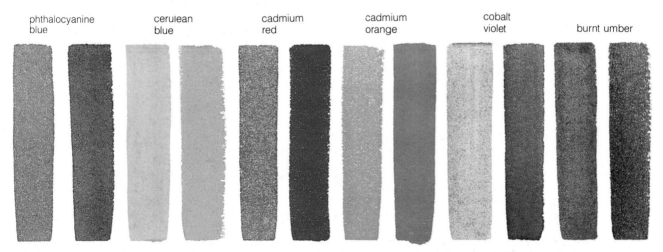

phthalocyanine blue cerulean blue cadmium red cadmium orange cobalt violet burnt umber

Fig. III-5. Differences in Brands of Pigment. *Each of the colors shown, while it can be clearly associated with its pigment name, nevertheless differs substantially in each brand shown. It will be up to you to decide which pigments you prefer after you have tested them.*

Chapter **IV**

Supplies and Procedures

You have no doubt accumulated an assortment of supplies suitable for your own style and method of painting. You may have strong personal preferences for materials. Perhaps you use shortcuts that are highly idiosyncratic. You can achieve more consistent results in color exploration if you select your pigments and supplies according to the recommendations here, and if you use the procedures described in this chapter for the exercises.

Additional supplies

A white support is preferable in color exploration. Use a top quality watercolor paper such as Arches, or canvas pads for oils and acrylics.

Additional materials for exploring color include a half-inch aquarelle for watercolor, or a half-inch bristle or synthetic "bright" (an oil painters' brush); half-inch masking tape or white artists' tape for sectioning the support to isolate colors; a ballpoint pen for notation on the exercises; waterproof India ink; and a sketchbook. Rags and paper towels are essential. A small, hand-held hair dryer is also helpful. *(Fig. IV-1)*

The white palette, 12″ or larger (two, if you can manage it), should have a fairly large mixing area, divided, if you prefer. *(Fig. IV-2)* The white surface helps you to judge how the colors look on a white support. A certain amount of staining is normal. The porcelain butcher's tray is ideal. Paper palettes won't do for watercolor, but are suitable for oils and acrylics.

Have an additional assortment of brushes for the painting exercises. *(Fig. IV-3)* Select only the best quality you can afford. Synthetics have a limited capacity for retaining water, but make good, sharp edges. Sable, though terribly costly, is preferred for pointed round brushes but is not necessary in the flats.

Test your brushes at the store before buying them. A reputable supplier expects this. Stir the brush in a glass of clean water to remove the sizing that is holding the shape. Form the brush with a snap of your wrist. A good round brush should have a sharp point and full "belly." Shape the flat brush between your fingers and look for a straight, chisel edge and fullness near the ferrule. *(Fig. IV-4)*.

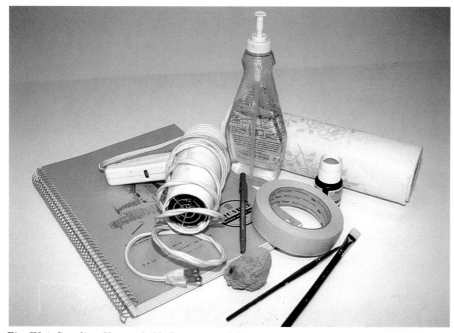

Fig. IV-1. Supplies. *You probably have most of these supplies, or their equivalents, among your painting equipment. Keep them all located in the area where you will be exploring your colors.*

Finally—and this is of utmost importance—you will need clean water or thinner and lots of it, to avoid contamination of colors. Use two large containers—one for cleaning the brush, the other for picking up clean diluent to carry to the pigment. Develop good habits at the outset.

Addenda

Lighting

In order to judge colors better, work under good lights. The cool north light desired by many artists is acceptable for color work, but is not available to every work place. Some artists combine fluorescent and incandescent bulbs or use warm and cool fluorescent bulbs together. Look for special "daylight" incandescent or fluorescent bulbs. Some of these bulbs reflect color to within 91% of the purity of daylight. Ideally, you should evaluate a painting under the same type of light it will be viewed under. For color exploration, however, use a mixture of lights. *(Fig. IV-5)* Incandescent light alone is too yellow/red and fluorescent is too blue. A combination of the two gives acceptable light for studying color mixtures.

Source material

Work from original source material: develop your sketches from photographs you have taken and design your own nonobjective compositions. Please don't copy the work of other artists. This is your opportunity to discover your color personality—to develop your *own* sensitivity to color.

Fig. IV-2. Palettes. *Any type of white palette is acceptable for color exploration. The watercolor palette shown enables you to squeeze out all of the colors on the recommended list, but this should only be done for the exercises in which every pigment is tested at the same time. Self-adhesive labels with the names of the pigments may be affixed to the outside edge of the palette to eliminate confusion.*

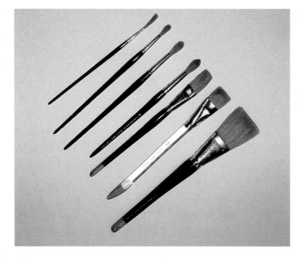

Fig. IV-3. Brushes. *You probably have your own favorites. If you are just beginning your brush collection (every artist has one, I think!), you will want to start with an assortment of rounds and flats like these.*

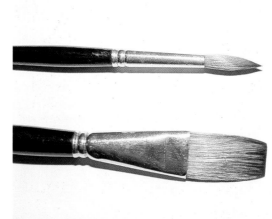

Fig. IV-4. Good Brushes. *When you test a new brush, washing out the sizing and snapping your wrist with the brush in hand, a good sable round will come to a sharp point. Note also the full "belly" of the brush. The flat should have a fine, chisel edge.*

If you paint from photographs, don't rely on the colors in the photo. Photographic color may be affected by filters, film type and camera quality. A creative interpretation of the subject should be more or less independent of local color, the actual color of the subject. Develop your own interpretations—that's the purpose of color exploration.

Fig. IV-5. Lighting. *One type of art lamp with fairly balanced light combines a fluorescent ring with an incandescent bulb. These are sometimes made to clip onto the edge of a drawing table. Check your lighting specialty store for other color-corrected lighting.*

Matting and framing

Select your mat and frame to enhance the color in your painting. As you become more and more sensitive to the effects of simultaneous contrast, you will begin to understand why neutrals are preferred. The artist, wanting his painting to be seen for itself, frequently conflicts with the interior designer, who sees the painting as an accessory to a room. Brightly colored framing is usually distracting and has an undesirable influence on the color relationships in the picture.

Setting the palette

As you explore your pigments, lay out the colors systematically. Squeeze the pigments onto the palette in the same orderly arrangement every time you paint. When you decide on a permanent basic palette, you will be able to find your colors immediately and will run less risk of contaminating them with other colors. You don't want to find phthalo blue where you were expecting French ultramarine!

One logical arrangement of pigments follows the order of the spectrum with red, orange, yellow, green, blue, and violet across the palette and neutrals in an area to themselves. Another arrangement aligns warm hues (the reds, oranges and yellows) and cool hues (the greens, blues and violets) on opposite sides of the palette. *(Fig. IV-6)* If some other layout appeals to you, use it—but be consistent.

Use fresh, clean pigments for the exercises. Keep careful notes on the location of each color on the palette until you finish testing the color and remove it from the palette. Change the thinner frequently. Small quantities of pigment will be sufficient for most of the tests.

warm hues

cool hues

warm/cool

of each hue

Fig. IV-6. Palette Arrangements. *Any one of the arrangements shown would be a logical way of placing your pigments on the palette. Choose one that appeals to you and make a point of always placing your colors in the same arrangement. Devise your own plan if none of these suits you.*

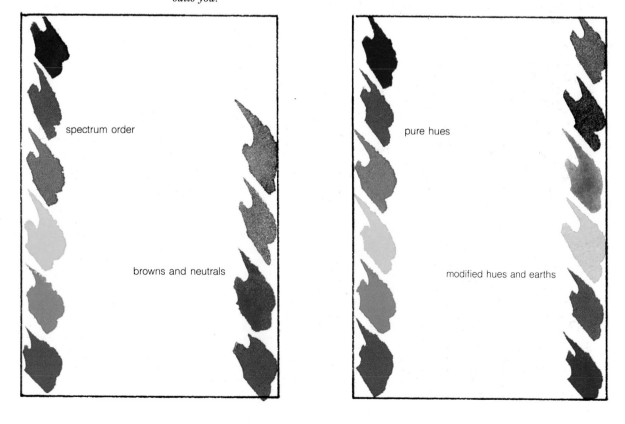

spectrum order

browns and neutrals

pure hues

modified hues and earths

Fig. IV-7A. The Journal. Your sketchbook-journal will be an invaluable aid to exploring color, and if you develop the habit of using it to record your artistic activities, as in a diary, it will continue to serve you long after the basic exercises are completed.

The journal

Begin at once to keep a journal in your sketchbook. If you wish, restrict the journal to color, and use it entirely as a reference. On the other hand, consider the pleasure that can be gained by keeping a personal sketchbook diary, in which you record details of your paintings—the support and pigments you use, the source of the subject matter—as well as workshops you attend, demonstrations you see, and your observations of color in nature. *(Fig. IV-7)*

Take detailed notes on the colors you test, your reactions, the different effects you observe, ideas for subjects suitable to the colors, comparisons of new colors with those you are familiar with. Record the names of the pigments you use in your paintings and why you chose them. Note what effects you achieved through color and your satisfaction or dissatisfaction with the palette.

Eugène Delacroix kept a wonderful journal. Every practicing artist should read it. Delacroix described his museum visits and how he analyzed the paintings he studied there. He recorded his observations of effects of light on human skin; he commented on music, literature and social progress. Everything Delacroix experienced contributed to his artistic development; much of this is found in his journal.

Fig. IV-7B. Emerging Spring by Nita Leland. Watercolor. 18″ × 24″. This painting evolved from a photograph of a Savannah marsh, taken on a gray November day. The journal entry reconstructs some of the planning that pre-ceded the painting and how it happened to evolve as springtime. Such planning helps to solve problems and frees you to paint more spontaneously.
Collection of Mr. and Mrs. Alfred Schneider, Jr.

Putting your thoughts on paper helps you to clarify your artistic thinking. Vincent van Gogh, estranged from the art world of his day, poured out his artistic longings in lengthy letters to his brother, his only sympathetic sounding board. He put into words what he tried to put into his work, and thus clarified for himself the task before him. A journal can be extremely useful in helping you to understand yourself and your art.

The exercises

Isolate the color mixtures you explore by forming 12 to 16 small rectangles on the support with strips of masking tape or white artists' tape. This will be referred to as the "sectioned sheet." *(Fig. IV-8)* On the masking tape note the pigments you use in the experiments. When you remove the tape, transfer your notation to the support for a permanent record. (The tape removes easily if you warm it briefly with a hair dryer. Do not leave the tape on paper for an extended time.) The white strip separating the experiments modifies the strong influence colors have upon each other when they are placed side by side.

You will do three types of exercises here:

1. **Pigments:** These tests reveal the properties of individual pigments, their similarities and differences, familiarizing you with the characteristics of the pigments on the recommended lists.
2. **Mixtures:** You will discover beautiful color mixtures by working through the mixing exercises, by exploring compatible color circles, and by studying color schemes.
3. **Paintings:** When you know how colors behave in combination and in context, you will utilize this knowledge to develop sketches as experiments in color and color composition, a stepping stone away from applying your new-found knowledge of color in your work.

Nearly every aspect of color exploration depends upon your intuitive responses, coupled with a growing intellectual understanding of how color works. There are no formulas for expressive painting and no perfect palette. Individuality is the governing factor in color selection and use.

Before you begin the study of color, clean the sullied color off your palette. Fresh, clean pigment is the essential ingredient of successful color study.

Fine materials, organization, and good work habits contribute to successful results in color exploration. Each exercise serves a purpose and should be carefully completed. The journal is a vital component of your studies and observations. Be faithful in recording the results of your studies without delay after each exercise is completed.

Exercise #2

Make the first entry in your journal today. After dating the page, list the colors on your palette at the start. Comment briefly on why you use these particular pigments. Think about what you hope to achieve through a serious study of color. What do you want to express in color? Write these things down. As the experiments progress, you will find it difficult to remember all of the pigment mixtures

and your immediate reactions to them. You'll be grateful for a detailed account in your journal.

The way to learn color is to *use* color and to become sensitive to color relationships and idiosyncrasies. Color exploration is a challenge. Your rewards are a deeper awareness of color potential and a greater depth of expression in your paintings.

Fig. IV-8A. The Sectioned Sheet. *Use masking tape to section off your watercolor paper or canvas and separate the color areas from one another, making the color effects easier to judge.*

Fig. IV-8B. *Warming the tape with a hairdryer makes it easier to remove from paper. Lift gently as you pull the tape away.*

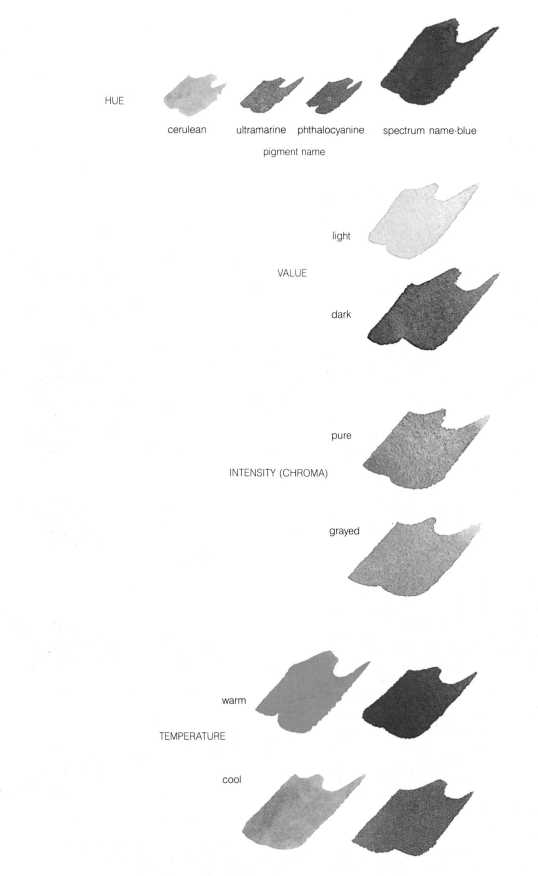

HUE

cerulean ultramarine phthalocyanine spectrum name-blue

pigment name

VALUE

light

dark

INTENSITY (CHROMA)

pure

grayed

TEMPERATURE

warm

cool

Fig. V-1. The Properties of Color

Chapter V
The Properties of Color

Hue, value, intensity, and temperature: these are the foundation words of the color vocabulary. Briefly described, *hue* is the name of the color; *value* is its lightness or darkness; *intensity* is its purity or grayness; *temperature* is its warmth or coolness. *(Fig. V-1)* *Achromatic* hues are black, white and gray—the neutrals, which lack color. All others are *chromatic* hues, having color. *(Fig. V-2)* The properties of hue, value and intensity are all represented on the color solids of the theorists described in Chapter I. Temperature appears here as a property of color because of its fundamental importance to color relationships in painting.

Your personal response to each color and color mixture is of paramount importance in discovering your color personality. Even your indifference to a color is significant. Note all of your reactions in your sketchbook journal. No one else will have the same reactions to every color that you experience. The exercises in this chapter establish the foundation of your color knowledge and begin to sensitize you to your own color preferences.

Hue

The *hue* is the name of the color in its purest and simplest form: red, orange, yellow, green, blue, violet—the colors of the spectrum. As a color moves away from its spot on the circle, it begins to assume the characteristics of its neighbor. The names of the tertiary (intermediate) hues indicate this: red-orange, yellow-orange, yellow-green, blue-green, blue-violet, and red-violet. *(Fig. V-3)* The usual arrangement of six spectral and six intermediate hues gives twelve hues, a workable number for color study.

Any given hue, such as red, has numerous pigment formulations. For example, alizarin crimson or cadmium red, both recognized as reds, should not be referred to as "hues," but as "paints" or "pigments." Hue is a general term for color names, whereas pigment names are more specific. There are twelve hues on the color circles you will use, but there are several pigment variations of each hue.

The rationale of the color circle

The placement of colors on the color wheel establishes logical relationships between them that are useful in color mixing and color composition. In your exploration of color, you will turn frequently to the color circle, a remarkably useful device, to help you organize and study color relationships.

Your first color circle illustrates the color-mixing capabilities of the pigments you now use.

Exercise #3
If you have been painting for a while, you probably have an assortment of pigments that includes several you use frequently. With the colors you know best, use mixtures of the brightest red, yellow and blue pigments to create colors as near to spectrum colors as the pigments allow. Do not use any of the violets, oranges and greens you have in your paintbox; mix these colors. Arrange the colors on a color circle as if they were the numbers on the face of a clock,

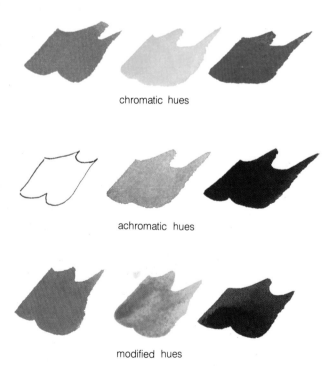

chromatic hues

achromatic hues

modified hues

Fig. V-2. Types of Hues. *Chromatic hues are called "colors." Achromatic hues are referred to as "neutrals." The modified hues are sometimes called "neutraled" or "neutralized" hues.*

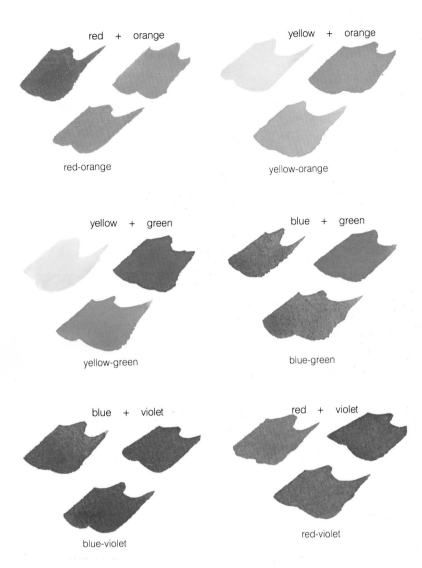

red + orange

yellow + orange

red-orange

yellow-orange

yellow + green

blue + green

yellow-green

blue-green

blue + violet

red + violet

blue-violet

red-violet

Fig. V-3. Tertiaries. *Between each primary and secondary color on the circle is an intermediate hue called a "tertiary." These hues retain qualities of both colors in the mixture.*

beginning with yellow at the top (12 o'clock) and moving clockwise toward green in the following order: yellow, yellow-green, green, blue-green, blue (4 o'clock), blue-violet, violet, red-violet, red (8 o'clock), red-orange, orange, yellow-orange. *(Fig. V-4)* Note the pigments you use on the exercise sheet and in your journal, along with the brand names. If you feel any mixture is particularly effective—or less than satisfactory—note that as well.

Don't expect to achieve spectral purity with pigments. It can't be done. Your present palette may not have a particularly good selection of paints for the creation of a near-spectral color circle. This exercise demonstrates your palette's limitations. Some sections of the circle will have relatively clear mixtures; others will probably seem muddy.

Later on you will find pigments that improve the unsatisfactory areas, making it possible to create color circles a little nearer to spectrum purity. You will also discover several combinations of pigments that make unexpectedly beautiful color mixtures far removed from the intense clarity of the spectrum.

Value

Value is the degree of light or dark of a color between the extremes of white and black. Ascending toward white are the "tints"; descending toward black are the "shades." Every color has a value range of tints and shades. Colors are often shown on charts as having the same value at full strength; actually, the values of pure, unmixed colors vary greatly. *(Fig. V-5)* Yellow is the hue lightest in value, becoming white in a very few steps; violet is the darkest hue, quickly descending to black. All other hues fall between. Red and green are similar in value and are situated near the middle of the value scale.

Exercise #4

The value scale in black and white, an achromatic scale, shows the full range of values. Using Payne's gray, ivory black or neutral tint, make the value chart described below, consisting of nine values from darkest shade to lightest tint. *(Fig. V-6)* The white support may represent the value of white. Make discernible differences between each of the steps on the scale.

Divide a one-and-a-half-inch-wide vertical column into nine segments. Beginning at the bottom of the column, paint a strip of black, using only enough thinner to make the paint flow. At the top of the column mix the lightest possible tint with a small amount of pigment and a great deal of thinner. At the center of the scale place a mixture of pigment and diluent that is a value equidistant between the other two. Make a larger quantity of this middle value mixture. The remaining values may be mixed by adding thinner for lighter values or pigment for darker values to the middle value mixture. Show distinct, progressive steps between the values. You may find it necessary to paint several scales before you are satisfied with the results.

This value exercise helps you to learn the proportions of thinner to pigment that change the values; it also teaches you to judge value relationships accurately.

Exercise #5

To see how light and dark values are created in color, select six or more pigments from your palette, including the brightest red, yellow and blue you have. With thinner for tints (lights) and with neutral tint or ivory black for shades (darks), mix light to dark values of each color as you did with black, making a vertical chart showing the gradation of the values in columns. *(Fig. V-7)* Some colors have a more extensive value range than others, retaining their color identities as they become darker. Blue remains recognizable as blue throughout its value range. Yellow changes very quickly to green or brown as it is lowered in value. Yellow has few value steps where it is clearly identifiable as yellow. Remember: show a discernible difference between

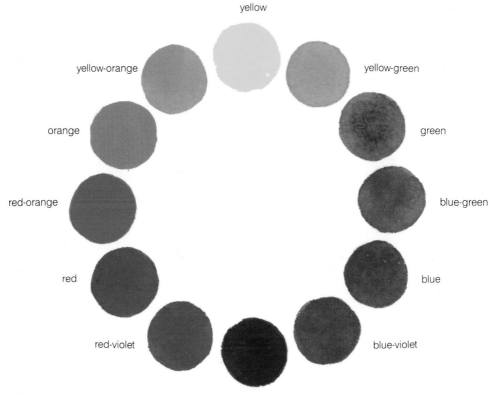

yellow

yellow-orange · · · yellow-green

orange · · · green

red-orange · · · blue-green

red · · · blue

red-violet · · · blue-violet

violet

Fig. V-4. The Color Circle. *Lay out every color circle like the face of a clock, with yellow at 12 o'clock. Have each color directly opposite the color shown above. If you are not already familiar with the color circle, memorize it, or place it where it is within view of your work area.*

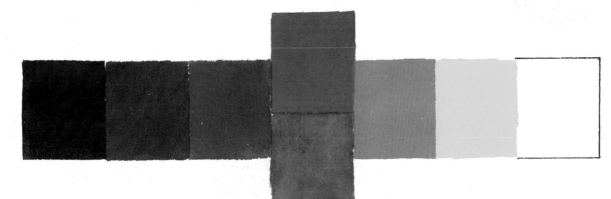

Fig. V-5. Color Values. *Hues are situated at different value levels on the scale between white and black.*

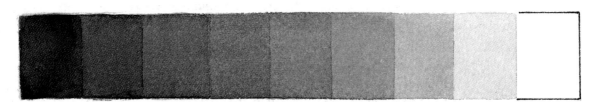

Fig. V-6. The Value Chart in Black and White

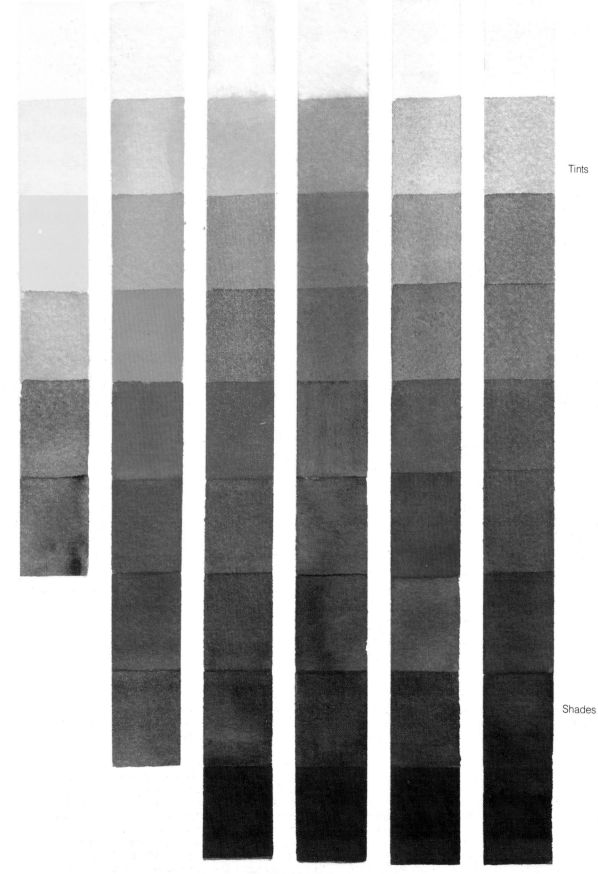

Tints

Shades

Fig. V-7. The Value Chart in Color

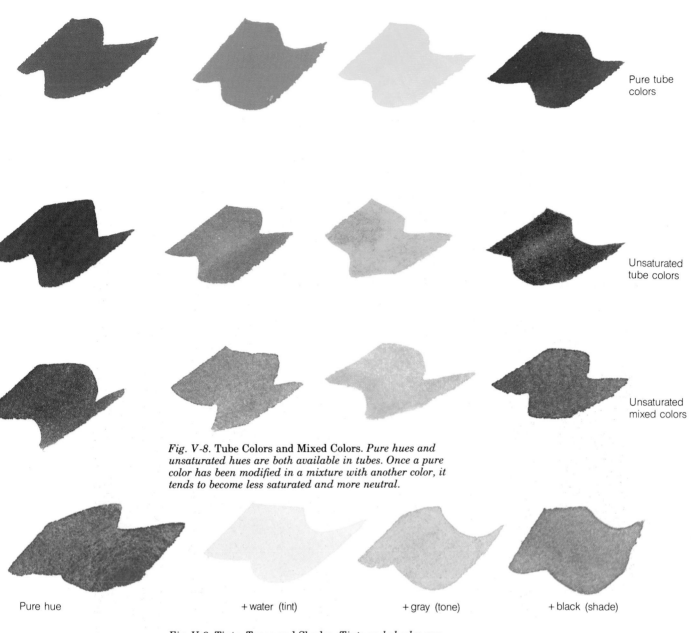

Pure tube colors

Unsaturated tube colors

Unsaturated mixed colors

Fig. V-8. Tube Colors and Mixed Colors. *Pure hues and unsaturated hues are both available in tubes. Once a pure color has been modified in a mixture with another color, it tends to become less saturated and more neutral.*

Pure hue + water (tint) + gray (tone) + black (shade)

Fig. V-9. Tints, Tones and Shades. *Tints and shades run the gamut between black and white on the value scale. Tones are mixtures of pure hues with gray.*

value steps and place the original color at its proper value level before mixing the tints and shades. The changes need not be precisely measurable, but should be apparent to the critical eye.

Intensity

The purity or saturation (sometimes called "chroma") of a color is referred to as its *intensity*. Pigments look intense when they come from the tube, but they can never be as brilliant and pure as projected or transmitted light. Mixtures of colors adjacent on the color circle are relatively bright. When the parent colors are at a distance from each other on the wheel,

the mixtures are less intense.

At this point it becomes necessary to expand the definition of neutral pigments, presently limited to black, gray and white, to include any pigments or mixtures of pigments that are unsaturated hues. *(Fig. V-8)* Some tube colors are unsaturated hues. The earth colors—the siennas, ochres and umbers— and the oxides are among these colors, which will be referred to occasionally as neutral or unsaturated pigments. When a saturated pigment is modified by mixing it with any color that alters its purity, it, too, becomes a more neutral, unsaturated hue, nevertheless retaining the color identity of the original hue.

51

Light tones Pure hue Middle tones

Fig. V-10. The Intensity Chart

Why is a mixture of colors less brilliant than the pigments that combine to create it? The color you see is normally caused by light reflected off a surface. If white light strikes a white, unpigmented surface, you see white. If pure, colored light strikes a white surface, you see the same pure color reflected. When white light strikes a painted surface, however, its rays are not all reflected. Some of the rays are absorbed, others are partially reflected; the remainder are reflected as the color of the object.

The presence of impurities or unwanted colors in the pigment will dull the reflected color. For example: when you mix ultramarine blue (a reddish-blue) and alizarin crimson (a bluish-red), nearly all of the yellow rays present in the light that strikes the pigment are absorbed and a bright purple or violet results. But when you mix ultramarine blue with cadmium red light, which contains a great deal of yellow, many yellow rays are reflected along with the red and the blue. They contaminate the mixture, and it becomes muddy-looking.

It is advisable not to mix too much in painting, rather just enough that the colors in the mixture are still vaguely identifiable when examined closely. A more vibrant color results from the use of this so-called "broken color."

In most color systems the intensity of a pure color is altered by adding a gray of the same value as the color, in increasing amounts, until the hue itself has become gray. These modified mixtures that lie between pure color and gray on a scale are sometimes called "tones." You probably noticed in the tints and

shades exercise that pure color is modified as it steps down the value scale. Students are sometimes confused by value/intensity changes. Note that color remains pure as it becomes a tint, because only thinner is added in the value exercise. It is modified in intensity by the addition of even the smallest amount of neutral color. *(Fig. V-9)*

The unsaturated tube colors may serve as effective contrasts for pigments of greater intensity or as neutralizing ingredients in mixtures, giving more pleasing results than you can achieve by mixing colors with black or gray. You may find that some of the unsaturated tube colors, such as burnt sienna and yellow ochre, are so useful that they will have a permanent place on your basic palette.

Exercise #6

Place a patch of each pure pigment used in the values exercise (six pigments, including a red, a yellow and a blue) at its greatest saturation vertically on the center of the page. Make horizontal rows on each side of the patch of pigment. These rows will contain the scale of tones of each hue. *(Fig. V-10)* Prepare a middle value gray with neutral tint or ivory black, corresponding to the middle value on your black-and-white value chart. Mix a small amount of middle value gray with one of your pigments and place the mixture to the right of the saturated patch. Add increasing amounts of the gray, and less of the saturated pigment, until the original identity of the pigment becomes indistinguishable from the gray. The change takes place rapidly with some pigments. Others retain some of their original color even as they become quite gray. Sometimes even the darkest of these neutral mixtures retains a color identity that imparts vibrancy to passages in a painting.

To alter the intensity of lighter values, add more diluent and less saturated pigment to each mixture, along with decreasing amounts of gray; place in the horizontal column to the left of the saturated patch. The result is an increasingly de-saturated tint.

The exercise illustrates "tones"—chroma changes in middle and light values. Pigments naturally lighter in value make appealing tints and change drastically as they darken or lose intensity. Pigments of darker values make rich shades and tones and retain color identity throughout change.

Temperature

The spectrum is divided between warm colors and cool colors. This is color *temperature.* Yellow, orange and red are the warm colors of sunlight and fire; green, blue and violet represent the coolness of grass, water and shadow. In painting, "warm" and "cool" become relative terms dependent upon color relationships in context. The warm/cool dichotomy is greatly complicated when you switch from spectral hues to pigments. A pigment that appears warm in one area of a painting may take on a cooler aspect in an area where it is surrounded by warm colors.

Why is this so?

Hues have many warm and cool variations in pigment: ultramarine, phthalocyanine, cobalt, cerulean, Antwerp and indigo are all "blue" pigments, therefore they are positioned on the cool side of the color circle. Yet ultramarine and cobalt, having

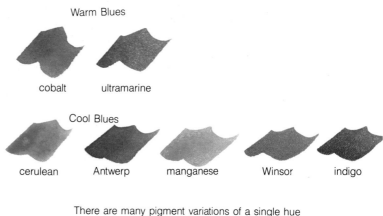

Warm Blues

cobalt ultramarine

Cool Blues

cerulean Antwerp manganese Winsor indigo

There are many pigment variations of a single hue

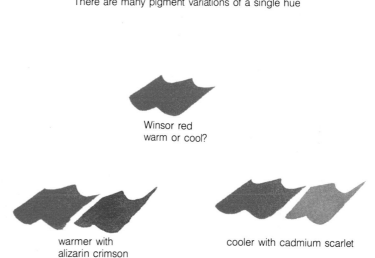

Winsor red
warm or cool?

warmer with
alizarin crimson

cooler with cadmium scarlet

The adjacent hue may alter the temperature of a color

Fig. V-11. Color Temperature. *In pigments the color temperature is relative to the colors being compared. Blue is a cool hue, but the blue pigments vary greatly as to temperature. Any given pigment may seem warm or cool, depending on the color that is placed beside it.*

traces of red-violet, are warm; the remainder are cool pigments. *(Fig. V-11)*

Warm and cool relativity changes according to context. The pigment Winsor red, which by itself is a clear red on the warm side of the circle, becomes a cool red when it is placed next to cadmium scarlet. Adjacent to alizarin crimson, Winsor red takes on a warm aspect. The cadmium scarlet is extremely warm with traces of yellow in it; the alizarin crimson is more nearly a blue-red, and therefore cool.

Exercise #7

Place a patch of each red pigment next to every other red. Do you see how the pigment temperature changes according to the color next to it? Remember

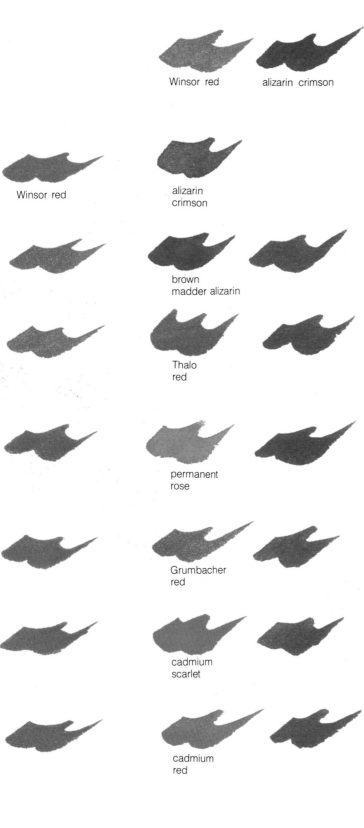

that warm reds lean toward orange—they have a little yellow in them. Cool reds tend toward violet—they have a little blue in them. Repeat with the yellows and blues in the paint box. *(Fig. V-12)*

Color temperature helps you to create depth and movement, along with mood. Warm colors are aggressive and appear to advance; cool colors seem to recede. Establish the temperature of a pigment relative to the other pigments near it in the painting.

Color temperature is a key factor in the expressive statement in a painting. A cool color isolated in a warm painting can quickly destroy the feeling the artist is attempting to convey—or can create contrast that puts "zing" into the painting. Look for the distinctions between warm and cool pigments. The next exercise forces you to judge the warm/cool aspects of pigments straight from the tube, and gives you your first contact with every color on the recommended list.

The pigment chart

In order to have a complete record of every color you test, paint and label a patch of every pigment in your paint box, including all of the colors on the color exploration list. Paint each pigment on the circle at its saturated level. Do not use old paint from your palette. Use only fresh, clean pigment and clean thinner. *(Fig. V-13)*

Exercise #8

Divide a large circle into six sections. Paint patches of the pigments that approximate the primary and secondary spectral hues in the appropriate points around the perimeter. Also, around the perimeter of the circle, place other brilliant pigments near the related hues most like them in temperature. For example, Antwerp blue is placed in the outer perimeter near Winsor blue, both in the region bordering cool blue-green; permanent magenta goes near alizarin crimson, in the red-violet range. Inside the circle, place the less saturated earth colors and neutral pigments—the ochres, siennas and grays. Think about temperature before placing the colors. Raw sienna is a warm, neutral yellow, nearer yellow-orange than Naples yellow is. Burnt sienna tends toward red-orange, while burnt umber is slightly grayer.

Note the brands used on the chart, placing duplicate colors by different manufacturers together so they may be compared. Add every pigment you purchase to this record. The chart will become an invaluable reference to you. There are no precise placements for the pigments. Don't depend too much on this illustration. Your own judgment must govern. Brands may vary to a surprising degree and so may opinions. Practice makes it easier to see temperature differences in pigments.

Your studio is your laboratory; color exploration is your research. There are no shortcuts to learning the properties of color. First-hand experience with pigments is the only way. Learn the terminology of color. Use the reference charts, such as the pigment chart you have just made. Train your eye to see distinctions between pigments, as well as between different brands of the same color, in hue, value, intensity and temperature.

Fig. V-12. Comparing Pigment Temperatures

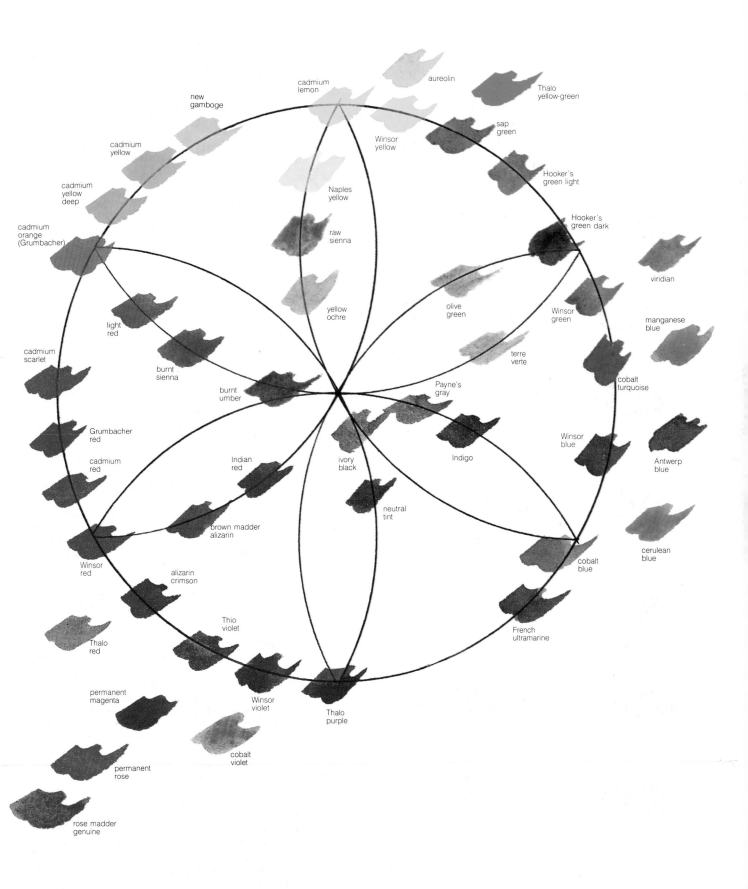

Fig. V-13. The Pigment Chart

55

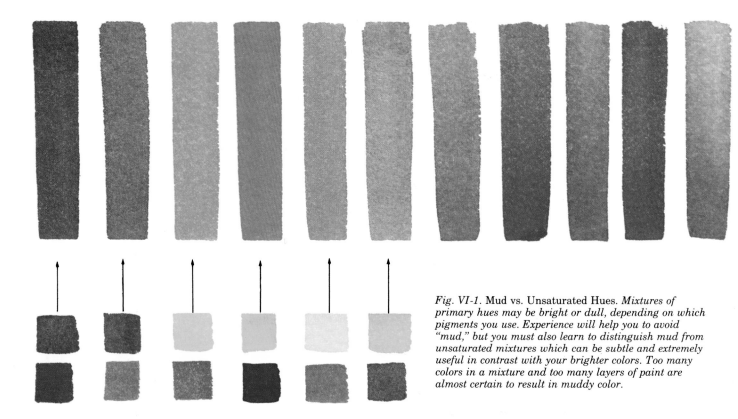

Fig. VI-1. Mud vs. Unsaturated Hues. *Mixtures of primary hues may be bright or dull, depending on which pigments you use. Experience will help you to avoid "mud," but you must also learn to distinguish mud from unsaturated mixtures which can be subtle and extremely useful in contrast with your brighter colors. Too many colors in a mixture and too many layers of paint are almost certain to result in muddy color.*

Chapter **VI**

The Exploration of Pigments

Everyone loves surprises—except, perhaps, the artist trying to create a well-planned, well-executed painting. The proverbial "happy accident" is a rare occurrence. Don't rely on chance to give you good color!

The more you paint, the more comfortable you will become with the way pigments behave. Many combine easily and beautifully. However, just when you feel certain you can handle pigments, you may introduce a new color that doesn't seem to work.

Incomplete knowledge of pigments often results in "mud," a condition quickly recognized by artists, yet difficult to define: a chalky, heavy mixture lacking brilliance and transparency. It is important to see the difference between modified or unsaturated hues and muddy mixtures. What seems muddy in one painting may be useful in a different context.

Similarities and differences between pigments are both important to the artist. You can utilize similarities to create harmonious surface appearances on the paper. Mixtures will cause little difficulty and results will be relatively predictable. When you understand the differences between pigments, you become aware that you don't have to avoid problem pigments completely. *(Fig. VI-1)*

You have many more options when you know your pigments. A number of artists prefer to use only non-staining transparent pigments. They avoid the stains because of their intensity, the opaques because of their propensity for clouding mixtures, and the sedimentary, settling colors because of the granular look of the washes. These artists are depriving themselves of the excitement and subtlety of many beautiful pigments and of unusual color effects.

Composition of Paint

Pigment: Pure Powdered Color

Medium	Oils	Transparent Watercolors	Acrylics	Pastels
Binder	Oil	Natural Gum	Acrylic Emulsion	Weak Gum Solution
Solvent	Turpentine or Mineral Spirits	Water	Water	None
Handling	Opaque, Buttery	Transparent, Fluid	Opaque or Transparent, Flexible	Opaque, Dry

Opaque Water Media	Egg Tempera	Gouache	Casein	
Binder	Egg Yolk	Natural Gum	Milk Solids	
Solvent	Water	Water	Water	
Handling	Durable Sheen	Mat Finish	Durable	

All of the paints above begin with powdered pigments. Some have additional additives to improve the pigment mixture. Some pigments don't combine well with the binders in all media and will not be found on manufacturers' lists.

Fig. VI-2. Composition of Paint

A brief background of the composition and classification of pigments will help you to understand their behavior. Systematic testing of the pigments reveals their transparency or opacity, staining quality, tinting strength, sedimentary properties, and glazing possibilities. No color theory is involved in these studies, only the exploration of the pigments themselves.

Composition of paints

Ground pigments are the coloring substance of painting media. *(Fig. VI-2)* The manufacturer combines the powdered pigment with a medium, or vehicle, that surrounds the pigment particle and adheres it to the support. Each pigment has a different grinding procedure: some require greater pressure and a much longer processing period than others. The degree to which color reflects from the paint molecules or passes through transparent colors to reflect the white

of the support is largely determined by proper grinding of the pigment particles. Overgrinding may damage certain pigments; undergrinding may produce a gritty product. Strength and brilliance are at risk with improper grinding. Cobalt blue and cerulean blue suffer greatly from being too tightly ground; the alizarins, which are dyes precipitated on a base, require great pressure.

The most brilliant paints, designated "artists' colors," contain a larger amount of colorant than the cheaper grades. Student-grade paints and the familiar children's paint box sets may include undesirable additives called "extenders" or "fillers." These additives dilute the pigment and produce a weak, unsatisfactory paint.

Colors that are mixtures of pigments (sap green, Payne's gray and Hooker's green, for example), are dissimilar in each brand. *(Fig. VI-3)* The ingredients in the paint may be of fine quality, but their proportions differ in each manufacturer's formula.

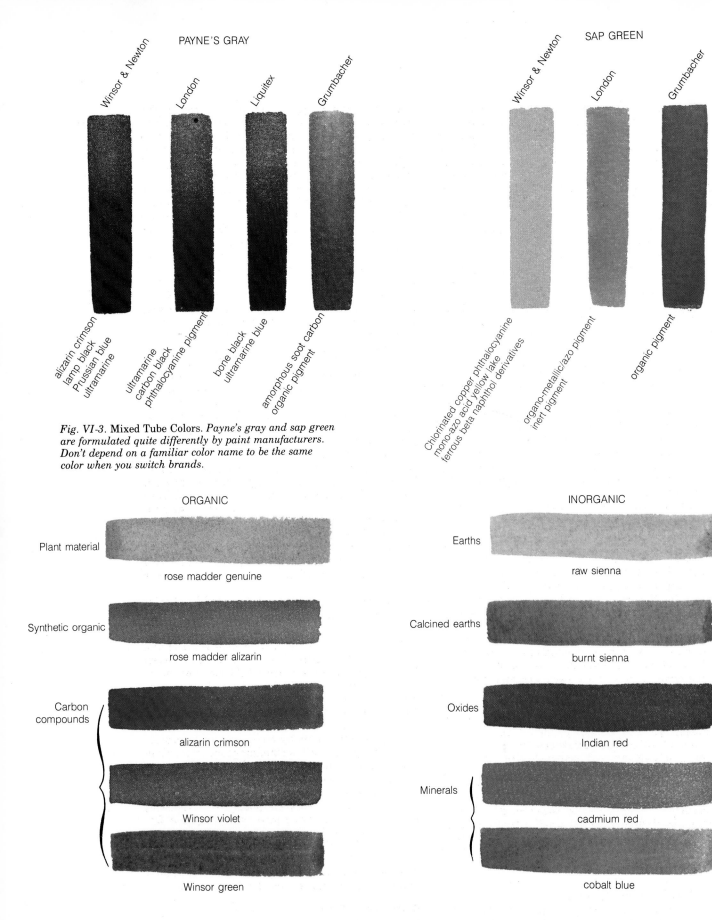

PAYNE'S GRAY

Winsor & Newton

London

Liquitex

Grumbacher

alizarin crimson
lamp black
Prussian blue
ultramarine

ultramarine
carbon black
phthalocyanine pigment

bone black
ultramarine blue

amorphous soot carbon
organic pigment

SAP GREEN

Winsor & Newton

London

Grumbacher

Chlorinated copper phthalocyanine
mono-azo acid yellow lake
ferrous beta naphthol derivatives

organo-metallic/azo pigment
inert pigment

organic pigment

Fig. VI-3. Mixed Tube Colors. *Payne's gray and sap green
are formulated quite differently by paint manufacturers.
Don't depend on a familiar color name to be the same
color when you switch brands.*

ORGANIC

Plant material — rose madder genuine

Synthetic organic — rose madder alizarin

Carbon
compounds — alizarin crimson

Winsor violet

Winsor green

INORGANIC

Earths — raw sienna

Calcined earths — burnt sienna

Oxides — Indian red

Minerals — cadmium red

cobalt blue

Fig. VI-4. Classifications of Pigments. *In many cases the
organic/inorganic classification of pigments is academic:
manufacturers have formulated a great many synthetic
pigments to replace natural materials. However, manufac-
turers of better quality paint still make the natural
pigments, although costs have escalated in recent years.*

58

Manufacturers prepare some artists' colors from costly metallic pigments and rare organic materials. Winsor & Newton still makes unusual pigments for artists willing to pay the price. Paints bearing the same names as these expensive pigments are usually synthetic in cheaper grades and seldom possess the unique qualities of the colors they are named for. Cheaper colors are garish compared to the pure hues of genuine rose madder and cobalt blue, to name just two that possess great delicacy of hue in their natural forms.

Few "fugitive" colors remain on the manufacturers' color charts. These colors fade or change completely with the passage of time. Avoid colors of doubtful permanence. Refer to Ralph Mayer's *Artist's Handbook of Materials and Techniques* or the Winsor & Newton Company's "Notes on the Composition and Permanence of Artists' Colours."

Classification of pigments

Early artists used the natural materials at hand for painting. Insects, shellfish, fruits, berries and minerals from the earth provided a broad selection of colors for dying fabrics and painting art objects. However, few of these possessed the intensity of the colors that appeared following Henry Perkin's discovery in 1856 of aniline dyes made in the laboratory from coal tar. Chemical reactions produce the colors of these compounds in almost endless variety.

Pigments are classified as organic or inorganic, depending on the source of the coloring matter. *(Fig. VI-4) Organic* pigments come from living matter—plant or animal material—or from chemical compounds containing carbon, fabricated in the laboratory. Genuine rose madder comes from plant material; sepia was once made from the ink sacs of the cuttlefish; the alizarins and phthalocyanines are chemical compounds. Organic colors often possess great chromatic intensity, purity, and transparency. Synthetic organic pigments sometimes surpass the brilliance of their natural counterparts, but when delicacy of hue is desired, don't use substitutes.

Inorganic pigments are earths (raw sienna and raw umber), calcined earths (burnt sienna and burnt umber) and minerals (the cadmiums, cobalts, and oxides). The earth colors show a tendency to be less saturated than most other pigments. The minerals are often brilliant and sometimes opaque.

Many of the natural materials are costly and difficult to secure. In some cases manufacturers have developed satisfactory synthetic replacements. So many synthetic pigments are now available that classification might well be based on the natural/synthetic division rather than the traditional organic/inorganic. You should decide for yourself whether or not you prefer the natural pigments or their synthetic counterparts.

Transparency/opacity

A transparent layer of paint permits the white reflective surface of the support to shine through it. Most watercolor pigments are transparent to some degree, and some oil paints also have this trait. A few have uncommonly strong covering power. The paints sold as "opaque watercolors" (gouache, casein and tempera) contain additives such as precipitated chalk or some other substance to impart opacity. A painting in opaque watercolor has a decidedly different look from a transparent watercolor.

The watercolor paints used in these exercises are characterized as highly transparent, semi-transparent or opaque. They usually possess these properties naturally, owing to the substances from which they are ground, not because of additives.

Highly transparent colors are effectively used as glazes. A glaze is a thin wash of paint over another color, permitting the first color to show through. Glazes alter colors, but do not cover them. Glazes correctly applied have a delicate, luminous quality seldom equalled by mixing the same two colors together and applying them as a single wash.

Semi-transparent colors can be used as glazes if they are sufficiently diluted. There is little risk of murky color when they are mixed with transparent pigments, but in combination with opaque paints, the semi-transparent colors may be more difficult to handle. If the opaque pigment takes over, the mixture will become dense in spite of the slight transparency of the semi-transparent pigment.

Opaque pigments can create problems if they are used carelessly. They are disagreeable as glazes, leaving a chalky-looking surface that stands out unnaturally against a transparent background. They cover the underlying paint and the white support, as well. Opaques impart opacity to all colors they are mixed with. Nevertheless, many of the opaque pigments are brilliant; others are beautifully subtle. Don't avoid them because you don't understand how to use them, or you will limit your choices of pigments unnecessarily.

Begin now to explore the pigments and familiarize yourself with their transparency or opacity.

Exercise #9

Paint several half-inch-wide strips of undiluted India ink on a white support. (Use an old brush and wash it thoroughly afterwards with mild soap and water to remove all traces of the ink.) When the ink strips are dry, paint a three-inch band of every pigment across the ink. *(Fig. VI-5)* Add enough thinner to the paint so it flows without losing its brilliance. Arrange the pigments by hues, leaving spaces between groupings to allow for adding new colors when you acquire them.

Notice that some of the colors nearly disappear where they lie across the ink strip; others cover the black entirely. Those that disappear are transparent; the paints with covering power are opaque. A few of the pigments leave a visible film that partially covers the ink; these paints are denoted as "semi-transparent." Some of the delicate-looking pigments—cerulean blue, for example—are quite opaque; many intense colors are completely transparent.

Staining quality

Staining pigments penetrate the fibers of the support and cannot be removed without leaving a trace of color. If you prefer to paint spontaneous, direct

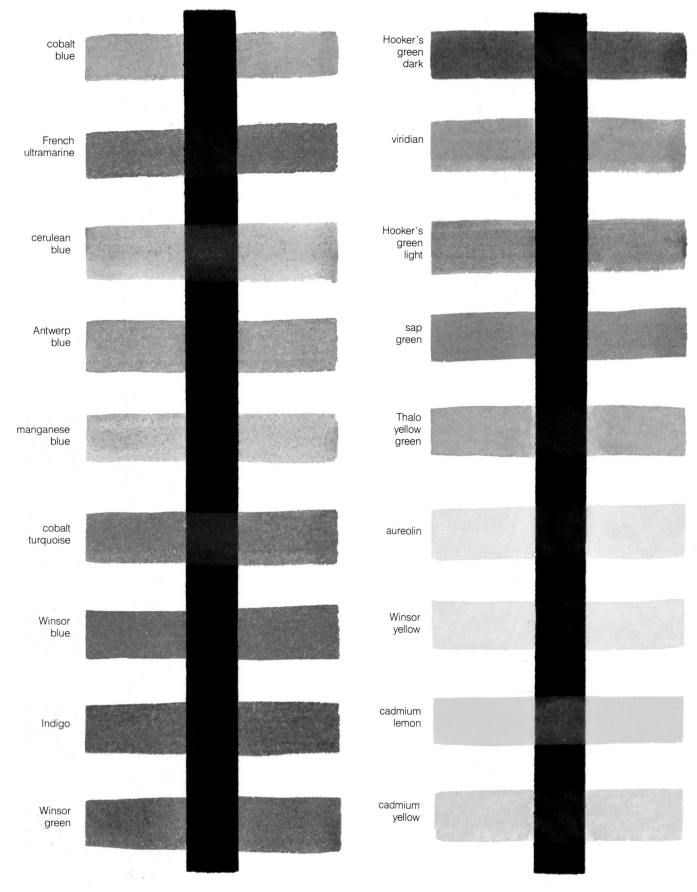

cobalt
blue

French
ultramarine

cerulean
blue

Antwerp
blue

manganese
blue

cobalt
turquoise

Winsor
blue

Indigo

Winsor
green

Hooker's
green
dark

viridian

Hooker's
green
light

sap
green

Thalo
yellow
green

aureolin

Winsor
yellow

cadmium
lemon

cadmium
yellow

Fig. VI-5A. Transparency/Opacity Chart

new
gamboge

Naples
yellow

cadmium
red light

yellow
ochre

Grumbacher
red

raw
sienna

Winsor
red

burnt
sienna

alizarin
crimson

Indian
red

brown
madder
alizarin

light
red

permanent
rose

Payne's
gray

rose
madder
genuine

neutral
tint

rose
madder
alizarin

ivory
black

Fig. VI-5B. Transparency/Opacity Chart

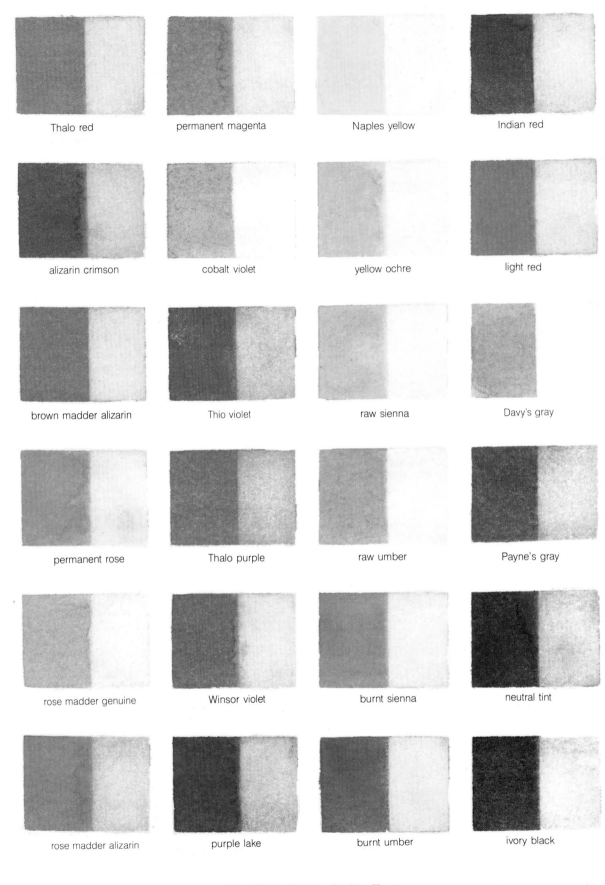

Thalo red permanent magenta Naples yellow Indian red

alizarin crimson cobalt violet yellow ochre light red

brown madder alizarin Thio violet raw sienna Davy's gray

permanent rose Thalo purple raw umber Payne's gray

rose madder genuine Winsor violet burnt sienna neutral tint

rose madder alizarin purple lake burnt umber ivory black

Fig. VI-6A. **Staining Quality Chart**

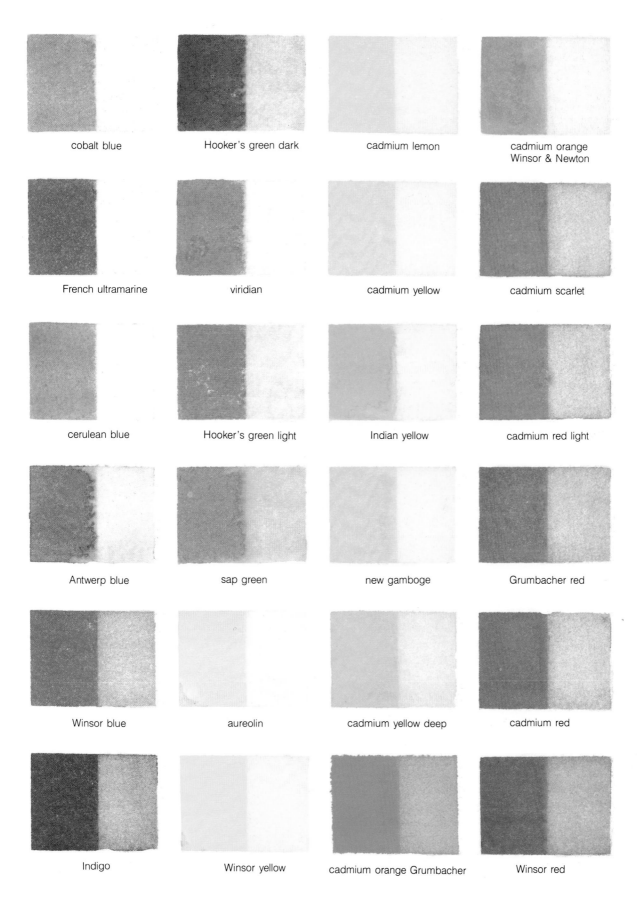

cobalt blue	Hooker's green dark	cadmium lemon	cadmium orange Winsor & Newton
French ultramarine	viridian	cadmium yellow	cadmium scarlet
cerulean blue	Hooker's green light	Indian yellow	cadmium red light
Antwerp blue	sap green	new gamboge	Grumbacher red
Winsor blue	aureolin	cadmium yellow deep	cadmium red
Indigo	Winsor yellow	cadmium orange Grumbacher	Winsor red

Fig. VI-6B. Staining Quality Chart

watercolors with no corrections or scrubbing out, you will have no problem with stains. Non-staining pigments are necessary, however, if your technique involves "lifting" color or sponging out areas, using stencils, or if a great deal of correction is required.

Some artists utilize the staining quality of paint by intentionally staining, scrubbing, and glazing over the remaining stain, a technique that might be described as "indirect layering." Though uncommon, this method can result in very rich effects.

Some transparent colors are highly staining. A few of the earth colors, the cadmiums and many synthetic colors have a tendency to stain. Synthetic formulations of naturally non-staining pigments often stain; these are generally found in the student grades of paint. Brands of paint vary widely, so don't pre-judge your pigments. Test them!

Exercise #10

Paint a square of each pigment on a sheet of paper or canvas. Cover one side of each square with a piece of cardboard or matboard and scrub the visible half with a sponge dampened with thinner, picking up loosened pigment with a rag or paper towel. *(Fig. VI-6)* Do not damage the support, but *do* scrub vigorously enough to loosen the surface pigment. If you're working in watercolor, you need good paper for this exercise. Many papers do not withstand this rough treatment. A number of pigments remove easily; others stain permanently. If you change brands later, don't depend on what you have learned about a specific pigment. Many of the newer synthetic colors are more staining than the same colors made of natural materials. The only way to be certain is to try them.

Fig. VI-7. Tinting Strength. *Blend pigments on damp paper and observe which colors invade mixtures aggressively and which are easily overpowered.*

Tinting strength

Some pigments on the color charts are "dynamite." They have a tendency to overpower nearly every color you combine them with. Others are so delicate you must squeeze out an inordinate amount of paint to make an impact on another color. When you are considering adding a new pigment to your palette, test it first to be certain it is neither too weak nor too strong for your purposes.

Exercise #11

Prepare a sectioned sheet. Begin with four pairs of colors: alizarin crimson and rose madder genuine; phthalo blue and Antwerp blue; phthalo green and viridian; Winsor yellow and aureolin. *(Fig. VI-7)*

Brush clean diluent onto one of the rectangles on the sheet. Mingle each of these pigments with the other colors listed above, dropping the pigments in roughly equal proportions into a dampened space on the sheet and mixing only slightly. Notice the contrast in tinting strength of the pigments. Alizarin crimson invades mixtures with most of the other colors, but there are several that can stand up to its strength. Rose madder genuine is overpowered by most of them. Continue mingling colors until you have seen how they all interact. When you have tested the colors listed, test other colors on the recommended list for tinting strength.

Be careful about combining pigments in your paintings if they vary to extremes in tinting strength. Limit use of delicate colors to palettes having colors they have some effect on when mixed in normal proportions. For example, even a large quantity of rose madder genuine will scarcely affect phthalo green in a mixture, but alizarin crimson can hold its own with the phthalos. When you introduce a new color to your palette, test its tinting strength against the other colors you use, so it won't be overpowering—or overpowered—in your mixtures.

Sedimentary and spreading watercolor pigments

A number of watercolor pigments settle into the valleys of the watercolor paper. The settling tendency of the sedimentary pigments can be used to make beautiful granular effects. Conversely, some other paints seem to "explode" when you drop them onto wet paper, creating interesting "blossoms." You can control the sedimentary pigments to a great extent and keep them within bounds on the paper; the spreading pigments are less tractable and quickly "jump" into any wet area they touch. When you combine the two in a mixture, the spreading pigment may create a halo around the settling paint, an interesting, delightful effect—if you are expecting it! *(Fig. VI-8)*

Fig. VI-8A. Spreading Pigment

Fig. VI-8B. Settling Pigment

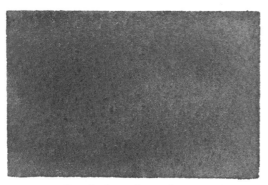

French ultramarine settling

Cerulean blue settling

Raw sienna settling

Cadmium lemon
non-settling pigment

Winsor red spreading

Cerulean blue
Alizarin crimson

Fig. VI-8C. Settling and Spreading Pigments. Settling (or sedimentary) pigments have a granular texture in washes. Other pigments lack this characteristic. Some pigments jump into damp areas and spread a great deal. Others remain where they are placed. When two pigments with these different qualities are mixed, the spreading pigment sometimes forms a halo around the settling color.

Exercise #12

Paint each color on half of a slightly dampened square on a sectioned paper. Try alizarin crimson, Winsor red, cerulean blue, raw sienna, Indian red, phthalo blue, ultramarine blue and any others you might want to add. Notice that some colors stay very nearly where you place them. The spreading colors seem to blossom. Mix a sedimentary pigment with a spreading color on your palette, instead of on the paper, and apply to a damp square. Do you see how the colors separate? *(Fig. VI-9)*

cobalt blue French ultramarine cerulean blue Winsor blue

Winsor green manganese sap green Winsor yellow

cadmium yellow Winsor red alizarin crimson cobalt violet

Payne's gray yellow ochre raw sienna Indian red

brown madder alizarin burnt umber burnt umber cerulean blue
 ultramarine alizarin crimson

cobalt violet raw sienna Indian red ultramarine
viridian Winsor blue Winsor blue Winsor red

Fig. VI-9. Settling/Spreading Pigment Chart

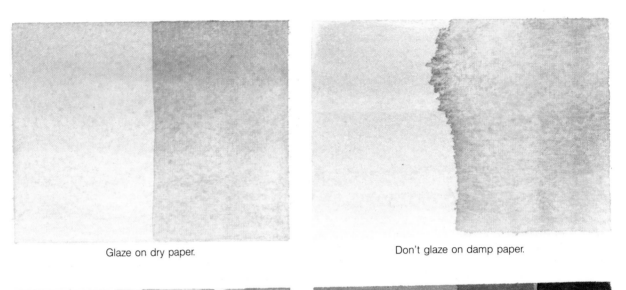

Glaze on dry paper. Don't glaze on damp paper.

Transparent glaze Opaque glaze Analogous glaze (crimson) Complementary glaze (green)

Fig. VI-10. Glazes. Several things must be considered when applying glazes. The underlying wash must be completely dry, and the glazing pigment should be very transparent. You should learn how to select your glazes to intensify or to neutralize the colors beneath them.

Glazing

Glazing is a time-honored technique usually associated with oil and acrylic painting. The principle is to apply a thin, transparent wash over another color so the underlying color shows through the glaze. Watercolorists frequenty avoid glazing, fearing to disturb the underpainting and create a muddy appearance in the painting. Several considerations help to avoid these problems. *(Fig. VI-10)* First of all, let the underlying wash dry thoroughly. Don't attempt a glaze on a damp wash. Don't pre-wet the painted surface, or the underlying paint will soften and pick up as you lay the glaze. Second, work quickly. Third, don't glaze over a heavy underlying paint layer. Finally, use only the transparent pigments, or an occasional semi-transparent paint, for

the glaze. Glazing a color with an adjacent hue or a color near it on the color wheel will give a clearer result than glazing over a color on the opposite side of the circle. Such a complementary glaze modifies the intensity of the colors.

The beauty and luminosity of a glaze can enhance a painting wonderfully. Experiment with many different combinations of underlayers and glazes. You will find this technique useful when a color needs adjustment to bring it into harmony with the rest of the painting or to alter a value slightly. Glazes may be used equally effectively over small or large areas. *(Fig. VI-11)* Sometimes a neutral glaze surrounding the focal point will strengthen the impact of a center of interest.

Exercise #13

Run washes of transparent pigments in the rectangles of a sectioned sheet and let them dry completely. Then run a second transparent wash halfway across the first. Notice how the underlying wash changes. Try many different combinations, grading some washes up and some down. *(Fig. VI-12)* Three or more glazes can be effective if you choose suitably transparent pigments. Try another sheet with a few of the semi-transparent pigments for the glaze. And finally, run some glazes with cerulean blue and Indian red to see the chalky look of opaque glazes.

Fig. VI-11. Glazes. *Glazes need not always be used over large areas in a painting. Countless small glazes of the most transparent pigments may create a subtle, opalescent quality in the atmosphere of a painting.*

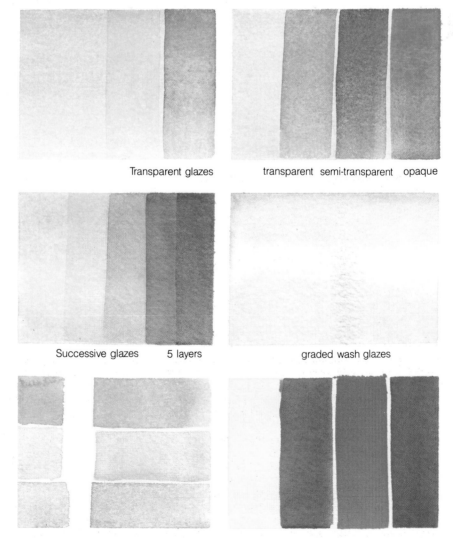

Fig. VI-12. Glazing Chart

Transparent glazes

transparent semi-transparent opaque

Successive glazes 5 layers

graded wash glazes

Mixtures glazes

Ineffective glazes

A. Table salt

B. Kosher salt

Fig. VI-13. Salt. Either table salt or kosher salt will be effective in watercolor washes. The amount of water in the wash has a decided effect on the area treated with salt. In A the small dots indicate an almost dry surface; the large "blossom" formed where the paper was quite wet and some of the salt dissolved.

Salt effects in watercolor

One of the more popular tricks of today's watercolorists is to sprinkle salt into a damp wash, creating unusual textural effects. The permanence of such "seasoned" paintings is an unresolved issue. Nevertheless, some artists use a lot of it. Use your own judgment: is the effect worth the possible risk? A word of caution: brush the salt carefully away from the paper when the wash has dried. Any residue on the paper could continue to work on the wash if the painting is exposed to dampness.

Both ordinary table salt and kosher salt will work. *(Fig. VI-13)* Cold press or hot press paper is recommended. Rough paper seems to cause the grains of salt to settle into the valleys and sometimes doesn't create the desired effect. Don't wet the paper too much, or the salt will simply dissolve in the water. If the paper is too dry, little or no texture appears. *(Fig. VI-14)*

Exercise #14

Place a wash of the pigment you want to test on a sectioned sheet. While the wash is still damp, sprinkle a small amount of salt into it and let it dry completely. *(Fig. VI-15)* A salted wash takes longer to dry than a normal wash. Some pigments create dramatic textures with the salt, others are affected very little. Note the pigments that give the best effect for future use. When you consider using the salt technique, don't allow the unusual effects of the salt to carry the painting. Integrate the "happy accidents" into the composition.

Fig. VI-14. Salt. Salt works most effectively in the first damp washes on the painting, absorbing the color and leaving varied textural effects. Paintings of snow, surf, flowers—and especially abstractions or non objective designs—can sometimes benefit from a little pinch of salt in the early stages.

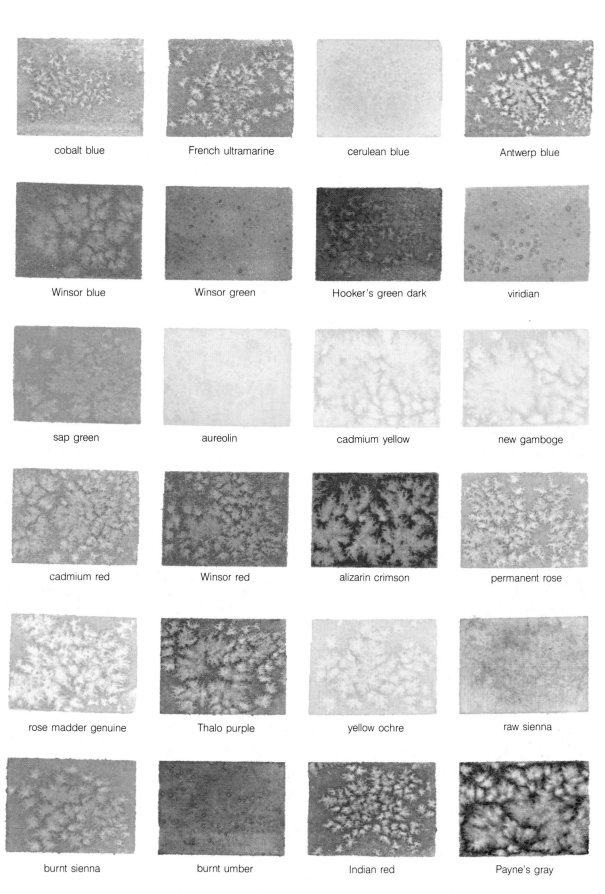

cobalt blue	French ultramarine	cerulean blue	Antwerp blue
Winsor blue	Winsor green	Hooker's green dark	viridian
sap green	aureolin	cadmium yellow	new gamboge
cadmium red	Winsor red	alizarin crimson	permanent rose
rose madder genuine	Thalo purple	yellow ochre	raw sienna
burnt sienna	burnt umber	Indian red	Payne's gray

Fig. VI-15. Salt Chart

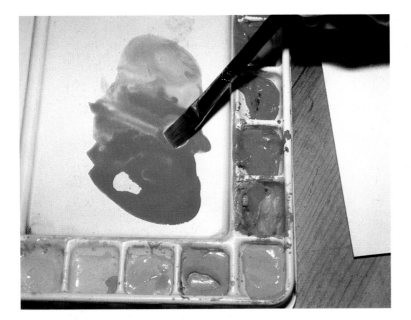

Fully mixed

Partially mixed
on the palette

Partially mixed
on damp pape[r]

Fig. VI-16A. Color Mixing. *Pigments should not be mixed too much. Stop mixing while you can still see the original colors on the palette, along with the mixture.*

Fig. VI-17A. Color Mixing. *Show these three types of mixtures on a color mixing chart.*

Color mixing

One of the keys to good color is to restrain yourself from mixing the pigments too much. The mixture should show three colors: the two original pigments in the mixture and the mixture itself. This gives a livelier vibration to the color. Try mixing two pigments on the palette, having an area on each side of the mixture that is pure color. Pull the brush across the mixture, picking up both pure colors and the mixture at one sweep. Go directly to the support with loaded brush. Another way to ensure that you don't overmix your colors is to apply each color in the mixture separately, mixing directly on the support. *(Fig. VI-16)*

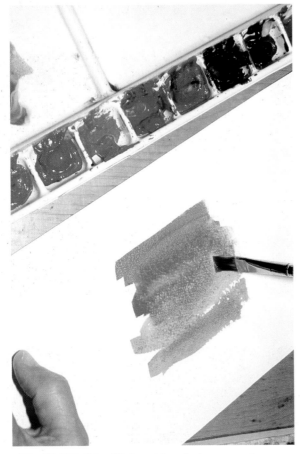

Fig. VI-16B. Color Mixing. *After placing areas of pure pigment on the support, mix slightly so three colors are apparent—the mixture and its two component pigments.*

Exercise #15

Prepare a sectioned sheet with masking tape. From several pairs of pigments select one pair and mix the colors thoroughly on the palette. Apply to one section. Then place the pure colors at the edges of the mixture on your palette and sweep your brush across it. Apply to another section without mixing the colors too much. You want to see three colors in the mixture. Apply unmixed tube colors from this pair directly to the paper, mixing a bit on the paper. The lightly-mixed sections seem more colorful than the over-mixed section. *(Fig. VI-17)* Repeat the three types of mixtures with other color pairs.

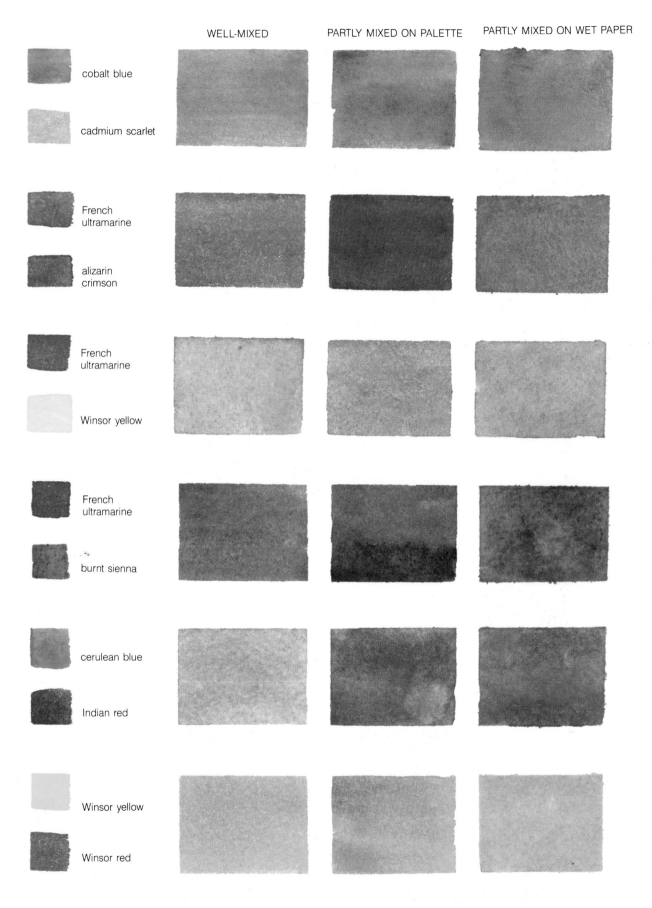

WELL-MIXED PARTLY MIXED ON PALETTE PARTLY MIXED ON WET PAPER

cobalt blue

cadmium scarlet

French
ultramarine

alizarin
crimson

French
ultramarine

Winsor yellow

French
ultramarine

burnt sienna

cerulean blue

Indian red

Winsor yellow

Winsor red

Fig. VI-17B. Color Mixing Chart

73

Fig. VI-18. Sister's World *by Homer O. Hacker, A.W.S. Watercolor. 28″ × 21½″. The browns show a hint of blue in this almost-monochromatic painting. Serenity is communicated through the choice of neutrals to dominate the color scheme.*

Problem mixtures

A few colors create problems for artists. Brown and gray, rich darks and green seem to be the most difficult. As a consequence, many artists use tubes of these colors in order to avoid mixing them. The tube colors seldom give satisfactory results and frequently may interfere with the color harmony of the painting.

Grays and Browns

Van Gogh wrote of the variety of grays in nature—red-gray, yellow-gray, blue-gray, green-gray, orange-gray, and violet-gray. One way to achieve successful grays and browns is to give the mixture a "color identity," or color bias, toward a chromatic hue in the mixture. *(Fig. VI-18)* If you use a tube gray or brown, add another color to bring it to life. Better yet, mix the color you want from two complementary colors, across the color circle from each other, and let this mixture lean toward one of the original colors in the mixture. Many artists feel that the surest way to achieve lively neutrals is to mix complementary colors, opposites on the color wheel.

Another key to harmonious and lively grays and browns is to use only pigments already in the painting, thus avoiding discord. Don't come to the end of a painting and scatter Payne's gray or burnt umber around the composition to create neutrals.

Exercise #16

Select pigment equivalents for each primary hue: red, yellow and blue. Begin with any primary on the color wheel, for example, start with blue. Mix the secondary color—orange—by combining the remaining two primaries, in this case, yellow and red. Now combine the primary and the mixed secondary color—blue and orange—on a sectioned sheet, having each original color and the mixture visible, as you did in the mixing exercise. The mixture should lean toward one of the original colors. The result will be a modified neutral with a color identity, either blue or orange. *(Fig. VI-19)* Repeat with yellow/violet and red/green mixtures. Some of the mixtures will be gray and brown, others will lean toward green, red or blue. The variations are marvelous!

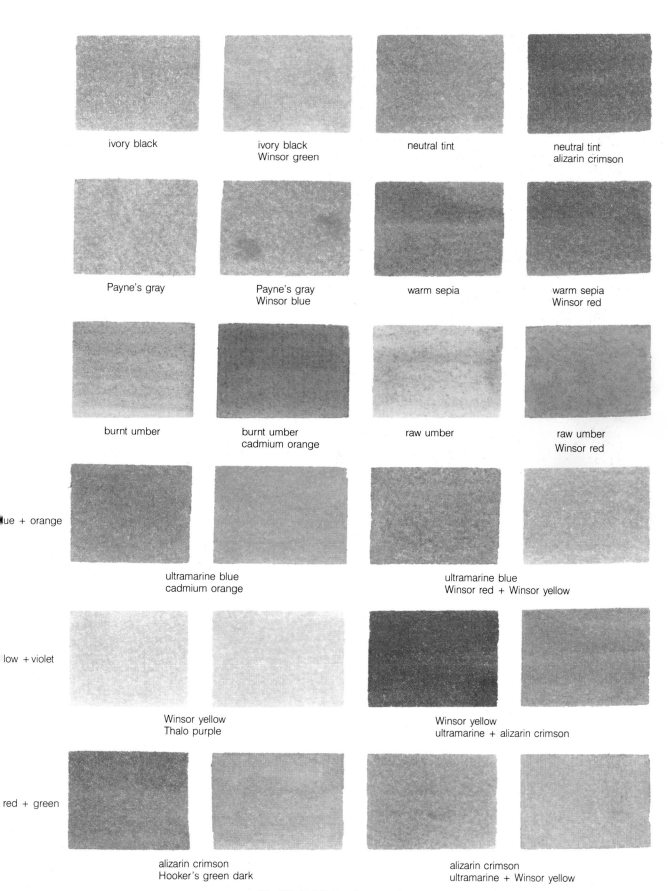

ivory black

ivory black
Winsor green

neutral tint

neutral tint
alizarin crimson

Payne's gray

Payne's gray
Winsor blue

warm sepia

warm sepia
Winsor red

burnt umber

burnt umber
cadmium orange

raw umber

raw umber
Winsor red

blue + orange

ultramarine blue
cadmium orange

ultramarine blue
Winsor red + Winsor yellow

low + violet

Winsor yellow
Thalo purple

Winsor yellow
ultramarine + alizarin crimson

red + green

alizarin crimson
Hooker's green dark

alizarin crimson
ultramarine + Winsor yellow

Fig. VI-19. **Mixing Grays and Browns**

Fig. VI-20. Middle Earth Series *by Glenn Bradshaw, A.W.S. Casein on rice paper. 12" × 17". Using black as a color is a challenge successfully met in Bradshaw's paint-* *ing. The blacks glow with the hint of other colors and provide a subtle background for meteoric flashes of intense color.*

Darks

Strong darks are difficult to create, especially if you hope for transparent darks. A black from the tube won't be satisfactory, as a rule. Darks harmonious with the colors in your paintings are possible, however. *(Fig. VI-20)* Begin with the combinations below. Don't depend on formulas, but try the recommended colors now, and eventually you will find suitable places for them on your palette. You will discover other ways to mix darks as you continue to work with pigments.

Exercise #17

Mix alizarin crimson and phthalo green for an intense black leaning toward red or green; add phthalo blue if you want to make blue-black. Any combination of these three colors will be transparent and intense. Don't use this mixture with delicate color combinations. It will be overpowering and discordant. Try ultramarine blue and burnt umber for a blue-black or a brown-black. Substitute burnt sienna for the burnt umber to create a slightly warmer dark. *(Fig. VI-21)* The latter mixture is not so transparent nor intense as the alizarin crimson/ phthalo green combination, so it works well with less brilliant color schemes. Some of the complementary mixtures from the previous exercise make good darks as the quantities of the pigments are increased. When you need dark areas in your painting, select pigments that are harmonious with the colors in the painting, usually pigments that already appear somewhere in the composition.

Payne's gray

Payne's gray
Winsor blue

neutral tint

neutral tint
alizarin crimson

ivory black

ivory black
Winsor red

lamp black

lamp black
Winsor blue

+Winsor blue

ALIZARIN CRIMSON/WINSOR GREEN

+Winsor blue

WINSOR RED/WINSOR GREEN

ultramarine
burnt umber

ultramarine
burnt sienna

ultramarine
Indian red

Winsor blue
burnt umber

Winsor blue
Indian red

Winsor blue
cadmium orange

ultramarine
cadmium scarlet

Winsor blue
burnt sienna

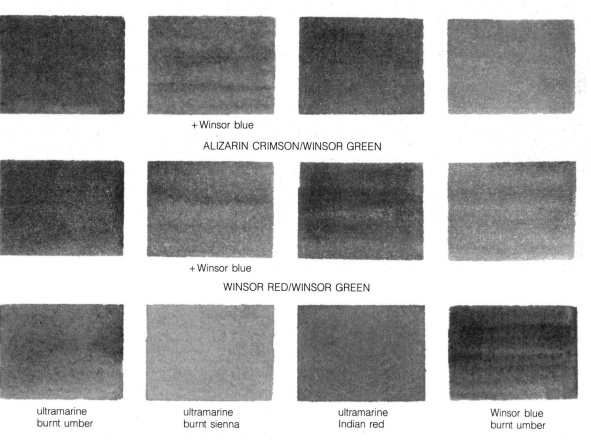

Fig. VI-21. **Mixing Darks**

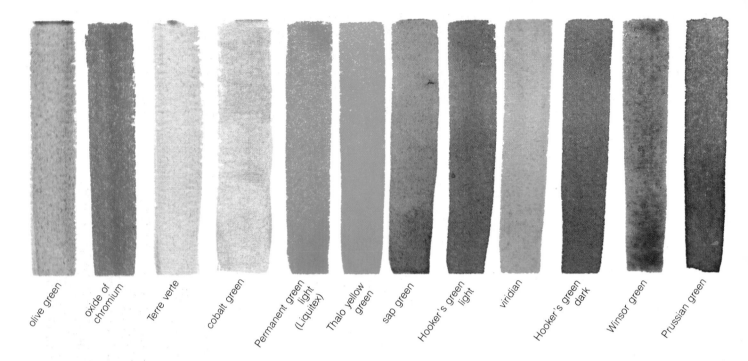

olive green · oxide of chromium · Terre verte · cobalt green · Permanent green light (Liquitex) · Thalo yellow green · sap green · Hooker's green light · viridian · Hooker's green dark · Winsor green · Prussian green

Fig. VI-22. Tube Greens. *There are many greens available in tube colors, but somehow they don't quite suit most purposes. They are too bright, too dull, too weak or too strong! There are much better ways of using green in your paintings.*

Fig. VI-23. Cypress Carousel *by Pat Kelly. Mixed media. 20″ × 30″. A variety of greens dance across the surface of this rhythmic painting. Tube greens have been mixed with other colors to provide livelier, more expressive color.*
Collection of William and Laurie Franz.

Greens

When there are so many ways of mixing green, why do greens create such problems for painters? Dependence on tube colors may be responsible. *(Fig. VI-22)* Not one is a very convincing natural green. Many are artificial-looking colors. If you find one you like, don't be tempted to use it for all of the greens in your painting; it will be repetitious and boring. Instead, learn to vary the tube greens by mixing them with other pigments already in the painting. Better yet—learn to mix greens using all of the yellows and blues at your fingertips. *(Fig. VI-23)*

Exercise #18

Squeeze some phthalo green on your palette. Mix a *very* small amount of it with every color in your paint box and paint a sample patch of the mixture on your support. Do the same thing with other greens and label each sample as you paint it. What a beautiful array of blues and greens you can achieve! Keep in mind that this can be done with any pigment, as well as with green, to test the range of color mixtures possible with pigments. *(Fig. VI-24)*

Exercise #19

Use a sectioned sheet. Starting with ultramarine blue in the first section, mix green, using any yellow plus ultramarine. In the next square use the ultramarine with a different yellow. Continue in this manner, labeling carefully, until you have mixed all of your yellows with ultramarine blue. *(Fig. VI-25)*

Repeat the procedure with a different blue, mixing the yellows in the same sequence as before, until you have used all of the blues and yellows. Another lovely array of greens! If you mix a very small amount of each of the reds into the green mixtures to de-saturate or darken them, you will have still more greens. Beautiful greens should be a problem no longer! If you have labeled carefully and taken notes on the pigments in this exercise, you can find any green you want on your practice sheet

You can see that you do not need to buy all of the dozens of different pigments manufactured to have unlimited color choices. Now you are aware of some of the similarities and differences in pigments. You should consider degrees of compatibility when you combine pigments. Pigment characteristics and idiosyncracies become increasingly obvious the longer you work with colors. You are no doubt cognizant now of the endless possibilities of color mixtures, because you have explored some of them first-hand.

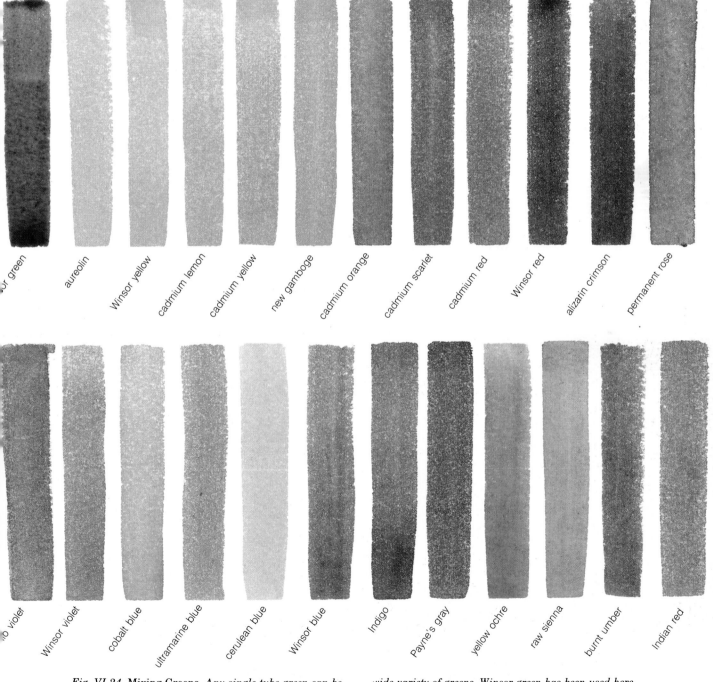

Fig. VI-24. **Mixing Greens.** *Any single tube green can be mixed with the other colors on your palette to create a wide variety of greens. Winsor green has been used here. Explore other tube greens, as well.*

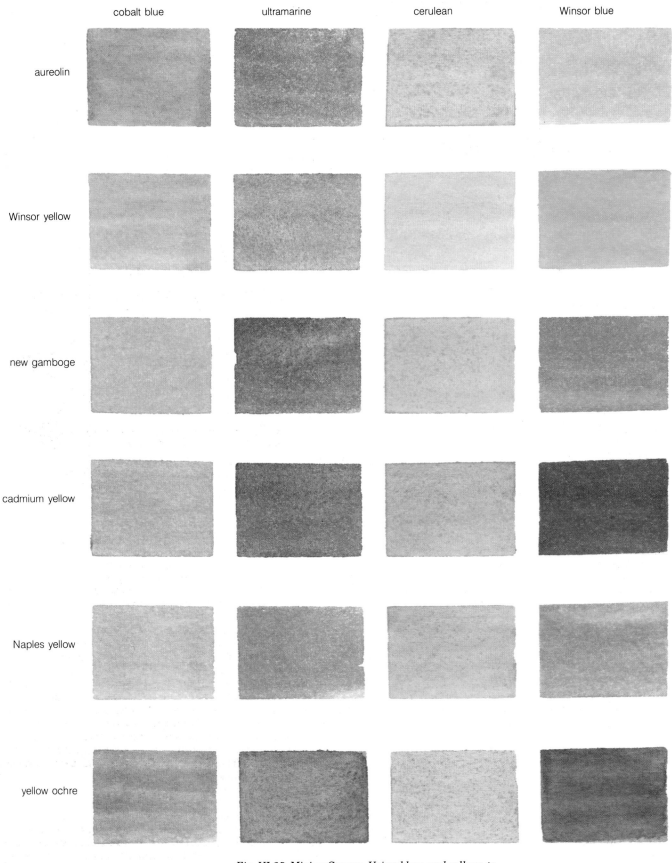

cobalt blue ultramarine cerulean Winsor blue

aureolin

Winsor yellow

new gamboge

cadmium yellow

Naples yellow

yellow ochre

Fig. VI-25. **Mixing Greens.** *Using blues and yellows to mix the greens will give you any rich or subtle green you could possibly require.*

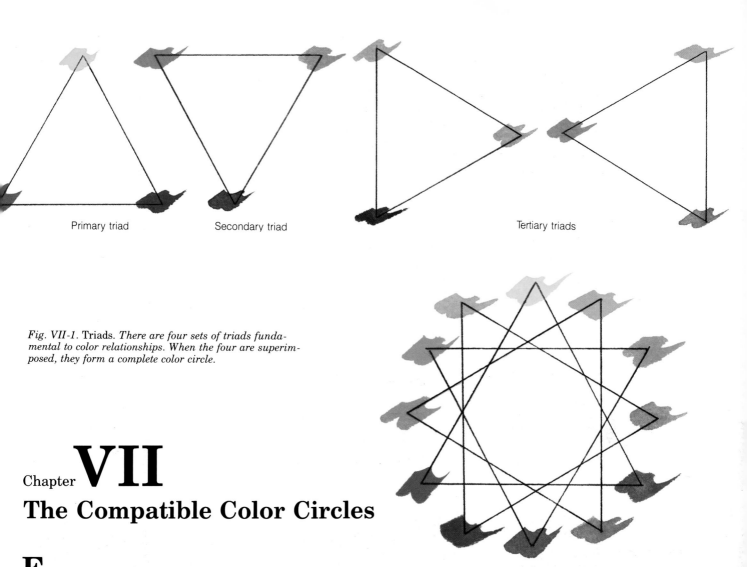

Fig. VII-1. Triads. *There are four sets of triads fundamental to color relationships. When the four are superimposed, they form a complete color circle.*

Primary triad Secondary triad Tertiary triads

Chapter **VII**
The Compatible Color Circles

For centuries students and theorists have used the color circle, or color wheel, as a tool for color study. From the time Newton curved his diagram of the visible spectrum of light and joined it end to end, theorists have explored and analyzed the relationships of the spectral colors according to their positions on the color circle. Artists have learned to select colors because of their proximity or opposition, or according to prescribed orderly systems, based on the relative locations of hues on the color circle. No other device has such importance to the artist working in chromatic media.

Color wheels may represent varying ideas. Several different arrangements of hues around the circle have been proposed. Newton's original color circle included indigo blue as one of the spectral colors. Some, like Ostwald's circle, have eight fundamental colors, others only six. Still others show twelve hues around the circle. The traditional primaries of red, yellow and blue are by no means universal. Red, yellow, blue and green are called primaries on one circle; red, green and violet on another. Vermilion, green and blue-green have also been used as primaries. Each group of colors represents some underlying logic of orderly relationships of hues to the theorist who proposed it.

Herbert Ives proposed a circle having as primaries magenta, yellow and cyan, the subtractive primaries associated with transparent pigments and dyes used in printing and photography. This triad alters the familiar relationships between primary colors as painters know them. The magenta, yellow and cyan primaries are a modification of the red, yellow and blue triad. Red-orange has been completely removed from the Ives circle. This interesting combination has creative possibilities that will be explored in greater detail later.

The most commonly recognized color circle has the primary hues, red, yellow and blue, equidistant on the circle. These hues were described as pigment primaries around 1731 by J. C. Le Blon, who reported that most colors could be mixed with red, yellow and blue, which could not themselves be mixed from any other pigments. Artists had almost certainly been aware of this for centuries! Most color systems developed for artists acknowledge the fundamental nature of this triad. The studies of compatible pigments in this chapter are based upon the familiar red, yellow and blue combination.

The triads

Once the primary nature of red, yellow and blue was discovered by scientists, their triadic relationship on the color circle came to be fully appreciated. (*Fig. VII-1*) The fact that the mixtures of any two primaries yielded another triad of importance became apparent. These mixtures are called "secondary" colors.

High key

Middle key

Low key

Full contrast

Fig. VII-2. Value Key. *On the value scale several different ranges may be selected, each creating a different expression in the painting.*

Fig. VII-3A. *"High Key"—Sheer Fantasy by Karen Kline. Watercolor. 13½" × 19".*

Fig. VII-3B. *"Low Key"—Bird's Nest by Harriet Hazinski. Watercolor on gesso board. 20" × 15".*

The color circle here has four sets of triads. The *primary colors* are red, yellow and blue, the fundamental colors that cannot be mixed. Mixtures of two primaries result in three *secondary colors*: red + yellow = orange; blue + yellow = green; red + blue = violet. The remaining colors are *tertiary colors*, mixtures of a primary and its neighboring secondary. The two tertiary triads are red-orange, yellow-green, blue-violet and red-violet, yellow-orange, blue-green. The tertiaries are sometimes called "intermediate" hues.

Color key

The color/value contrast inherent in compatible pigments is called "color key" and is used to suggest style or mood in a painting. (*Fig. VII-2*) Full contrast paintings have a complete range of color values, from white to the darkest possible dark. Such paintings have considerable dramatic potential, the light and dark accents underlining the focal point of the subject.

At the light end of the value scale are the "high key" colors, which are limited to light and middle values. High key paintings may be poetic or optimistic. At the darker limit is "low key" color contrast, restricted to middle and dark values, creating moody expression. A "middle key" value scheme is seldom used; this is considered an incomplete range. Emphatic darks or lights create impact. The middle value range is valuable as the background for color/value accents in the other color key arrangements. (*Fig. VII-3A, 3B, 3C, 3D*) Each of the compatible pigment groups has a slightly different value range, giving numerous variations in color key.

Mixing Color Circles

The mixtures of each group of primaries in this chapter have been achieved by combining pigments sharing similar physical properties. Note that pigment properties are rarely identical, but within certain limits they can be matched so they work well together.

You cannot duplicate the purity of spectral hues in pigment mixtures. The colors of projected light are pure; pigment colors are not. When red, blue-violet and green lights are combined, the mixtures become progressively lighter until pure white light results from the mixture of all three. Mixtures of red, yellow and blue pigments become progressively darker as more colors are added.

To make compatible color circles you will match as closely as possible some of these characteristics of specific primary pigments: transparency, intensity and tinting strength. Then you will create color circles from them, *approximating* the hues named on the spectral circle as nearly as the limited primary triad will allow—one pigment each for red, yellow and blue. In one circle the red may be more nearly pink; in another it will be red-brown. In each case these pigments will be compatible with others in the same circle. Some very beautiful combinations will result as you mix the intermediate hues for the circle.

One of the resulting color circles includes delicate tints desirable in paintings of atmosphere and light. Another incorporates the stunning intensity of pure, staining pigments. Still others show subtle, unsaturated tones. Understanding how compatible pigments interact will enable you to use colors with conviction, with awareness of their strengths and limitations in controlled primary mixtures. In these exercises, don't fall back on supplementary pigments to fill in the color wheel. Every color must be *mixed*, using your choices among the recommended primary pigments.

The study of compatible pigments reveals the expressive potential of all pigments. The risk of discordant color diminishes when you limit yourself to primary triads of compatible pigments at this early stage of color exploration.

Pigment compatibility

Perfect matches between pigments are rare. Nevertheless, you can select those that share similar qualities in order to create coherent, distinctive color. Follow the steps in the next exercise closely and you will be able to evaluate the compatibility of all of your pigments.

Exercise #20

Spread your exploration exercises on a large surface. Use the transparency/opacity, staining quality and tinting strength exercises.

From the transparency/opacity chart make one list of the opaque pigments and a second list of the transparent and semi-transparent pigments among the thirty colors on the recommended list. (*Fig. VII-4*) There are nine opaques on my list: cerulean blue, cadmium lemon, cadmium yellow medium, yellow ochre, Indian red, light red oxide, cadmium red light, cadmium red medium and Naples yellow. The remaining pigments are either fully or semi-transparent. If your charts show slightly different results, note that brands differ. Also, remember that it is impossible to prescribe an exact thinner-to-pigment ratio to ensure that artists achieve identical results in the tests.

Fig. VII-3C. "Middle Key"—Autumn Mist by Nita Leland. Watercolor. 22″ × 15″.

Fig. VII-3D. "Full Contrast"—Farren's Dock by Jean S. Walther. Watercolor. 20½″ × 26½″.

Selecting Compatible Pigments

Opaques	Transparent and Semi-Transparent	
U cerulean blue cadmium lemon cadmium yellow U yellow ochre U Naples yellow cadmium red light cadmium red U Indian red U light red U = unsaturated	ultramarine blue Winsor blue U indigo blue Antwerp blue cobalt blue viridian Hooker's green dark Winsor green new gamboge aureolin	U raw sienna Winsor yellow Winsor red Grumbacher red alizarin crimson U brown madder alizarin permanent rose rose madder genuine U burnt sienna U burnt umber U Payne's gray, ivory, black, or neutral tint

Subdivisions of Compatible Pigments		
Opaque unsaturated cerulean blue yellow ochre Naples yellow Indian red light red	**"Bright" unsaturated** indigo raw sienna brown madder alizarin	**Old Masters'** **unsaturated** Payne's gray, ivory, black, or neutral tint yellow ochre, raw sienna burnt sienna burnt umber
Delicate-transparent- **saturated** Antwerp blue cobalt blue viridian aureolin permanent rose rose madder genuine	**Intense-transparent-** **saturated** Winsor blue Winsor yellow Winsor red Winsor green Grumbacher red alizarin crimson	**Remainder: opaque &** **transparent-saturated** ultramarine blue cadmium lemon cadmium yellow cadmium red light cadmium red Hooker's green dark new gamboge

Fig. VII-4. Selecting Compatible Pigments. *Follow directions carefully in this exercise. Be sure you understand why each pigment has been classified in a particular category before you subdivide them into triads.*

Mark the unsaturated pigments in both columns: Indian red, light red oxide, brown madder alizarin, burnt sienna, burnt umber, yellow ochre, raw sienna, Naples yellow, cerulean blue, indigo blue, Payne's gray, ivory black or neutral tint. These unsaturated pigments can be further subdivided into red, yellow and blue triads, matching the pigments for transparency/opacity and relative brightness. There are three of these compatible, unsaturated triads; only one is opaque. With them you will develop unsaturated color circles.

The Opaque Triad—The most dense of the unsaturated pigments are Indian red or light red, yellow ochre or Naples yellow and cerulean blue. This combination is very opaque and earthier than most other triads. In selecting a yellow, you may find the yellow ochre a better choice than Naples yellow.

The Bright Unsaturated Triad—Brown madder alizarin, raw sienna and indigo blue are highly transparent, but none of them are spectral pigments. The brown madder alizarin, true to its name, is a brownish-red; the raw sienna is a lovely, unsaturated yellow; and the indigo has a decidedly gray tone to it. As a primary triad, these three pigments yield rich, distinctive intermediate hues.

The Old Masters' Triad—The last of the unsaturated triads calls for burnt sienna or burnt umber, yellow ochre and Payne's gray, ivory black or neutral tint. Start with burnt sienna as red in this palette, with Payne's gray as blue. Palettes of this type are called "old masters' palettes" because some of the early masters were limited to a few such pigments. The pigments are transparent or semi-transparent.

The remaining pigments on the recommended list, whether opaque, transparent or semi-transparent, are saturated pigments, unmodified by neutral tones. These pigments vary greatly in tinting strength. Sort them into three groups of pigments.

The Delicate Triad—On the list of the transparent pigments these are the most gentle of the saturated colors. Rose madder genuine, permanent rose, aureolin, cobalt blue, Antwerp blue and viridian share transparency and delicacy of hue. The primary triad consists of rose madder genuine or permanent rose, aureolin and cobalt blue or Antwerp blue.

The Intense Triad—The powerful, intense pigments, Winsor red, Grumbacher red, alizarin crimson, Winsor yellow, Winsor blue and Winsor green, are all transparent stains having great tinting strength. Use alizarin crimson, Winsor or Grumbacher red, Winsor yellow and Winsor blue for the primary triad. The alizarin crimson gives altogether different mixtures from the other two reds, which are interchangeable.

The Standard Triad—The last group of colors, long popular with artists, is not so well-matched as the other five triads, but is closest to the traditional red-yellow-blue spectral triad. The pigments are cadmium red light, cadmium red medium, cadmium lemon, cadmium yellow medium (all opaque pigments), new gamboge (transparent), French ultramarine blue (semi-transparent) and Hooker's green deep (transparent). For the primary triad use either red with ultramarine blue. Use new gamboge for the yellow, so the mixtures can benefit from its transparency. The opacity of the cadmium colors tends to muddy mixtures, but they are such brilliant hues they should be considered for the palette.

From each of the six groups above, select one pigment each to represent red, yellow and blue. Do not use the greens just now (*Fig. VII-5*).

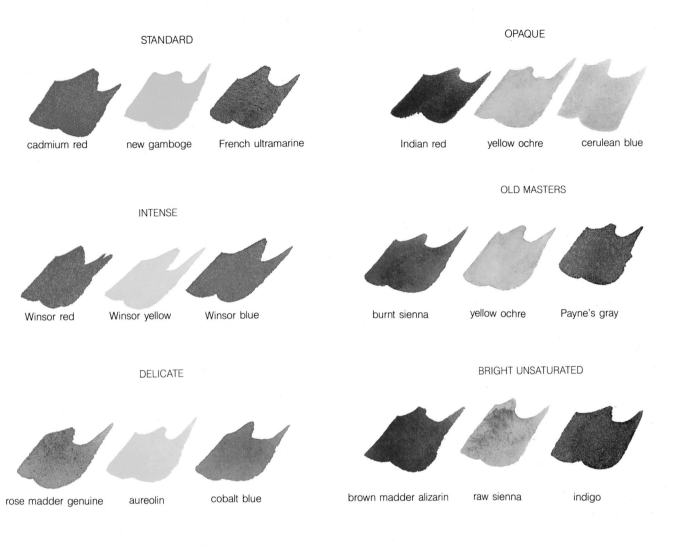

STANDARD

cadmium red new gamboge French ultramarine

INTENSE

Winsor red Winsor yellow Winsor blue

DELICATE

rose madder genuine aureolin cobalt blue

OPAQUE

Indian red yellow ochre cerulean blue

OLD MASTERS

burnt sienna yellow ochre Payne's gray

BRIGHT UNSATURATED

brown madder alizarin raw sienna indigo

Fig. VII-5. The Compatible Triads. *These are my choices for the triads. If you make any substitutions, make them from the recommended list of pigments. Later you can try other combinations.*

Exercise #21

Make a template of heavy paper or cardboard, using an eight-inch circle with 12 small circles the size of a quarter around the perimeter. (*Fig. VII-6*) Several of these eight-inch circles may be placed on a single support for easy comparison. Space the small circles evenly around the large circle like the numbers on a clock. Be sure that each circle is directly across from another on the opposite side.

Every color circle in the exercises has the same arrangement of hues. Position the twelve primary, secondary and tertiary colors that comprise the circle, beginning with yellow at the top.

Each group of compatible primary colors has a distinctive name assigned to it. The triads are reasonably well-balanced, although the pigments included may not be the only ones that have the proper characteristics for any given triad. Attempt variations and substitutions after you have completed the initial exploration.

The compatible color circles are not intended to provide formulas for your palettes, but to illustrate how well pigments work together when they share similar characteristics. The palettes may be altered in numerous ways, as long as the pigments that are added or substituted have some qualities in common with the others on the same color circle.

Fig. VII-6A. Cutting a Template. *Use a stencil knife to cut a template out of heavy paper or cardboard.*

Fig. VII-6B. The Template. *A template will expedite the work with color circles in this chapter and may be used for other exercises later, if you wish.*

Fig. VII-7. Mixing the Color Circle. *Using only the colors listed in each primary triad, mix the secondaries and then the tertiaries, filling in the appropriate space on the circle.*

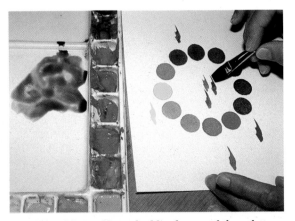

Fig. VII-8. Mixing Neutrals. *Mix the run-of-the-palette—all three pigments on the triad—to create neutrals related to the compatible circle. Place a sample or two of this mixture at the center of the circle. On the unsaturated circles the neutral mixtures are not very far removed from the colors on the circle itself.*

Mixing colors for the compatible circles

Create a color circle with each of the compatible primary triads, using only three of the pigments from each group to represent red, yellow and blue. Keep the pigments as clean as possible when you mix the secondaries and tertiaries.

Begin with yellow at the top of the circle. With yellow and blue, mix a green that you feel belongs midway between the two; add enough yellow to a portion of the mixture to create yellow-green; add sufficient blue to the remainder of the mixture to make blue-green. *(Fig. VII-7)* Whether or not you have achieved the optimum color for the pigments used is a subjective judgment. Paint each hue or mixture in the appropriate spot on the circle, labeling the primaries with their pigment names.

Continue around the circle, beginning each time with the primary, then mixing the secondary, and finally creating the tertiaries. Each set of matched primaries yields strikingly different color mixtures. Each color circle is unique. The mixed colors do not resemble spectral hues, but disclose the wide range of hues possible with any given set of primary pigments.

Upon completion of each circle, mix all three primary pigments slightly to create neutral mixtures. *(Fig. VII-8)* Give these mixtures a recognizable color bias toward one of the original colors in the mixture. Place spots of the neutrals toward the center of the appropriate circle. There are many variations of these mixed, unsaturated hues that lean toward one or another of the hues on the circle.

As you complete each circle, select a subject or develop a nonobjective composition suitable to the colors on the circle. Let one color dominate the others in your sketch by the greater quantity used or by its intensity. Can you achieve a full range of values with the pigments of each circle? What is the color value range of each circle?

The standard palette

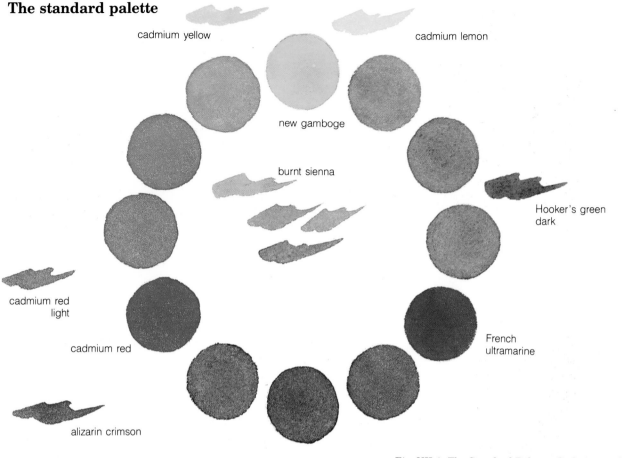

cadmium yellow

cadmium lemon

new gamboge

burnt sienna

Hooker's green dark

cadmium red light

cadmium red

French ultramarine

alizarin crimson

Fig. VII-9. The Standard Palette. *Cadmium red, new gamboge and French ultramarine comprise the standard palette here. This is an excellent landscape palette, particularly on the cool side of the color circle, where subtle greens and violets can be mixed.*

Exercise #22

The standard palette contains three "workhorse" pigments found on many artists' basic palettes: cadmium red light or cadmium red medium, new gamboge, and ultramarine blue. *(Fig. VII-9)* Ultramarine blue is semi-transparent and the cadmium reds are very opaque. The new gamboge imparts some degree of transparency. Colors mixed using the standard triad are of intermediate intensity and slight opacity. The mixtures have considerable expressive possibilities. Many artists use these pigments as the foundation for their color work.

The scope of subjects suitable to the standard palette is very broad. The violets lack brilliance, however, because the cadmium reds possess a great deal of yellow that quickly modifies mixtures with ultramarine blue. Oranges are bright and greens are satisfactory. A fairly complete range of color and value contrasts is easily achieved with the standard triad. The characteristic brilliance of the pigments is modified in mixtures.

When the color circle is finished, do a small painting with the three pigments of the standard palette. Select a subject or design a small abstract. Create a mood or make a visual statement pleasing to you. *(Fig. VII-10)*

Fig. VII-10. Mallards on the Wing *by Nita Leland.* Watercolor. 18″ × 24″. *Private collection.*

The delicate palette

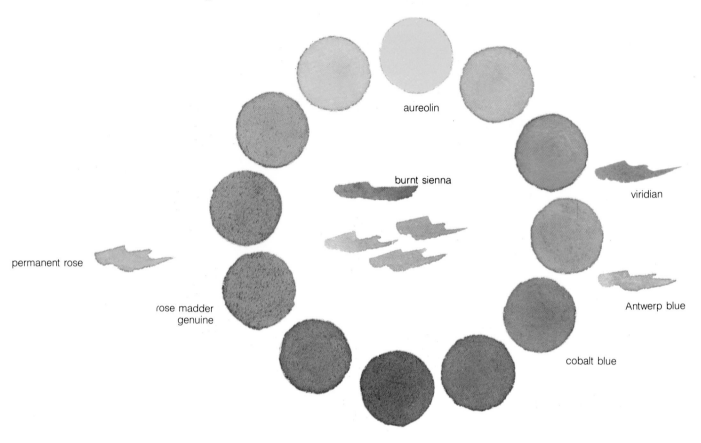

aureolin

burnt sienna

viridian

permanent rose

Antwerp blue

rose madder
genuine

cobalt blue

Fig. VII-11. The Delicate Palette. *The color circle is mixed using rose madder genuine, aureolin and cobalt blue. Flowers are a good choice of subject for this palette, as well as effects of light. Antwerp blue was used in the painting example, instead of cobalt blue.*

Exercise #23

Delicate tinting colors—permanent rose or rose madder genuine, aureolin yellow, and Antwerp blue or cobalt blue—combine to make an exquisite high-key color circle, limited in contrast and very transparent. *(Fig. VII-11)* The delicate tints are excellent glazing colors and are exceptionally expressive in mixtures. In watercolor, the colors are easily lifted. Flowers are delightful subjects for the tinting palette, but don't limit yourself to the obvious. Light-filled landscapes are especially effective when they are painted with the delicate tinting colors, but strong darks cannot be created.

Consider a subject appropriate to the colors you have mixed and placed on the circle, then use the colors to say something special about the subject in a small painting. *(Fig. VII-12)*

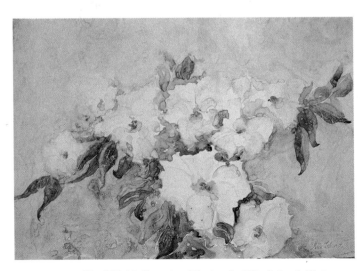

Fig. VII-12. Essence of Spring *by Nita Leland. Watercolor. 15″ × 20″.*

The intense palette

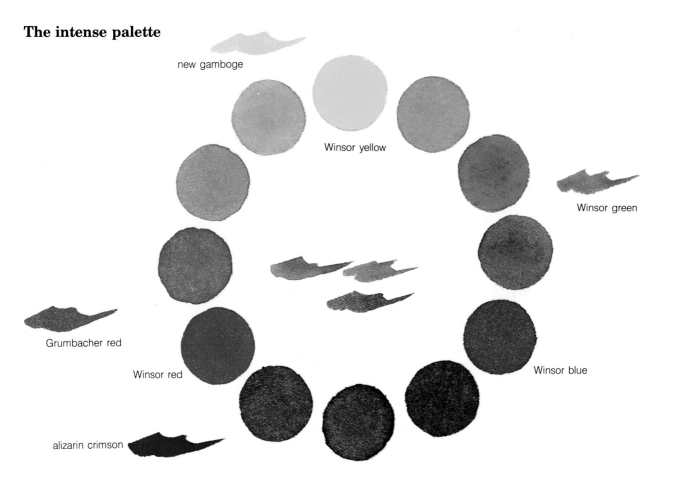

new gamboge

Winsor yellow

Winsor green

Winsor blue

Winsor red

Grumbacher red

alizarin crimson

Fig. VII-13. The Intense Palette. *Winsor red, Winsor yellow and Winsor blue are well-matched on this beautiful circle. Alizarin crimson would make more intense purples and unsaturated oranges. The range of subjects is unlimited with this palette.*

Exercise #24

A very transparent, staining triad consists of Winsor or Grumbacher red or alizarin crimson, Winsor yellow, and Winsor blue or one of the other phthalo blues. *(Fig. VII-13)* Dramatic, bold statements may be made, featuring rich, intense darks. The color/value range is at its most complete. These dynamic pigments generate tremendous energy, brilliance and sharp contrast in any subject, including cityscapes, landscapes, and flowers. Nonobjective compositions are particularly strong when the intense triad is used. The transparency of the pigments makes them useful as glazes, although they must be well diluted for that purpose.

After completing the color circle, do a small painting, taking full advantage of the boldness and excitement of the colors. Remember to place the greatest light/dark contrast near the center of interest. The intense triad is undeniably the most powerful group of colors you will explore—although not necessarily the most suitable for every artist's expressive purpose. *(Fig. VII-14)*

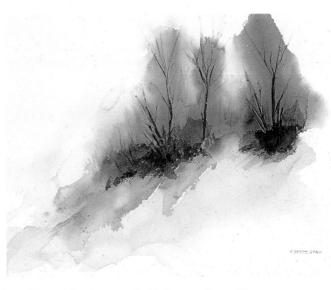

Fig. VII-14. Blue Fantasia *by E. German Green. Watercolor. 15″ × 22″.*

The opaque palette

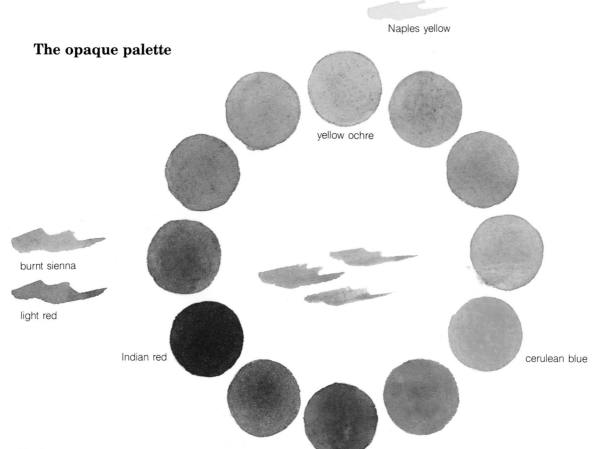

Naples yellow

yellow ochre

burnt sienna

light red

Indian red

cerulean blue

Fig. VII-15. The Opaque Palette. *Using Indian red, yellow ochre and cerulean blue can be a real challenge. The mixtures are by no means colorless, but extremes of value and color contrasts are almost impossible to achieve. There is a very subtle color expression to this palette.*

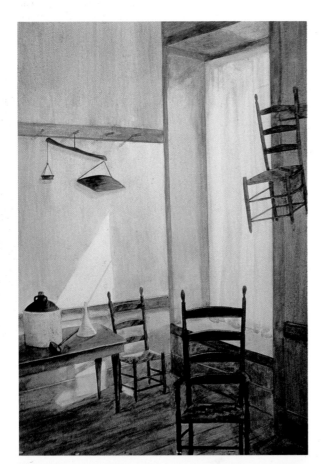

Exercise #25

Indian red or light red oxide, yellow ochre or Naples yellow and cerulean blue are extremely dense in mixtures, having great covering potential. *(Fig. VII-15)* The Indian red and light red are powerful. Use them sparingly. (Try some substitutes for these pigments later.) The opaque unsaturated palette is unusual and difficult to use, often resulting in a low key, moody painting. If the pigment is applied in a very pale wash, a higher key will result. Each of the mixtures is distinctive. Extreme darks are virtually impossible to achieve. The opaque palette in watercolor is particularly successful on wet paper, allowing for the settling properties of the dense pigments. Subjects appropriate for the palette might be rocks, machinery or the concrete of a cityscape.

Create the opaque color circle in the usual way. Select a suitable subject and do a small painting. Avoid letting middle values dominate the painting. Strong whites play strikingly against the opaque pigments and help to relieve their heavy qualities. *(Fig. VII-16)*

Fig. VII-16. Shaker Shadows *by Nita Leland. Watercolor. 30″ × 22″.*

Collection of Dr. and Mrs. John K. Wiley.

The old masters' palette

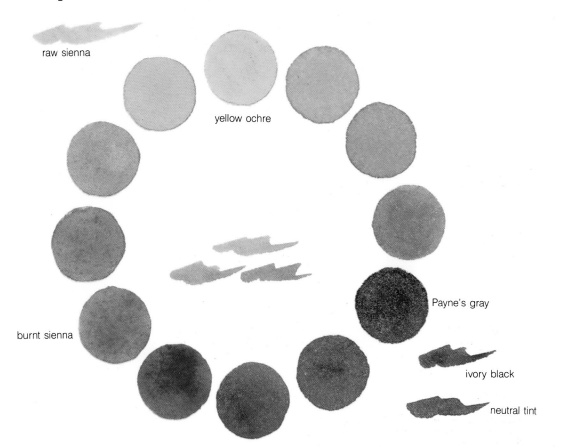

raw sienna

yellow ochre

burnt sienna

Payne's gray

ivory black

neutral tint

Fig. VII-17. The Old Masters' Palette. *The limited range achievable with burnt sienna, yellow ochre and Payne's gray possesses great unity.*

Exercise #26

The "old masters'" triad is an unsaturated palette variation that gives semi-transparent, subtle mixtures: burnt sienna or burnt umber represents the red, yellow ochre is the yellow, and Payne's gray, ivory black or neutral tint stands in for blue. *(Fig. VII-17)* The brand of Payne's gray used will affect the mixtures. Burnt sienna yields livelier mixtures than burnt umber as the red in the triad. The old masters' palette is surprisingly effective, particularly if you emphasize light and dark contrast in the manner of the Renaissance painters. Any subject is suitable, although the palette lacks brilliance. Many artists respond more readily to bolder color mixtures, but the subtlety of this palette is very moving and highly effective.

Complete the old masters' color circle. Paint a subject that takes full advantage of the potential of the unsaturated palette, moody and atmospheric. *(Fig. VII-18)*

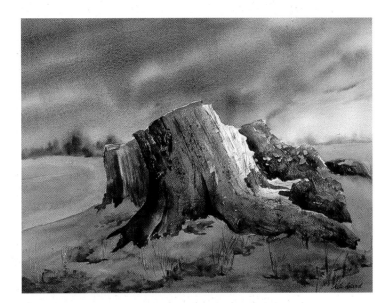

Fig. VII-18. Returning to Dust *by Nita Leland. Watercolor. 14″ × 20″.*
Collection of Edward Hager.

The bright unsaturated palette

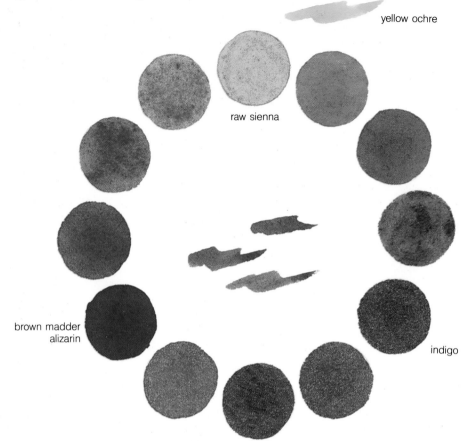

yellow ochre

raw sienna

brown madder
alizarin

indigo

Fig. VII-19. The Bright Unsaturated Palette. *The rich pigments of this triad combine to give unusual color effects. Brown madder alizarin, raw sienna and indigo are all slightly grayed pigments.*

Exercise #27

Brown madder alizarin, raw sienna and indigo blue comprise another unsaturated selection that is considerably brighter than the old masters' palette, but is still not of the purity of hue of the intense, delicate or standard triads. *(Fig. VII-19)* The mixtures of the unsaturated transparent pigments are rich and distinctive.

Paint the unsaturated color circle and do a sketch. What differences do you see between this and the old masters' triad? *(Fig. VII-20)*

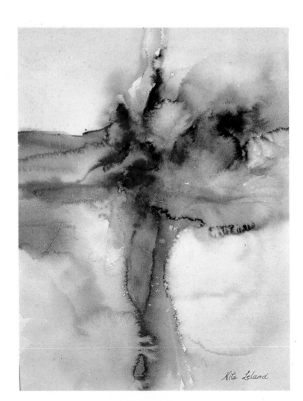

Fig. VII-20. Pirouette *by Nita Leland. Watercolor. 16" × 12".*

Collection of April Evans.

Other combinations—other colors

The six compatible palettes show the range of color expression possible with primary pigments. Use them as they are given here, then enhance them with other matching pigments. Most of the colors in your paint box have characteristics in common with at least one of the pigment triads.

The possibilities of additional combinations are innumerable. Now is the time to try them. What variations occurred to you as you worked on the color circles? Are the primary pigments from your former palette compatible with each other? Could they be combined in a separate color circle? Perhaps one of your colors will enhance a circle just studied. Look at the exercises on pigments and see if you can find other compatible combinations or pigments that might substitute effectively for one or more of the primaries on the six color circles just completed. (Fig. VII-21)

The recommended pigments in the color circles do not represent inflexible formulas. They are a point of departure for your enquiries. Ask yourself questions: Is indigo blue strong enough to work with the intense palette? Is Antwerp blue preferable to cobalt blue on the delicate palette? What happens when an opaque is combined with transparent pigments? Is there another place for brown madder alizarin on one of the circles? Where do assorted yellows fit in? Do any unsaturated pigments have a place on the brighter palettes? Can darks somehow be achieved with the tinting or opaque palettes? Your search should not end with the things you have learned on the color circles. Continue independently to investigate possibilities as yet unexplored.

Perhaps you want to develop an entirely different set of compatible primary pigments. Paint a color circle and a sketch with your set, so you can examine all of the possibilities of these mixtures.

Exercise #28

Study your remaining pigments. Find places for them on one of the compatible circles, placing unsaturated hues toward the center and more intense pigments near the perimeter. Refer to the exercises on transparency, intensity and tinting strength to help you in matching their properties to those of the primaries on the color circles. Some pigments adapt to several circles. There is no "right" place for every color. These are personal opinions. In the final analysis, the right place is whatever satisfies you.

To get started, add faithful alizarin crimson to the standard palette, so you can mix the purple that eluded you in the standard color circle. If you used Winsor or Grumbacher red for the intense triad, remember that alizarin crimson is also a transparent stain, and try it with the staining colors, along with phthalo green, to enable you to make intense, transparent darks.

The wonderful feature of color circle exploration is that, once you have seen what you can do with compatible primary pigments, you probably will not feel the need to use a lot of other pigments for awhile. The compatible triads possess remarkable unity, harmony and versatility.

On the other hand, leave no pigment unexplored.

Payne's gray, yellow ochre, burnt sienna

Ivory black, yellow ochre, burnt sienna

Neutral tint, yellow ochre, burnt sienna

Fig. VII-21. Pigment Substitutions. *Changing any one of the pigments on the palettes will alter the color expression in different ways. If you are dissatisfied with any of the color circles, try some of the other pigments having the same qualities.*

Fig. VII-22. Different Palettes with a Single Subject.
Each triad contributes an entirely different color expression to the subject. Try them all.

Opaque triad

You never know when a painting may call for the extra punch that only one pigment can provide. You will know which one to use when that time comes.

Exercise #29

Conclude the exploration of primary triads with a painting exercise that demonstrates the use of different color groups to affect the expression of a subject in a painting.

Select a *single subject* and plan a simple composition or abstract of several simple shapes. Write down a few words that describe various ideas about the subject. Think about which colors can best be used to reveal each expressive idea. Paint several small sketches of the subject, using a *different triad* for each painting. *(Fig. VII-22)* Do some mixtures work better with the subject than others? Note the great variety of choices and the different effects of each palette.

Remember—even in your small sketches, a dominant color is important. One of the principles of design most necessary to communicate your expressive idea is dominance of hue.

Delicate triad

Intense triad

At this point your color personality begins to reveal itself. You will respond more readily to one combination of colors than to another. As variations and substitutions occur to you, explore these ideas, too. React to the challenge of color. Search constantly for ways to expand your favorite compatible pigment combination.

The color circles you have painted will serve as a useful reference when you develop color ideas for your paintings. Sometimes your choice of subject will suggest the selection of colors. At other times, you will be led to custom–fit a subject to the colors you are in the mood to paint. Nonobjective painting is particularly interesting when approached from the standpoint of color as the subject of the painting.

Whatever happened to "mud"? Banished, I hope. You have what you need now to begin making personal color statements in your paintings with distinctive, harmonious color.

The key to successful color expression is knowing from experience what your pigments will do.

Old Master's triad

Fig. VIII-1A. Hot Toddy Time *by John Pike, A.W.S.*
Watercolor. 22" × 30". Private collection.
Courtesy of Zellah Pike.

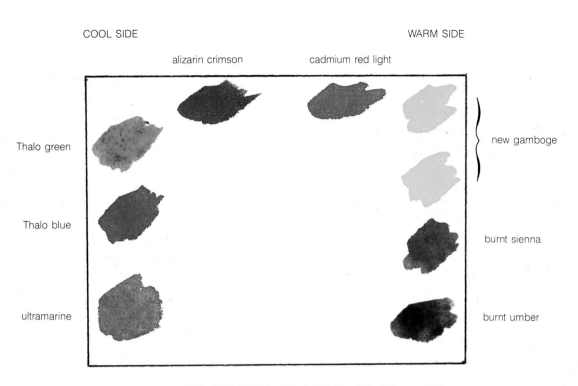

COOL SIDE WARM SIDE

alizarin crimson cadmium red light

Thalo green

new gamboge

Thalo blue

burnt sienna

ultramarine

burnt umber

Fig. VIII-1B. John Pike's Palette. *John Pike used this well-balanced palette for most of his colorful paintings. You won't find "mud" in a Pike watercolor. He kept two mounds of the same yellow—one for mixing with other colors and one to provide clean, bright yellows.*

Chapter **VIII**

Selecting Your Palette

By now you have tested at least thirty pigments from the list of colors recommended for color exploration. You are familiar with many of the characteristics affecting pigment selection. You understand how to combine pigments in compatible primary triads and how to use these combinations in paintings. No doubt you have discovered some beautiful colors that you are eager to make a permanent part of your palette; you have probably had a negative response to a few colors. Your color personality makes these intuitive choices for you, but your new knowledge of color properties and mixtures of compatible pigments enables you to take advantage of all of the pigments available to you for artistic expression.

With so many colors to choose from, you must narrow the selection to a workable number. Most artists rely upon a basic working palette of pigments that forms the backbone of their work, augmented by additional pigments needed for a particular painting. Unfortunately, many artists have no rationale for the selection of colors on their palettes. They have no idea what makes color work.

You are capable of planning a palette of pigments you have a strong preference for, that you can count on to work well with each other. You know how to test them to assure that they will achieve the effects you want in your paintings. You can repeat a successful arrangement of colors, because your original selection was made knowledgeably and not at random.

You do not require a large number of colors to paint expressive pictures. Three primaries in any of six compatible-pigment combinations are enough for

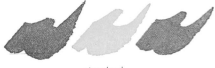 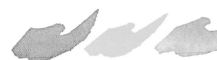 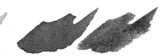

standard delicate burnt sienna
 burnt umber

standard intense alizarin crimson
 Winsor green

delicate opaque burnt sienna
 viridian

intense bright unsaturated yellow ochre
 burnt sienna

Fig. VIII-2. Basic Palettes. Here are four of the innumerable ways you can combine compatible triads into a basic working palette of your own. Select the colors that you discovered a special affinity for as you explored them.

most artists' needs in the early stages of color exploration. You have no doubt felt a stronger attraction to some of the combinations than to others; these should form the nucleus of your basic working palette, with the others held in reserve for special subjects.

Start with eight pigments on your palette. Eight is not a magic number, but enables you to have two sets of primaries on the palette, along with a couple of unsaturated pigments. If you prefer to mix unsaturated colors, use the remaining two spaces to expand your selection of primary colors.

According to some artists, the ideal palette consists of a warm and a cool pigment of each primary hue plus warm and cool neutrals. John Pike was an advocate of this system. *(Fig. VIII-1A, 1B)* Using the color circles of compatible pigments, you can easily develop such a palette with pigments having similar characteristics. Here are several possibilities for basic palettes, accompanied by a brief explanation of the selections. Instead of grays or blacks, browns are substituted as neutrals, because they are livelier and won't deaden mixtures so quickly when used to modify hues. *(Fig. VIII-2)*

- *Standard triad + delicate triad + burnt sienna + burnt umber*—These eight pigments are expressive throughout the range of full contrast, high and low key. Exchange colors between the triads by diluting the standard colors so they won't overpower the delicate tinting colors.

- *Standard triad + intense triad + alizarin crimson + phthalo green*—This is a strong palette of great brilliance. Exchange colors freely between the triads; the transparent, intense triad prevents the semi-transparents of the standard triad from becoming muddy. A wide range of color contrasts is possible. The standard palette holds its own with the stains.

- *Delicate triad + opaque triad + burnt sienna + viridian*—This palette is tricky, but interesting. Colors may be exchanged to some degree. Viridian adds a lovely, cool note to the mixtures of tints. Burnt sienna brings a glow to the opaque triad that is less overpowering than Indian red or light red. Limited darks are possible with burnt sienna.

- *Intense triad + bright unsaturated triad + new gamboge + burnt sienna*—These pigments have great flexibility, brilliance and transparency. Exchange colors freely.

Stretch your mind to devise combinations that are not listed here. Many other arrangements are possible, including triads that you discovered for yourself while exploring the color circles of compatible pigments. Don't overlook the old masters' palette!

Notice that the above combinations sometimes list both transparent and opaque pigments, increasing the versatility of both triads. Palettes that include only transparent colors are unnecessarily limited. Incorporate beautiful opaques, such as the cadmiums, by combining them with transparent pigments of equal brilliance.

Notice also that the intense staining palette is not associated with the delicate tinting palette. It is virtually impossible to reconcile the tinting strength

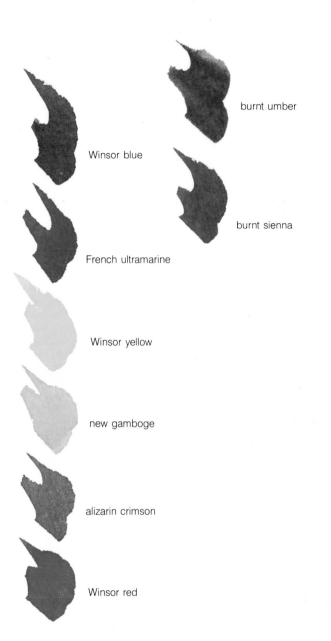

burnt umber

Winsor blue

burnt sienna

French ultramarine

Winsor yellow

new gamboge

alizarin crimson

Winsor red

Fig. VIII-3. The Basic Palette for the Four Seasons

Fig. VIII-4A. "Winter"—Mantle of White *by Nita Leland. Watercolor. 18" × 24".*
Collection of Kathleen L. Patterson.

of the intense palette with the delicate bloom of the tinting colors.

Those colors not included on your basic working palette are still available to you any time a subject calls for a distinctive color expression. Be flexible, but keep in mind the compatibility of the pigments. You tested your old favorites along with the recommended pigments; you can find a suitable group of colors each is compatible with and continue to use them.

Your basic palette will be unique and your paintings will reflect that individuality. Look at the palettes of famous painters described in Faber Birren's *The History of Color in Painting.* Among the greatest artists in history, no two palettes are exactly alike!

Setting your basic palette

Begin with a perfectly clean palette. It seems a shame to wash off the beautiful pigments you have tested, but you should begin with uncontaminated color. Pigments provide richer mixtures when they are squeezed fresh from the tube at the start of each painting session.

Fig. VIII-4B. "Spring"—Arrival of Spring *by Nita Leland. Watercolor. 18" × 24".*

Place like hues together on the palette, with neutrals off to themselves. Arrange the palette in spectrum order with red at one end, blue at the other. Leave empty spaces between hues, so new colors may join their families when you increase your selection. You may prefer to place warm colors on one side and cool colors on the other.

New ideas about colors will frequently occur to you. Abandon the basic palette from time to time and accept the challenge of new color experiments. Start a page of "pigments to explore" or "triads to try" in your journal, jotting them down when they first cross your mind. Otherwise, you may not remember them when the spirit moves you to do some color exploration. You can learn a lot in a few minutes on days you haven't much time to paint or don't feel up to starting a major painting.

Above all, be flexible about your basic palette. You should feel comfortable about making changes or additions to enhance the color in your work. You have a "limited palette" now—a selected number of colors from which you sometimes make an even narrower selection, depending on the color effect you are seeking. The possibilities of this small palette are almost unlimited.

There are eighty-eight keys on a piano, but the composer uses only a few of them to compose his rhapsodies! And you need only these few pigments to make beautiful pictures.

Exercise #30

Record in your journal the eight pigments you have selected to comprise your basic palette. Note what motivated you to choose those particular colors and how this palette differs from the colors you were using when you began color exploration. You may have a few ideas already on other colors to augment your palette. Jot them down to try later.

Paint a color circle using all of the primaries on your new working palette. Compare this circle with the one you did with your old palette. Have your colors changed? Have you achieved greater purity in your mixtures? Do you prefer the brighter colors, or have your investigations of color drawn you to the subtleties of the modified, unsaturated mixtures? Are there any areas on the wheel that are unsatisfactory? Consider the many pigments you have tested and decide whether or not there is one that will improve that section. Are its properties similar to the other pigments you have chosen? Try it. If it works, place the additional color on your palette.

Exercise #31

Paint the four seasons or four nonobjective sketches with the new palette. *(Fig. VIII-3)* Bring out the early sketches you did with your old palette. How do the paintings differ? Do you feel that the new colors have improved your ability to say something personal about the subject? There should be more clarity in the paintings—and less mud! *(Fig. VIII-4A, 4B, 4C, 4D)*

Fig. VIII-4C. "Summer"—Fourth of July *by Nita Leland. Watercolor. 12″ × 16″.*

Fig. VIII-4D. "Fall"—Pintails *by Nita Leland. Watercolor. 18″ × 24″.*

Fig. VIII-6. Fable Falls *by Carole Shoemaker. Watercolor. 22" × 37". Here is a vibrantly expressive color statement, far removed from a literal interpretation of the subject. The artist has responded to color without reserve.*

Fig. VIII-5. Hilltop House *by E. German Green. Watercolor. 15" × 20". Realistic color is suggested, but is subordinated to the idea of a pastoral landscape of delicate, expressive color that had its beginning in the mind's eye of the artist.*

Expressing yourself

Now that you have a basic working palette, think about the ways an artist uses his pigments to express his personality. Listen to Henri Matisse: "Above all, express a vision of colors, the harmony of which corresponds to your feeling." The selection of pigments is highly individual; your personality is revealed when you use those colors in a painting.

A common way of using color is to record the local colors of objects without regard to the needs of the painting. Many representational painters depend upon this use of color. Painting seemed historically bound to the illusion of reality for many years, until the time of the Impressionists, when the painting was thought of as a "new reality," with a life of its own. Students are inclined to use the conventional approach, until they develop some confidence in themselves along with a greater understanding of color use.

The Impressionists painted directly from the subject, observing the phenomena of light and color carefully and painting these effects in new ways. They became aware of the complementary nature of color in shadows and the colors of changing light that washed the landscape from morning to night. These effects seemed more important to them than the local color of each object in the painting.

It may take some time for your eye to become fully sensitized to the subtleties of color in nature.

Make every effort to overcome lazy habits of seeing that limit you to your first impression and a careless interpretation of color. *(Fig. VIII-5)*

Emotional Expression
Painting what the subject makes you *feel* is a highly desirable way to utilize color expression. Evoke a mood through color that reveals your emotional response to the subject, regardless of its local color. Most viewers react to this approach more sympathetically than to the reporting of facts about the subject. Try to describe the essential qualities of the subject, or an emotion, through color. *(Fig. VIII-6)*

Intellectual Expression
If you wish to take a purely intellectual approach, you may select color entirely by the rules of color design, using color not for its emotional appeal but for its formal relationships. For this you need a thorough understanding of color relationships, along with your knowledge of compatibility of pigments. This is another creative way to express your uniqueness; when you choose colors irrespective of subject, they are wholly "your" colors. *(Fig. VIII-7)*

Fig. VIII-7. This Structured Land by Doug Pasek, A.W.S., O.W.S. Acrylic watercolor. 28″ × 38″. There is a cool control in the use of color in Pasek's paintings. The color moves deliberately, because the artist has planned its movement as a significant part of the design.

Fig. VIII-8A. Emotional Expression. *The shapes originated with the idea of "dunes." The painting is an emotional expression of a storm or high winds on the dunes.*

Fig. VIII-8B. Intellectual Expression. *The idea of a storm on the dunes has been removed. The design has been reduced to arrangements of shapes and neutralized colors that still retain the "essence" of dunes. This sketch could be further developed into a full-scale painting based on the relationships that have already been established.*

Exercise #32

Select a subject that intrigues you. This is always important to achieving fine color expression. Indifference to the subject inhibits the artist as much as indifference to color or design.

Feel the loneliness of a place. Imagine the thoughts of a homeward-bound fisherman at the sight of a light above the rocks. Your involvement with the subject will enable you to express the poetry of the place. The subject is not a cliché when it shows your unique point of view or attitude.

Put poetry aside for a moment. Take a hard look at the subject. What do you see? If you paint outdoors, you see more than you can actually paint! As you plan your painting, simplify and eliminate detail, but above all, develop color ideas. If you paint from photographs or transparencies, be selective: use only what you need for each painting.

Paint two sketches of your subject. As you plan the first painting, decide how you can express *what you feel* about the subject in color. What essential qualities do you want to convey? Help the viewer to share your emotions. Make him say, "I don't care much for lighthouses (or barns, or birds, or flowers), but there is something very special about this painting." Use your basic palette, and have some fun with the colors. Dream up an inventive color plan.

Your second painting should be based on a color "idea" rather than any emotional or literal aspect of the subject. Color is the real subject of this painting. Depend on your intuition. Attempt to disregard local color and emotional connotations of the colors. *(Fig. VIII-8)*

Nonobjective artists may use color to create emotional or inventive exercises, without reference to subject matter. Explore the new basic palette in several nonobjective paintings.

Are you more excited about the emotional or the intellectual color approach? You may have noticed that the two approaches sometimes overlap during the planning and painting processes. Perhaps you are still a little timid about inventing color, and literal representation seems more comfortable to you. Work with color in all ways, training your eye to see the myriad colors around you, allowing your feelings free expression in color. Have an intellectual romp with color when you feel like it. Everything you do with color enriches your color vocabulary, making your paintings increasingly expressive as you paint.

Your experience with compatible pigments and color circles will develop color awareness and your ability to make unique statements in paintings with the most expressive of the elements of design—color. Color description is not the ideal goal of the painter; color *expression* is. Twentieth century artists have more freedom than any artists in history to utilize color and color relationships expressively. With your new palette you can take full advantage of this freedom.

Part Two

The objective of Part Two is to discover ways the pigments and their mixtures are used to accomplish color expression. Color contrasts and harmonies of light are studied, using compatible pigments and the basic palette. Painting exercises continue to provide direct observation of the pigments at work in realistic or nonobjective subjects, as you prefer. Complete familiarity with the pigments used in Part One is required before moving to the increased complexity of the expanded palettes. The journal is invaluable as the number of pigments grows and your experiences with color become more complex.

With the introduction of the expanded palettes, the exploration of specific pigments is complete. Any further augmentation of the palette will be accomplished according to your own desires. The full range of colors, from compatible pigments to the expanded palettes, is now available for use in the study of color organization with color schemes. Finally, color design is analyzed as the expressive power of the composition.

Throughout Part Two the lessons are accompanied by many illustrations of the work of contemporary artists. Study these carefully and turn back to earlier reproductions as well, because an important part of exploring color is finding the myriad ways color can be used for unique expression.

Fig. IX-1. Coloratura *by Alexander Ross, A.W.S. Acrylic.*
21″ × 30″. Adolph and Clara Obrig Prize for Watercolor,
The National Academy Open Exhibition (1980). The "joy-
ous statement in bold color" cited in the text is evident
throughout this elegant painting. There is a highly
sophisticated use of the pure hues interacting throughout
the composition.

Chapter **IX**

Color Contrasts

Making color work for you begins with employing
similarities and differences in pigments and hues.
The compatible color circles utilize the *similarities*
of pigments that share the traits of transparency,
intensity and tinting strength. Theoretical harmon-
ies of similar hues, including use of a single hue,
adjacent hues or a dominant colored light, will be
explored later.

Color harmony and contrast have long been the
study of leading theorists, from the extensive early
nineteenth century work of Chevreul to the explo-
rations of twentieth century artists in color-field and
optical art. The context of the colors is of the utmost
importance. Each touch of color to the painting alters
in numerous ways the relationships of colors already
there. You will no longer be working simply with
isolated patches of color on a chart or color circle.
The colors will now be seen as they relate to other
colors in mixing exercises and in paintings.

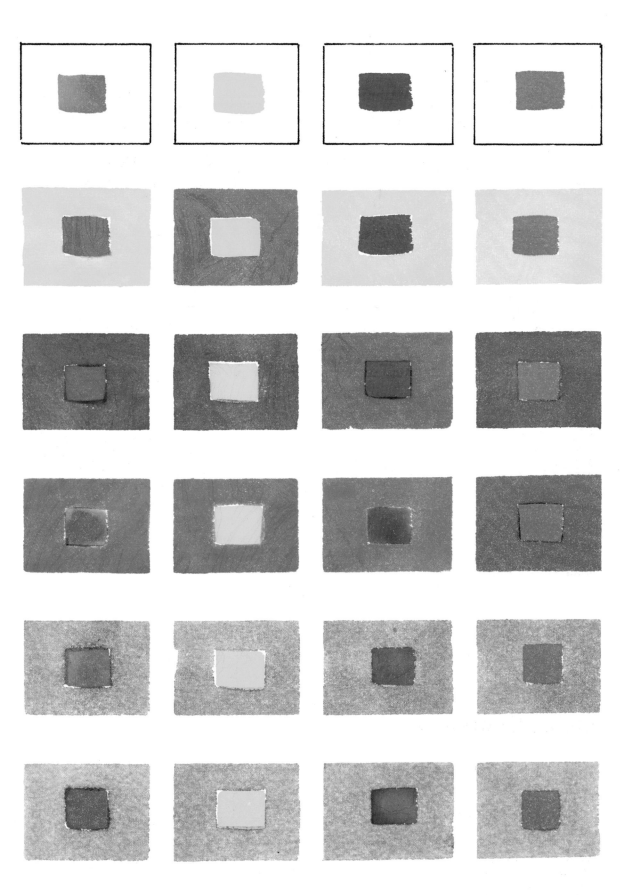

Fig. IX-2. Hue Contrast Chart

Fig. IX-3. Hue Contrast. *When pure hues are used together in roughly equal amounts, the result is decorative, particularly with the primary colors.*

Color contrasts

The Renaissance painters used light/dark (value) contrast; the Impressionists concentrated on warm/cool (temperature) contrast; the Fauves contrasted pure hues. Chevreul explored the mysteries of simultaneous contrast. Turner played pure tints against neutrals—intensity contrast. These are some of the *differences* between colors that are essential to expression in a painting: hue, value, intensity and temperature, which are contrasts of the properties of color; and quantity, complementary, and simultaneous and successive contrast, which are additional contrasts defined and explored by Chevreul.

Hue contrast

Intense colors placed side by side result in intense contrast. The paintings of the Fauves from the early part of the twentieth century—such artists as Vlaminck, Dufy, and Matisse—are good examples of contrast of hue. Primitive artists have exploited contrast of hue effectively throughout the ages. The decorative arts, porcelain glazes, brilliantly colored stained glass, mosaics, Pennsylvania Dutch stencil designs— are colorful, bright art forms that use contrast of hue to great advantage.

In addition to the effects of bright colors against one another, Chevreul observed that most hues seem brighter against black than against white and that colors seem even purer and more brilliant near gray. Advertising art is deliberately designed to capture the eye with sharp, dazzling color contrasts. Contrast of hue is exuberant, lively, a joyous statement in bold color. *(Fig. IX-1)* The quantities of the colors used and color dominance are of importance here.

Exercise #33

Begin by painting several small squares or circles of Winsor yellow or cadmium lemon on a sectioned sheet. Using other intense primaries—unmixed reds and blues—each diluted only enough to permit the paint to flow, place a half-inch band of color around the yellow. *(Fig. IX-2)* The central square of yellow stands out sharply next to some pigments, more so than it does when juxtaposed with others. Note the brilliance of the color contrasts. Study other pure hues in this manner. Record what you observe in your journal.

Remember to rest your eyes occasionally so physiological adaptations to the colors cannot unduly influence what you see.

Exercise #34

Do a simple sketch with pure primaries. *(Fig. IX-3)* A decorative effect can be achieved through the contrast of pure hues. The primaries are aggressive when used together. As more pure hues are added to the scheme, a more sophisticated knowledge of color may be needed to integrate them into the painting.

Fig. IX-4. Horizontal Rust by Franz Kline. Oil. 86¾″ × 49″. The strong abstract designs of Kline are ideally expressed in the extremes of black paint against a white ground. The small area of rust, for which the painting was named, is almost incidental, except that it does provide a focal point.

The Edwin and Virginia Irwin Memorial. Courtesy Cincinnati Art Museum.

Dominance of hue will enable you to establish a mood at the same time the pure hues decorate the surface.

Value contrast

Black against white is the extreme of light/dark contrast. Striking examples are the sumi-e (black ink paintings) of the oriental artist and the works of Franz Kline, a twentieth century American artist. *(Fig. IX-4)* Value contrasts help to assert color key. High key color is in the white to middle value range, excluding extreme darks; low key color is in the middle to dark range. Full value contrast runs the gamut from white to black. A middle value painting, lacking in contrast, is in danger of being dull and spiritless. Colors close in value may be harmonious, but they usually need contrast to make them visually exciting. Value contrasts have considerable visual impact: the attention of the viewer may be attracted by strong contrasts of value before the emotional expression of the color itself is felt. *(Fig. IX-5)*

Exercise #35

Divide a support into three sections lengthwise with masking tape. Across each section place squares of five gradated values of ivory black, Payne's gray or neutral tint at least three inches apart. In the top row, surround each of the five squares with a band of a light value of the gray; in the middle row paint a band of middle value gray around each square; around the bottom squares paint bands of dark value. *(Fig. IX-6)* Do you feel that the squares with the greatest value contrast attract the eye first? Do those with close values in the lighter ranges seem filled with light? Which seem to you to be the weakest combinations? From this exercise you may infer that

Fig. IX-5. Bushel of Blues *by Ray Ellis, A.W.S. Watercolor. 24½″ × 20″. From* South by Southeast *(Oxmoor Press, Inc.) The contrast of values here puts the emphasis on the white shapes. Near the area of the strongest contrast are placed the exquisite blue notes that eventually captivate the viewer.*

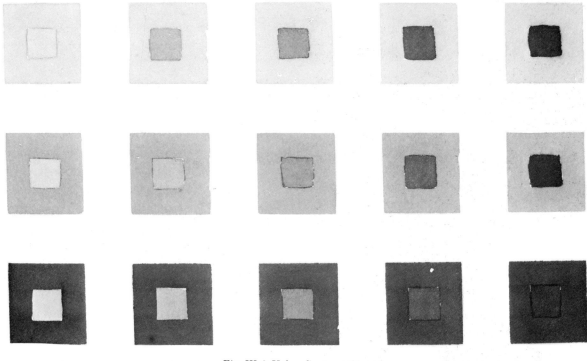

Fig. IX-6. Value Contrast Chart

High Key

Fig. IX-7A. Monochrome Sketches with Value Contrast

Low Key

it is wise to place the lightest lights and darkest darks—the greatest value contrasts—near the center of interest in the painting, where they are more likely to concentrate the attention of the viewer. The same effects of value contrast occur with chromatic hues.

Exercise #36

Don't overlook the expressive effects of color key by using only the full contrast value range. Plan a simple composition. Paint four small monochrome exercises based on this composition in high key, low key, full contrast and middle value ranges. *(Fig. IX-7)* Notice the difference of the expression in each painting, particularly how the lights and darks in the painting seem to enliven the surface and intensify the emotional impact.

Full Contrast

Fig. IX-7B. Monochrome Sketches with Value Contrast

Middle Key

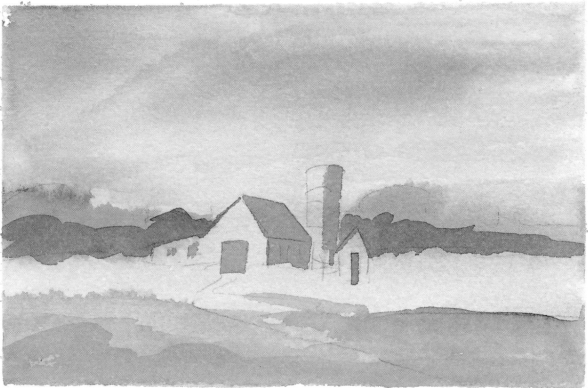

High Key

Fig. IX-8 Color Sketches with Value Contrast

Low Key

Exercise #37

You have explored value contrast in black and white; move on to color/value contrast in painting. Review color key of compatible pigments. Do several simple sketches of a single subject. *(Fig. IX-8)* Use different palettes, for example, the delicate palette for high key, the old masters' palette for low key, and a palette of your choice of primaries for full contrast. Each will make a different statement about the subject.

Intensity contrast

The emphasis in intensity contrast comes from the placement of areas of pure, saturated color within areas of neutrals. The contrast is bright/dull, the neutrals allowing brighter colors to achieve greater importance. J. M. W. Turner was a master of this approach, often using pure, delicate tints unmodified by mixing, adjacent to neutral areas. The pure color need not be raw, full-strength pigment, but may be

Full Contrast

Color Sketches with Value Contrast

Middle Key

Fig. IX-9. Dark of the Night *by Lawrence Goldsmith, A.W.S. Watercolor. 24″ × 18″. Unsaturated mixtures, rich in modified color, swirl around the small areas of pure hue. The eye travels through the painting, drawn to the clear color by contrast with its less intense surroundings.*

any pure color that has not been modified by the addition of gray, black, or the color's complement. A neutral that has been so modified should still retain a suggestion of one of the chromatic colors in the mixture.

A painting of a generally unsaturated appearance may be enhanced by the appropriate placement of areas of pure color near the center of interest, to capture the eye and hold the attention of the viewer. *(Fig. IX-9)* By the same token, you may provide relief for the viewer in a painting that is predominantly pure color by carefully arranging restful neutral passages within the painting.

Exercise #38

On a sectioned sheet place squares of pure pigment in the center of each section. Add a little neutral tint to the pure color on your palette. When the center is dry, place a band of the less intense mixture around each center square. Repeat, adding more gray to the mixture. As the surroundings become grayer, the pure color seems to become increasingly intense. The contrast of pure hue with neutral, modified colors accounts for this. *(Fig. IX-10A)*

Change of intensity has been described as the movement of a color toward neutral gray. Neutrals are more vibrant if they are mixed from the colors in the painting, rather than with gray, which can quickly deaden mixtures. Create "colored neutrals" by combining three primaries, mixing only enough to modify the brilliance of the component colors and retaining a color identity of one of the original colors in the mixture. Such mixtures can be effectively contrasted with the pure colors, which tend to dominate unsaturated hues. *(Fig. IX-10B)* Try this with the pigments on several of the compatible primary color circles.

Exercise #39

Paint a sketch with predominantly unsaturated colors. Introduce contrast of a pure color, along with value contrast. Does the contrast of unsaturated color against pure color give greater emphasis to the intense color than contrasting it with other pure hues?

Temperature contrast

The warm/cool contrast in painting has a great many applications. When the dominant temperature is warm, an expressive radiance seems to emanate from the painting; to prevent that radiance from fatiguing the eye, a cool contrast is also essential.

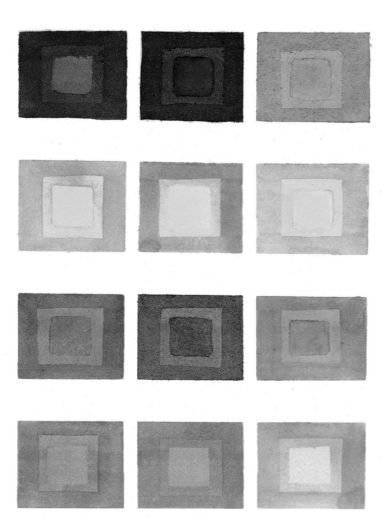

Fig. IX-10A. Intensity Contrast Chart

Fig. IX-10B. Intensity Contrast. *The mixtures that result from mingling primary hues are "neutraled" hues that can be used effectively in contrast with the pure colors in the mixtures. These modified mixtures are far more satisfactory than those in which gray is used to control the intensity of the pigment.*

Fig. IX-11. Harmony in Red and Gold *by Nita Leland.*
Watercolor. 9½" × 16". Temperature contrasts supersede
value contrasts in this painting: warm/cool is of greater
importance here than light/dark.
Collection of Mr. and Mrs. R. G. Moeller.

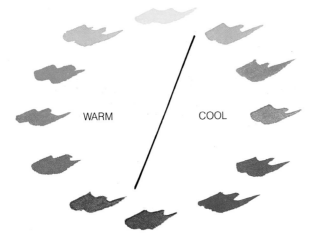

WARM COOL

Fig. IX-12. Warm and Cool on the Color Circle. *The*
distinction between warm and cool colors on the circle is
fairly clear. There is a slight overlap at red-violet and
yellow-green.

The opposite, of course, is true when a cool temperature dominates the color scheme, calling for the "zing" of warm contrast to enliven the piece. *(Fig. IX-11)* The Impressionists' preference for temperature contrast over value contrast contributed to the Academy's denigration of their work.

Warm/cool contrast provides movement into the deep space of a painting, as well as description of form. Because warm colors appear to advance and cool colors to recede, the use of warm colors in the foreground and cool hues in the distance projects the effect of atmospheric veils intervening between the object and the eye of the observer. Cézanne used warm/cool contrast in his paintings to achieve an illusion of three-dimensional form that was painterly rather than photographic.

Paintings done entirely with cool colors or warm colors are sometimes flat in appearance. Most of the

A.

B.

early Cubist paintings were a negation of color, being directed primarily at the surface aspects of objects as seen from several viewpoints. Volume and space were violated in the traditional sense in the development of the painting. Contrasts that contributed to three-dimensional illusionism were minimized. Contemporary artists sometimes reverse the traditional temperature relationships in order to jolt the viewer into a greater awareness of the expressive content of a painting beyond subject matter. The reversal may create a provocative movement within the painting.

The color circle is equally divided between warm and cool colors. A line drawn from top to bottom of the circle, beginning to the right of yellow and ending to the left of violet, places the warm hues to the left half of the circle, the cool to the right. *(Fig. IX-12)*

Fig. IX-13. Temperature Contrast. *A. The movement around a form from warm light to cool shadow leads to a realistic illusion of the subject. B. This is either a different kind of pear, or a different color movement, through the warm colors to the shadow.*

Fig. IX-14A. "Cool Dominance"—Centenarian by Nita Leland. Watercolor. 22" × 15".

Fig. IX-14B. "Warm Dominance"—Stony Creek by Nita Leland. Watercolor. 15" × 20".
Collection of Paul and Ruth Winterhalter.

Exercise #40

A simple demonstration of the movement of color from front to back of a form may be accomplished by painting a yellow pear. *(Fig. IX-13)* To show a turning of the form from light into shade, from near to far, work from the natural color of the object through the range of colors toward the cool side of the color circle: yellow to yellow/green, through the blues to a deep violet shadow. The observer's perception may sometimes have difficulty dealing with a gradation moving through the warm reds to arrive at violet. Nevertheless, the latter sequence may have greater creative possibilities. Try this as well.

Exercise #41

Paint a sketch with a warm dominance, another with a cool emphasis. *(Fig. IX-14)* Try a snow scene for the cool painting, with blue or violet shadows or a blue-green sky suggesting snow-filled clouds. Can you visualize that same snow scene in red-orange or yellow? It would be difficult to carry off an effect so contrary to the normal expression of a realistic subject. Conversely, can a sunny day be effectively conveyed with cool colors?

Fig. IX-15A. Main Street Bridge (First State) *by David L. Smith. Watercolor and ink. 13″ × 20″. The painting is predominantly a cool, monochrome composition.*

Fig. IX-15B. Main Street Bridge (Second State) *by David L. Smith. Watercolor and ink. 13″ × 20″. The monochrome painting has acquired depth and more vital expression through warm glazes over foreground areas, which provide a temperature contrast with the blues.*

Exercise #42

Paint a cool sketch of the subject. (*Fig. IX-15*) Use value contrast, keeping the colors cool. Glaze some of the foreground areas with warm washes. A livelier effect appears in the painting with temperature contrast. Atmospheric effect is enhanced. Do you see how warm and cool colors help each other?

Exercise #43

Now explore the push/pull effects of warm/cool reversal in a sketch. Plan a small arrangement of overlapping shapes, such as a landscape with distant hills. First, use a warm foreground and cool background; then reverse this traditional warm/close, cool/distant placement. The painting becomes active in a wholly different way. (*Fig. IX-16*)

Quantity contrast

From the first touch of color to the paper you are faced with the problem of balancing the colors. In *The Art of Color* Johannes Itten supports the premise of Goethe that colors have a definite proportional relationship to their complementary opposites, which must be maintained in order to achieve color balance. Thus, it is stated, yellow is more brilliant than the

Fig. IX-16. Reversing Warm/Cool Relationships

darker violet, its opposite, requiring a ratio of one part of yellow to three of violet for balance. One part of orange is said to be as bright as two parts of blue, while red and green are roughly equal. (*Fig. IX-17*) When these proportions are altered slightly, the colors become more vibrant. When they are changed a great deal, there is a danger of imbalance. To help maintain balance, give some thought to the quantities of the colors you use throughout the painting and to their relative intensity. All colors should be present in suitable proportions on both sides of an imaginary vertical axis.

Color dominance contributes greatly to color expression. A painting having equal amounts of colors may be decorative and still lack expressive energy. A dominant color theme, with the counterpoint of areas of contrasting color, helps to create interest and movement. A large area of a color strengthens the impression of richer hue. Also, larger areas of color lend emphasis to the smaller areas contrasted to them, more so if the large area is unsaturated and the small area is more intense. Trust your intuition to tell you when the color balance is reached that expresses your idea. (*Fig. IX-18*)

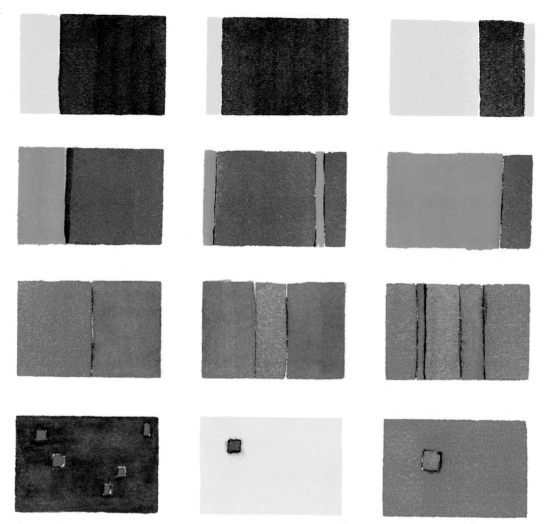

Fig. IX-17. Balance of Complementary Colors. *Colors are considered by some theorists to be balanced in the proportions given in the left-hand column. Changing the proportions creates more visual excitement.*

Fig. IX-18. Harbour Town Sky Show *by Nita Leland. Watercolor. 18″ × 24″. Large areas of the modified violets are everywhere in the painting, dominating the brighter scarlets by virtue of their greater quantities.*

Exercise #44

Paint a simple landscape, using two colors, such as Winsor blue and burnt sienna. Keep the emphasis on blue or blue-green. Use pale washes to suggest distance and darker values of the cool colors in the foreground areas. This is cool dominance. Inject small areas of burnt sienna into the painting to attract the eye and to help it travel through the painting. The larger quantity of blue-green creates the mood, but the contrast of the smaller, warm touches creates interest for the viewer and makes your painting come alive. (*Fig. IX-19*) If you increase the quantity of burnt sienna too much, that vitality may be endangered by weakening the dominance of the cool colors. At some point, if burnt sienna becomes the dominant color, the color expression of the entire painting is altered.

Complementary contrast

The hues directly opposite each other on the color circle are known as complementary colors. Complementary contrast is probably the most widely recognized of the color contrasts. Complements influence each other in two entirely different ways.

Fig. IX-19. Winter Creek *by Nita Leland. Watercolor. 22"* × 30". *You may create the cool feeling of a snow scene by using larger quantities of cool colors. However, contrast them with small areas of warm hues to keep the painting vibrant.*
Private collection.

Fig. IX-20. Bay Street Shoppers *by Bruce Lynn Peters, O.W.S. Watercolor. 21¼" × 29¼". Ohio Watercolor Society Traveling Exhibition (1982–3). The juxtaposition of pure hues creates the ambience of a busy outdoor market in the tropics. Other contrasts are found in the painting, but are of secondary importance to the opposition of the bright colors.*

Pure Hues

When opposites of pure hue are juxtaposed (adjacent), they enhance each other, creating a lively vibration—the color sings. (*Fig. IX-20*) Van Gogh used complementary vibrations a great deal; his bold brush strokes of pure complementary colors created excitement on the painted surface.

Exercise #45

Use intense or standard compatible pigments. Paint some primary/complementary squares on a sectioned sheet: red/green, blue/orange, yellow/violet. Place one square in the center and paint a band of the complement around it. Reverse the positions of the two hues. Strive for pure color, so you can clearly see the complementary contrast. (*Fig. IX-21*)

Pure Hue and a Modified Complement

Complements are also effective when one color is a pure hue and the other a complement that has been modified in intensity. (*Fig. IX-22*) When opposites are mixed, they gray each other. A complementary pair is made up of a primary hue and a secondary hue; the secondary is a mixture of the remaining two primaries. When the three primaries are all present in a mixture, neutralization results. Thus, red (primary) mixed with green (a secondary composed of yellow and blue) results in gray. (In pigment the result is often more nearly brown.) Each complementary product should have a color identity, such as "greenish-gray" or "reddish-gray." Using complementary mixtures you can enliven your painting with unsaturated hues of subtle beauty. The contrast of a saturated pigment played against this neutral background can be outstanding.

Exercise #46

Do a sketch with complementary contrast. Let one primary assume dominance. Use the standard or intense palettes so the contrast will be more apparent. Play the intense hues against colors that have been modified toward gray. (*Fig. IX-23*) Have you noticed that the warm/cool contrast is a complementary contrast?

Simultaneous and successive contrast

Faber Birren reports in his introductory notes to *The Principles of Harmony and Contrast of Colors* that Chevreul's studies were originally motivated by the criticism that the world famous Gobelins tapestry works used inferior dyes. The problem there was not with the dyes, but with how the colors were juxtaposed. Chevreul observed that all colors appeared more intense with certain colors than with others. Moreover, when black or gray was surrounded by green, the neutral took a reddish cast; adjacent to orange, a bluish cast. Throughout the range of hues, each hue seemed to call for its complement and imposed a complementary "cast" upon the neutral next to it. Chevreul's further studies confirmed that all hues had such an influence on the colors nearby, the degree of change depending partly on the size of the color areas.

Chevreul's examples of the simultaneous and successive contrast phenomena are very instructive. For more than a century artists have explored these

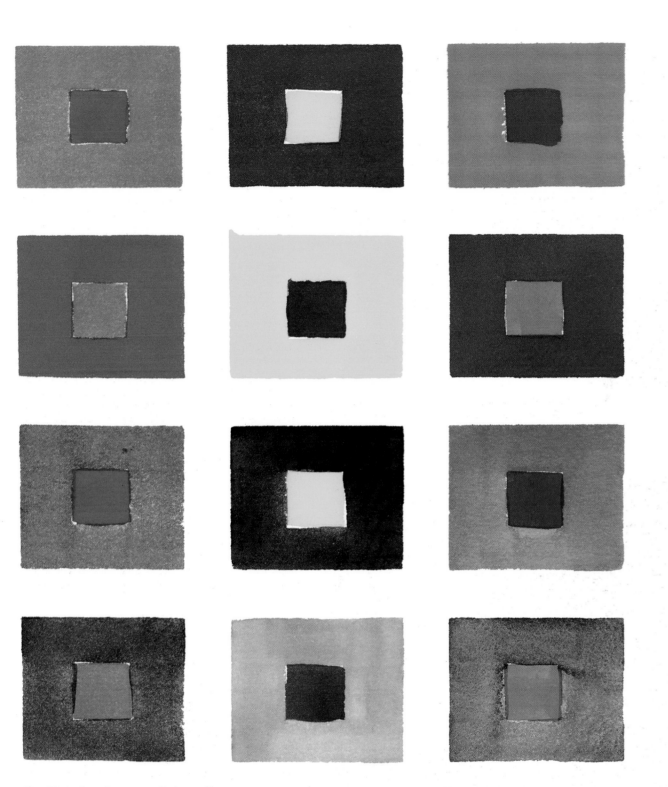

Fig. IX-21. Complementary Contrast Chart
Pure Hues and Pure Hues with Modified Complements

Fig. IX-22. Tulip Time *by Diane Coyle. Watercolor. 16½"* × 22". *The reds are surrounded by modified greens that bring the flowers forward. The complementary combination creates movement, along with the value patterns of the shadows on the leaves.*
Courtesy of WHIO-TV, Dayton, Ohio.

Fig. IX-23. Jug and Copper Pitcher *by Susan King. Oil. 20"* × 24". *The blue/orange complements are present everywhere in the painting, giving an impression of a consistent, harmonious light.*

ideas, from the tapestry-like brushwork of the Impressionists to the bold color arrangements of contemporary color-field painters.

Simultaneous Contrast
When the eye is exposed to a color, it seems to need the presence of the complementary as a balance to or a relief from the exposure. In simultaneous contrast the adjacent colors are affected by an overlap of the complements where the colors meet. Thus, a red passage in a painting will call forth a greenish tinge to the colors near it. You may sometimes need to anticipate this effect and compensate for it in your choice of pigments, placing, for example, a warmer yellow next to red to counteract an appearance of greenish-yellow that may result from simultaneous contrast.

Exercise #47
Paint a row of identical, middle value, neutral gray squares across a sectioned sheet. Surround each square with a different intense primary or secondary pigment. (*Fig. IX-24A*) Examine each section separately, covering the other sections from your view. Notice that the center area of neutral color appears slightly tinted with the complement of the pure hue surrounding it. The eye needs some practice at observing this phenomenon, so you may not see the effect immediately. For best results be sure your eyes are not fatigued from painting.

Successive Contrast
Simultaneous contrast deals with the immediate effect of a color upon its neighbor; successive contrast, also called afterimage, is a sort of delayed reaction to the exposure of the eye to a color. Goethe in his *Theory of Colors* noted, "Every decided color does a certain violence to the eye and forces the organ to opposition."

When the eye is stimulated by a bright color, it seeks rest that is provided by the complementary color—and may ·see the complement without its physical presence to provide the color sensation. Too much of a brilliant color in a painting can fatigue the eye of the viewer, but also may result in a weakening of the overall color effect through what is called "mixed contrast." The viewer's eye sees the complement as a glaze over other colors in the picture.

The artist working with intense color may find it increasingly difficult to judge color relationships in his painting if he does not consider the consequences of successive and mixed contrast and occasionally rest his eyes.

Exercise #48
Paint a bright red square on the left half of a clean sheet of paper. Stare at the square for twenty seconds. Cover the square and look at the blank side of the paper. Do you see a green square? The complementary square can also appear when you immediately close your eyes after concentrating on a bright color. (*Fig. IX-24B*)

To observe the effect of mixed contrast, cover one eye and stare at an area of bright red in Figure 24 for about twenty seconds. Then look at the area of yellow first with the exposed eye alone, then with the other eye alone. Do you see that the eye exposed

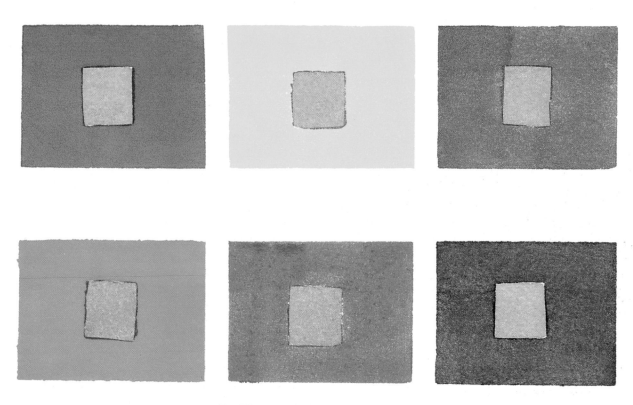

Fig. IX-24A. Simultaneous Contrast

Fig. IX-24B. Successive Contrast *(above). Stare at the red square for twenty seconds, then shift your gaze to the white area.* Mixed Contrast *(below). Stare at the red square for twenty seconds, then look at the yellow square.*

to red sees the yellow with a green cast to it? How do you suppose this might effect a painting of strong, pure hues?

Optical Mixing

Optical mixing occurs when colors are placed in small bits on the painting surface. If the bits of color are complementary, the usual vibration of adjacent complements yields to a somewhat softer look. The Neo-Impressionists, having studied the Chevreul researches into color, as well as Ogden Rood's *Modern Chromatics*, reasoned that individual brush strokes of pure color, placed side by side, would result in pure color effects. The eye is unable to distinguish small areas of color at a distance and sees only the mixture. A more luminous color is the result. We have already noted that pigment mixtures are darker than the original colors, whereas optical mixtures are an average of the brightness of the parent colors.

Exercise #49

Try a sketch using small bits of pure color on a white ground. (*Fig. IX-25*) Where you would like to see violet, use blue and red spots. To darken an area, place the colors closer together and use complementary colors. Do you see how the Neo-Impressionists created their interesting color effects? You will probably acquire a greater respect for the dedication of those early colorists when you have completed this exercise!

Using color contrasts

Several of the contrasts of color may be present in any one painting. By understanding how each contrast works and what effects may be expected from the use of contrasts, you can plan your color expression and carry it out consistently and effectively. A full value, cool painting with a blue dominance and complementary accents of orange/brown may express one idea; a high key, warm painting with neutral areas accented by bright, pure contrasts of intensity reflects still another idea. Color need not be used merely to represent the facts of the subject. Your feelings about the subject should also be interpreted through color.

Fig. IX-25. Optical Mixing

Chapter **X**
Harmonies of Light

Good color relationships contribute to harmony in the painting. The *Random House Dictionary* defines harmony as "a consistent, orderly or pleasing arrangement of parts." While this definition is not necessarily applicable to all art, it is certainly appropriate to the study of "harmonies of light," the special lighting effects described in this chapter.

To some extent, creating the illusion of light in a painting depends on the psychological suggestibility of the viewer. Through your choice of subject, compositional arrangement and technique, you set the stage for the color effect which is a simulation of light suggested by a carefully planned palette of colors. If all of these elements are successfully combined, the viewer will perceive the illusion. The colors alone may not convey a convincing lighting effect.

Be wary of formulas prescribing pigment mixtures to be used for certain subjects and color effects. Despite the pamphlets and books filled with color recipes (just a step away from paint-by-numbers), it is virtually impossible to judge the proportions of paints that go into such mixtures. Pigments are not the same from one brand to another, and the mixtures will vary accordingly. If we were truly able to mix colors according to measurements and specific ingredients, the joy of color expression would be reduced to the mechanics of following a recipe for biscuits.

Learning to paint harmonies of light takes a lot of patience and a great deal of practice. Your perseverance will be rewarded. There are many effects that depend heavily upon color for their beauty, and you will be able to achieve them.

Harmony of a single light source

A number of Renaissance painters were acknowledged masters of the effect of illumination. Rembrandt comes immediately to mind, along with Caravaggio, Titian and Vermeer. The basis for the appearance of light in their paintings is chiaroscuro, contrast of light and dark values. A source of light is frequently present in the painting, or strongly indicated. From this light a brilliant radiance emanates, reflecting from the center of interest—usually a face or a group of figures. The light bounces off planes lit directly by the source of illumination. The light values then fall sharply away into darkness, with very little gradation through the middle values.

Illumination in painting appears as a bright light encircled by dark values. After the Renaissance,

Fig. X-1. Illumination. *Monochrome sketch.*

Fig. X-2. Illumination. *Color painting from sketch.*

other artists occasionally used such effects. Henri de Toulouse-Lautrec sometimes painted cabaret scenes with a strange, ghostly illumination. Some of van Gogh's paintings show illuminated interiors. Effects of illumination are within your grasp when you take particular care with the arrangement of colors and values.

Exercise #50
Plan a simple composition suggesting a strong light source. This might be a figure by firelight or a still life with a candle. Study the objects, carefully selecting the planes that receive the light directly from the source, including the center of interest and the source of light itself, if it is within the painting. Make these the lightest values—perhaps white paper—so they attract attention. Design the light areas carefully so they move the eye around the painting and into the center of interest. Paint a monochrome sketch. (*Fig. X-1*) Keep edges sharp where they are struck directly by the light, gradually dissolving in darkness. Surround the center of interest and the lit planes with darks, strongly contrasted to the light areas.

Excessive contrast

Luminous gradation

Fig. X-3. Luminosity. Gradation is one of the keys to luminosity and luminous glow. Excessive contrast jolts the eye to a stop; gradation keeps the light expanding throughout the painting.

Repeat the study in color. (*Fig. X-2*) Your light source should be warm and light in value. Let it impart some of this warmth to the lit planes. The color accents on the objects are visible near the light, but virtually disappear into the darkness. The eye cannot see color where the light is dim.

Harmony of luminosity

Transparent watercolor has a natural tendency toward luminosity, a glow from within resulting from the reflection of white paper through the transparent layer of paint. This predisposition is undoubtedly a major reason why many painters of watercolors have chosen the medium. Other media are more dependent on color selection and arrangement to suggest luminosity.

A few artists have been unusually successful in suggesting a radiance glowing from within the paper or canvas. J. M. W. Turner achieved exceptional luminosity. Turner's later paintings were almost pure abstractions of color and light. The Luminist painters of the nineteenth century, George Inness and Frederick Church, for example, focused attention on the phenomena of sunrise, sunset, moonlight, rainbows, mist and other striking atmospheric effects. Such subjects have always been attractive to painters, and continue to be today.

Teachers often warn students to avoid spectacular subjects because they are difficult to paint. The tendency is to rely upon garish color and extreme value contrasts to achieve the effect, rather than using subtle gradations of pure tints moving toward neutral gray. In photographs, brilliant oranges and yellows sometimes become a background for flat, black foreground silhouettes that have the appearance of construction paper cut-outs. Gradation provides a softer and more pleasing color expression. (*Fig. X-3*)

Luminous Glow

Luminosity is a result of several factors. The first requirement in pigment is pure color—not necessarily bright, and not unsaturated—use the colors you labeled "tints" in the value exercise. These colors ascend the scale from saturated pigment to white through the addition of thinner. To suggest a luminous glow, the pure tint should be modified slowly, until it is surrounded in the painting by grays and middle darks. Color gradation through a range of analogous colors contributes to an appearance of expansion of the luminous color—a radiant glow.

Exercise #51

Select a palette of transparent primaries. Sketch a simple composition that includes a sky, a distant woodland—perhaps a large tree in the foreground. Begin with an area of pure light yellow. Surround the yellow paint with an aura of pure light red tint. Blend the pigments around the yellow center to a tint of red-orange. Encircle this red-orange area with a slightly darker mixture of the same pigments. Blend once more. Continue darkening the aura with blue, gradually changing it to a neutral hue of middle value as it moves away from the yellow area.

Paint the background trees with a slightly darker value of the sky color where the trees meet the sky, red-orange near the aura and a neutral blue-violet away from the light. The trees should become cool and dark at the lower edge of the tree line. There should be no intense darks in this area.

Indicate a simple foreground with sky and tree colors reflected. Paint the foreground objects light in value if they cross the aura in the sky—only a shade darker and less saturated than the sky. The farther objects are from the light in the sky, the darker they become. Your painting should be filled with a luminous glow that spreads across the paper and slowly fades away. (*Fig. X-4*)

Luminous Glazes

Another effective way to achieve luminosity in the painting is through a series of transparent glazes. (*Fig. X-5*) Care must be taken to use only transparent pigments. In order not to disturb underlying washes,

Fig. X-4. Fading Light *by Nita Leland. Watercolor. 15″ × 22″. The expanding light fills the painting with a luminous glow.*

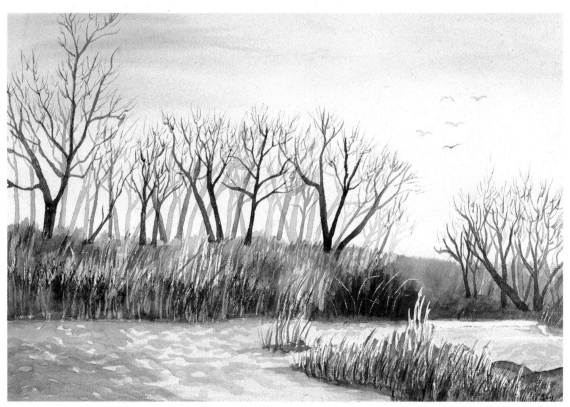

Fig. X-5. Promise of Spring *by Kay Smith. Watercolor. 13½″ × 19″. Glazes provide the delicate variations of color in the sky and on the pond.*

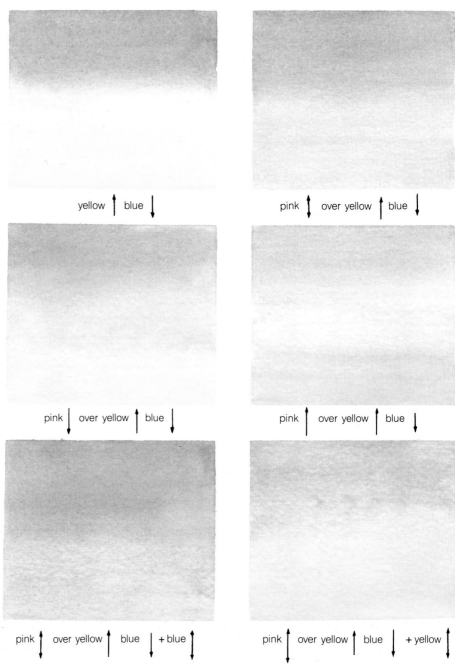

Fig. X-6. Luminous Glazes

each layer should be completely dry before the glaze is applied.

Some rather remarkable alterations may be made to a painting through luminous glazing. Atmospheric depth may be achieved with several layers of transparent glazes. A cold sky can be given a warm glow. If you specialize in glazing techniques, you may prefer to use acrylics, to ensure that the underlying washes will not be picked up or disturbed. Acrylic paint forms a layer that is insoluble when it dries.

Exercise #52

Lay a pale, yellow wash across the lower third of the support, near the horizon line. Bring a graded wash of blue down the page, barely meeting the yellow. Let this sky wash dry. Lay a transparent glaze of pale red tint over the sky and watch the blue turn to violet and the yellow turn to orange. Try other combinations of transparent glazes as well. (*Fig. X-6*)

Experiment with three or four successive glazes and you'll see how other interesting changes occur. Eventually, the glazes will neutralize one another. Nevertheless, some color will shine through the transparent layers. The more dilute and transparent your glazes, the longer you can work with successive glazes. (*Fig. X-7*) Pigments applied in glazes frequently appear to have more luminosity than the same pigments when they have been thoroughly mixed and applied in a single wash.

Harmony in shadows

Shadows may be effectively represented as a transparent veil through which the color of a surface is perceived. There may be color in shadows, complementary to the light illuminating the subject. Delacroix is said to have despaired over finding a satisfactory way to paint shadows on a gown, until he stepped into the bright sunshine and saw violet shadows on a horse-drawn cab. The Impressionists painted color in shadows, as well.

Shadows are best not represented as black and opaque. They may be simply a darker value of the color of the object on which they fall. A transparent glaze that permits the local color of the object to show through makes an effective shadow. *(Fig. X-8)* The glaze may be even more successful if it is complementary to the dominant light you are suggesting in the painting.

Artists have different methods of painting shadows. Some paint all of the neutral shadows on the paper first, feeling that they can judge the light/dark patterns in the painting more readily this way. A few artists paint no shadows until the painting is virtually completed, claiming that there is less likelihood of confusing the direction of light and scattering the shadows to all points of the compass. Many painters keep a fixed source of light in mind and develop the shadows along with the rest of the painting. *(Fig. X-9)*

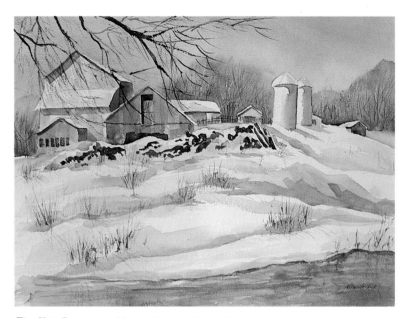

Fig. X-7. Successive Glazes. Snowdrifts by Nita Leland. Watercolor. 18″ × 24″.
Private Collection.

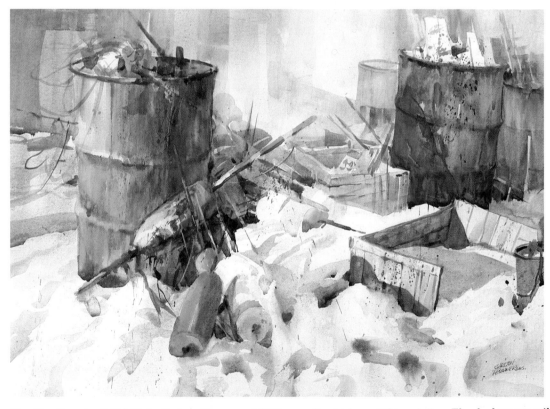

Fig. X-8. Exterior Still Life by Carlton Plummer, A.W.S. Watercolor. 20″ × 28″. National Academy Annual (1984). There is a wonderful variety of warm and cool color in the shadows of this painting. The shadows are veils over the objects and include colors reflected from other objects in the painting.

Fig. X-9. House on North Riverview *by David L. Smith. Watercolor and ink. 13″ × 20″. Shadows may be painted as neutrals over the objects on which they fall. Careful observation leads to an understanding of how shadows lie on the contours of objects.*

Exercise #53

Compare several ways of painting shadows. Paint three quick, small sketches of a building. Put black shadows on the first. In the second, modify and darken the color of the objects for the shadows—dark red on the side of a red barn, dark green on the grass, dark brown where the shadow lies on the road. Finally, in the third mix a transparent gray and use this mixture as a glaze over all shadow areas. *(Fig. X-10)* Each method described here has a different application, depending upon your style of painting. Keep in mind which result you prefer and try it in future paintings.

Exercise #54

If you have never painted a "shadows first" picture, try it. You may find that you like this method of getting into a painting quickly! Sketch your subject. Paint all shadows, using gray or a greatly modified blue or violet. Pay careful attention to the pattern of the shadow shapes on the page. Complete the painting, glazing over the shadows with the colors you have selected to represent the local colors of the objects. *(Fig. X-11)* There is a strong feeling of unity

and a cohesive pattern to a painting done by this method. Further emphasis may be added in shaded areas when the glazes are dry.

Try creating patterns of grays for a nonobjective composition. Add colored glazes to create interesting overlapping areas and a shallow illusion of depth in the painting.

Harmony in reflected light

As colors in your paintings are affected by the colors placed next to them, so are the colors of objects in nature influenced by surrounding colors. Reflected color can frequently be seen to affect the local color of an object seen in bright light. Most people are unaware of this effect. A still life on a table may reflect the color of the table on the objects in the arrangement. A red apple may impart a red glow to the pear beside it and receive a touch of yellow from the pear.

Place a piece of red paper next to your hand in a strong light. Observe how the color of your skin changes when you use green paper instead.

In a painting, reflected light helps to move the eye around the composition and to unify the colors, so that objects are not isolated from each other. As you become increasingly sensitive to color, visual phenomena will become more apparent to you and you'll realize how using reflected light in your paintings will make them more colorful and exciting.

Exercise #55

Set up a simple still life of several different colored objects. Try two distinct approaches in your sketch. Do one in which you represent each object literally with its local color. Repeat the study, looking for areas where the color reflects from one object to another. *(Fig. X-12)* The neutral shadows should have some of the reflected color as well.

Harmony of a dominant colored light

Chevreul defined harmony as the result of establishing "suitable connecting affinities between agreeable objects in order to compose a pleasing ensemble." He formulated three rules for achieving harmony using similarities in color:

- a monochrome hue
- analogous hues
- a dominant colored light

Black

Darker local color

Neutral glaze

Violet (complementary to yellow sunlight)

Fig. X-10. Shadows

Paint the shadow patterns first.

Glaze over the shadows and add accents.

Fig. X-11a. Shadows First. *The Landscape.*

Paint an abstract pattern first.

Glaze over the pattern.

Fig. X-11b. Shadows First. *Abstraction.*

Fig. X-12. Local Color vs. Reflected Color

Fig. X-13. Adobe Fort, Rancho de los Golondrinas *by Lowell Ellsworth Smith, A.W.S. Watercolor. 14″ × 21″. The dominant light on this landscape will be familiar to anyone who has traveled the southwestern United States. The subject and the colors selected all contribute to the viewer's recognition.*

Collection of Mr. and Mrs. E. B. Mitchell, Jr.

Fig. X-14. EAT *by Nita Leland. Watercolor. 15″ × 22″. This painting was toned with graded washes to contribute to the appearance of evening approaching. Untoned paper would have created a harsher light.*

Collection of Mr. and Mrs. Gerald H. Leland.

The first two will be discussed later. The third—a harmony of a dominant colored light—merits closer examination here. Chevreul wrote, "A painter is also master of his choice in a dominant color, which produces upon every object in his composition the same effect as if they were illuminated by a light of the same color, or, what amounts to the same thing, seen through a colored glass."

Dominant color may be achieved by underpainting, glazing or mixing a single color into all colors. These methods help to suggest the presence of consistent light in the painting.

A great many factors influence our perception of colors. Color constancy and local color are two that should be taken into consideration if you wish to become more aware of how colors are affected by light and thus more capable of producing interesting color in your paintings.

Color Constancy

Light is variable. According to Enid Verity in *Color Observed*, light is scattered by fine particles in the atmosphere, making daylight a combination of white light from the sun and blue from the sky. As the sun sets, its rays have a longer distance to travel through these particles, which filter the blue rays and change the light from yellow to orange to red.

The color of sunlight in the northern hemisphere is warmer on summer days than on winter days. The light of the southwest differs from the light of New England. (*Fig. X-13*) Clouds crossing the sun immediately change the quality of light on the landscape to a bluer "sky-light." A light cloud cover and massive cumulus clouds have different effects on the landscape.

However, the eye does not automatically perceive these changes. The eye unconsciously adjusts to illumination. We tend to recognize colors as they are, not taking into account changes in illumination. Unless you are aware of this tendency, you are likely to see a white shirt as white, whether it is in sunlight, under incandescent or fluorescent light, or often even when it is under colored light. Make a conscious effort to discern these differences, in order to increase your sensitivity to changes in color.

These were the kinds of observations the Impressionists made such a dedicated effort to record. Monet's well-known paintings of haystacks, painted at different times throughout the day, are clear examples of careful observation of the influence of changing light.

Local Color
Many artists do not take full advantage of the dominant light on the subject, because they become too involved with representing the local color of the object as they think it to be, rather than as it actually looks. This often results in a painting that lacks a feeling of light. The true local color of an object is the color it reflects in projected white light. Seldom is anything seen in such pure light. Under certain conditions, daylight will produce nearly true color, but even daylight changes with the time of day, the season and the weather.

The color of an object may be affected by this changing light of day, by artificial light of many different kinds, by color reflected from other objects, and by the shadows upon it. Whether the object is wet or dry also makes a difference in its surface color.

The challenge, then, is to discern the type of light, natural or artificial, on the subject and to discover ways to introduce that influence into the painting.

Achieving Dominant Light
When you create the illusion of the influence of colored light in your painting, you establish unity. There are three ways to do this: by toning the support, by glazing over the painting and by predetermining the dominant light of the time of day or of the season and using the colors in the painting that best represent that light.

Toned Support
Many artists tone their painting support in order to set the stage for the color dominance in a painting. Harmonious effects may be created this way, since every transparent color washed over the toned support is affected by the underpainting. The entire paper or canvas is covered with a tinted wash of a single color that is keyed to the dominant light called for in the painting. (*Fig. X-14*) If there are important white areas, they may be left untoned.

Fig. X-15. Toned and Untoned Paper

Exercise #56
Tone a small sheet of watercolor paper or canvas with a wash of pale yellow, such as aureolin or yellow ochre. Do two simple paintings of the same subject, using the toned sheet and an untoned sheet. (*Fig. X-15*) Can you see how the yellow has affected the toned painting? There is a feeling of harmony, but the brilliance of some of the colors is sacrificed; the painting is mellower and less crisp.

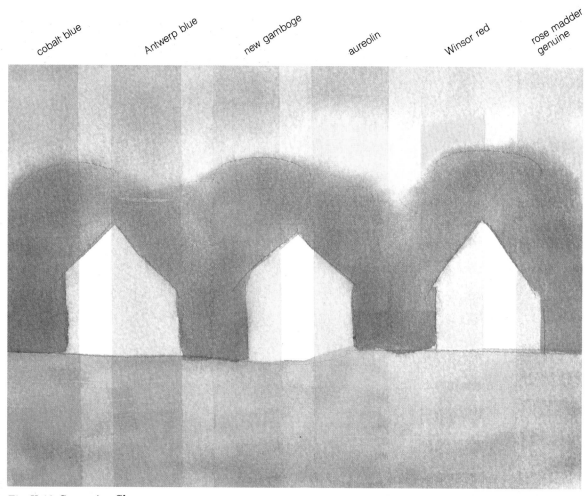

Fig. X-16. Comparing Glazes

Glazing

Dominant light can be achieved by glazing over the entire painting when it is completed, tying everything together with a single, modifying wash. This is sometimes a useful correction technique for a painting in which the color has gotten out of control. Try glazing if the painting is busy and the color seems disturbingly unrelated. The procedure is not fail-safe, however. The glaze may not be pleasing over all of the colors present in the painting. It is not imperative to tone or glaze the entire sheet. Whites may be reserved and other selected areas may be excluded from the wash, if you feel this will not impair the unity of the painting.

Exercise #57

Paint a simple landscape restricted to large color areas with no intricate detail. Run vertical glazes of pale tints over three separate areas in the painting. Use glazes of three transparent primaries. Consult your reference sheet on transparency/opacity, if necessary. Leave an inch of unglazed space on the painting between each glaze. (*Fig. X-16*) Observe how a blue sky turns green under a yellow glaze, violet beneath red and still more blue when a blue glaze is applied. Each color in the painting is affected in a different way, but the overall effect in any single glazed area is one of harmony.

The Impressionists seldom used undertoning and glazing methods, preferring to paint directly and to allow the pure colors to be unaffected by anything but the white of the canvas.

Dominant Atmospheric Light

In his journal, Delacroix described sunset and evening colors in vividly poetic terms, noting contrast effects in nature's colors. Careful observers are able to see the almost continuous variations in the light at different times of day, in different seasons and under differing atmospheric conditions. Seldom will two different people describe light in the same terms, nor will they paint it in quite the same way. This individuality contributes to personal expression.

Consider some of the general observations described below as points of departure for your own analysis of the qualities of light in nature. The light will not always be exactly as described at a certain time of day. Jot down in your journal other interesting effects you have observed at different times. Give careful thought to the palettes you have studied; think about the colors you might select to suggest the harmony of a dominant light.

The morning light seems luminous and clear in a complete value range, graded from light to dark with gentle contrasts. The night has washed the air clean of industrial pollution. Tints of scarlet, blue-greens and violets express the awakening day. (*Fig. X-17*)

The mid-day light appears to be a bright, yellow light that flattens form and calls forth strong contrasts of color and value. More saturated color can be used for this rather harsh light. (*Fig. X-18*)

The late afternoon light may have a softer, golden glow moving toward more neutral tones. The lengthening shadows contrast less with other values in the landscape. Distant objects may be veiled with mist. *(Fig. X-19)*

The twilight and early evening light seems to be a luminous light, tending toward blues and violets, with the sunset a deep, rich red-orange. Atmospheric build-up through the day sometimes causes the red rays to scatter widely and fill the sky and the landscape with color. *(Fig. X-20)*

As you can see, there are numerous ways to bring a dominant light into a painting. The important thing is always to be cognizant of dominant light upon the subject as you paint it. Other types of light may occur to you. *(Fig. X-21)* Indoor light provides still another area for scrutiny—candlelight or firelight, for instance, as compared to incandescent light. Unify your painting through the selection of colors you feel best express the light.

Exercise #58

Each of the types of light described above, or the many modifications they might have, is worthy of its own experiment. Try them in nonobjective compositions, as well as in representational paintings. Some of the color effects described can help to secure harmony and unique color expression in your nonobjective paintings. Your basic palette should be adequate to achieve the moods desired. At the same time, consider whether or not one of the matched primary palettes not included on your basic palette might be effective for a dominant light harmony.

The power of suggestion is a subtle aid to representing dominant light in a painting. Give your viewer clues wherever you can to help him identify the time of day and type of light, as well as the season. *(Fig. X-22)* Emphasizing the dominant light is a useful means of achieving harmony in your picture.

Your continued persistence in observing the changing light in the landscape will be rewarded by an ever-increasing sensitivity to the colors on your palette. You are sure to enlarge your capability of using all of the colors you have explored. Now you are ready to advance to the complexities of the expanded palettes.

Fig. X-17. Serenity *by Nita Leland. Watercolor. 20″ × 30″. The dominant light of morning.*
Private collection.

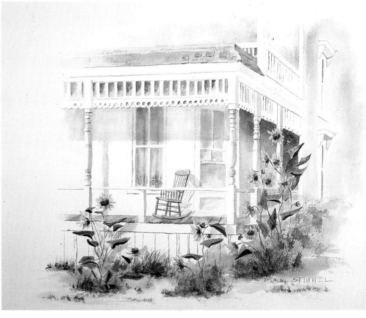

Fig. X-18. Lazy Afternoon *by Dottie Stimmel. Watercolor. 22″ × 28″. The dominant light of mid-day.*

Fig. X-19. Golden Afternoon. *by Nita Leland. Watercolor. 18″ × 24″. The dominant light of late afternoon.*
Private collection.

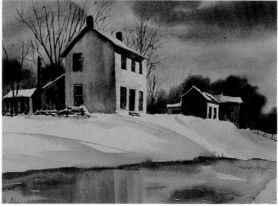

Fig. X-20. Twilight Reflections *by Nita Leland. Watercolor. 15″ × 22″. The dominant light of early evening.*
Collection of the Douglas J. Clow family.

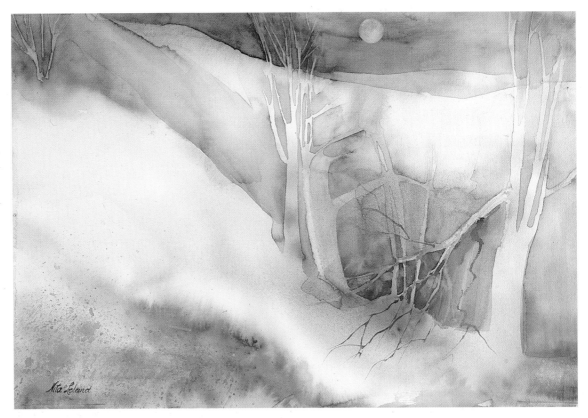

Fig. X-21. Blue Moon *by Nita Leland. Watercolor. 15" × 22". The dominant light of moonlight.*
Collection of April Evans.

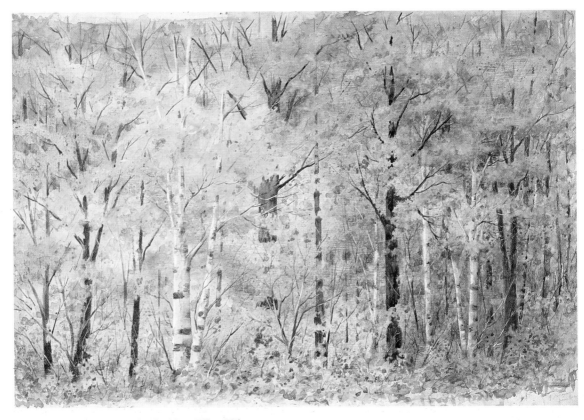

Fig. X-22. Autumn Splendor *by Mary Ellen Wilson. Watercolor. 18" × 28". The dominant light of autumn.*
Collection of Gladine Ward.

X- Less Purity

X- Less Transparency

Fig. XI-1. Selecting Pigments for Expanded Palettes. *Primary consideration should be given to the purity of the color. Unsaturated pigments are unsatisfactory. Transparency is important, but secondary.*

Chapter **XI**

The Expanded Palettes

You have seen the diversity of the colors of the compatible triads. They provide a great variety of color selections: high key, low key, intense and neutral. All are at your fingertips. The complete range of hues of the spectrum can be represented in compatible pigments, not in spectral perfection, to be sure, but harmoniously combined, giving mixtures of delicacy, strength or gentle neutrality. Numerous contrasts and effects are possible with these compatible triads. Color expression can be subtle and sensitive or dynamic and forceful, as you wish.

What might be gained, then, by increasing the number of pigments on the palette?

The goal of color exploration is to learn as much as possible about pigments, thereby achieving greater personal expression through color. So far, all of the colors on the circles have been mixed from three primary pigments. You have not considered the possibilities of a palette having a complete selection of pure, unmixed pigments to represent the spectral hues—twelve primaries, secondaries and tertiaries

of the fullest saturation possible with pigments. Clearly, such an expanded palette will expand the potential of your color expression.

The expanded palettes are carefully selected arrangements of twelve pigments, each chosen to approximate a spectral hue. You know that pigments are not pure in the spectral sense. The expanded palettes contain only pigments that are brilliantly saturated, with little or no modification. The pigments are selected first for their purity. Secondary consideration may be given to characteristics such as transparency. *(Fig. XI-1)* When the choice is between a transparent and an opaque pigment of equal brilliance, the transparent one snould be selected. This will result in purer mixtures. It is possible to develop expanded palettes that have only one or two opaque pigments.

Your personal reactions to colors continue to be of paramount importance. The pigments suggested for the two expanded palettes described here may be replaced with others of your preference, as long as the colors you select are intense and bear a close

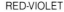

BLUE-GREEN RED-VIOLET

cerulean blue manganese blue Antwerp blue Winsor blue cobalt turquoise Thio violet permanent magenta permanent rose alizarin crimson Thalo red

Fig. XI-2. Pigment Selections are Variable. *Any of the pigments shown might be suitable for your expanded palettes.*

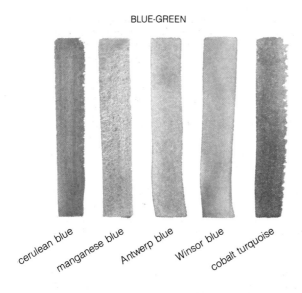

The traditional palette will include intermediate hues, added to the palette above.

The expanded palette will substitute red-violet for purple and blue-violet for blue.

Fig. XI-3. The Bradley Palette and The Ives Palette

resemblance to the spectral hue they are meant to represent on the color circle. Several of the hues in the spectrum have more than one pigment equivalent. You should decide which pigment you prefer for each hue after you have tested them. Select only one for each hue on the twelve-part color circle. You will have to make trade-offs: for example, I have chosen new gamboge as yellow-orange, because it is more transparent than cadmium yellow deep, which is somewhat closer to yellow-orange. *(Fig. XI-2)*

Expanded palettes enable you to develop distinctive color—color with impact and drama. With twelve colors in the traditional expanded palette and twelve more in the less common alternate expanded palette you will be ready for the advanced phases of color exploration. The possibilities for inventive color schemes and for creative use of the color contrasts are infinite.

Many artists already have a splendid array of colors on their palettes. It is not likely many of them give much thought to organizing their pigments to serve them better. Inexperienced artists seem especially careless with a cluttered palette. They tend to scrub into any color there, whether or not it is appropriate to the painting.

You have probably acquired unknowingly some of the pigments of an expanded palette. If you use as many as 24 to 30 tube colors, you may already have paints which will produce the intense and distinctive mixtures of the expanded palettes. On the other hand, you may have a rag-tag assortment of pigments that hasn't a hope of contributing to the rich color effects you would like to achieve in your paintings. Benefit from a full palette is gained when you sort and test pigments for intensity, transparency and tinting strength and remove all pigments that don't meet your requirements.

The traditional expanded palette

Just before the turn of the century an educator named Milton Bradley turned to the task of developing a comprehensible means of teaching color theory to children in the schools. Bradley lamented the fact that there were no standards for pigment

primaries. No specific result could be predicted when any two primaries were mixed in varying proportions, because the primaries themselves were inconsistent. A similar problem exists today in many of the pre-packaged assortments of paints on the market.

Bradley asserted the essential nature of six spectral hues in pigments—the primaries and the secondaries. He further declared that all six should be represented on the color circle by six pigments of spectral purity: the primaries, red, yellow and blue and the secondaries, orange, green and violet. In that way, Bradley concluded, secondaries would be as pure as primaries and more brilliant color effects could be achieved. Bradley's system provides a framework for the development here of an expanded-pigment system.

The first palette to be explored, the traditional expanded palette, is based on Bradley's idea of a different pigment for each color on the circle. *(Fig. XI-3)* Pure, unmixed pigments are used in the tertiary positions on the circle also, along with those in the primary and secondary positions. The twelve pigments on the circle are rich and powerful hues. The primaries on this palette retain their customary triadic relationship on the circle.

The alternate expanded palette

A second expanded palette is based on the color circle attributed to Herbert Ives. *(Fig. XI-3)* Faber Birren discusses the Ives palette at length in *Creative*

Color. The subtractive primaries of transparent dyes and pigments comprise the primary triad: magenta, yellow and cyan. The secondary triad is orange, green and violet. Many of the color relationships are intriguingly different from the traditional ones, having extraordinary visual appeal. Each hue is represented by a pure pigment, as in the system recommended by Bradley. Red-orange has been deleted from this circle. Magenta is located in the primary position, with red shifting around the circle to the spot vacated by red-orange. *(Fig. XI-4)* Ives's purple is now red-violet.

The danger exists that too many colors at hand may encourage careless habits. Mud threatens once again to ruin the paintings. Some of the pigments on the expanded palettes are opaque, but the circles are predominantly transparent, somewhat alleviating the problem of chalky mixtures.

You should be able to deal with the irregularities you encounter now, because the color exploration exercises have helped you to understand the characteristics of pigments. The inexperienced artist may need to spend more time with the compatible palettes and the basic working palette before attempting paintings with the expanded palettes.

Advantages of the expanded palettes

Your goals as a colorist determine whether or not you find it necessary to augment the colors you have already explored. The obvious advantage to the twelve-pigment palette is the availability of more

Fig. XI-4. Differences Between the Traditional and Alternate Palettes. *These differences alter the relationships on the color circles in numerous ways. The triangle shows the primary triads on each circle.*

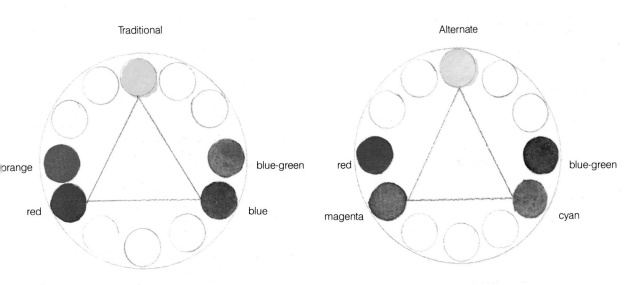

colors to choose from. You increase your selection of pigments and thus your capability of color expression. Familiar color mixtures of the past may be replaced by distinctive new mixtures. This is fresh territory to explore; you can add a different dimension to the color in your paintings.

Depending on their use, the expanded palettes can be decorative or expressive. *(Fig. XI-5)* Flat, intense color can create brilliant contrasts effective in many types of painting. All of the harmonies of contrast can be pushed to their limits. The mixed colors of the palettes may be unusual, sometimes dramatic. Some of them may not appeal to you at first. If you try to limit the opaque pigments on the palettes, your mixtures should be somewhat easier to control. You may replace any color that seems especially difficult for you to handle with another you feel more comfortable with.

The expanded palettes should be conducive to inventive painting, when you are motivated by a desire for unique color expression.

Pigments of the expanded palettes

The two expanded palettes have different primary triads: the traditional triad is red, yellow and blue; the alternate triad is magenta, yellow and cyan. As a consequence, the primary pigments called for in any color scheme or exercise that follows will differ,

depending on which of the expanded palettes you are using.

To avoid confusion, explore the first of the expanded palettes thoroughly before turning to the other. Test the new pigments listed for the expanded color circles, so you can adjust to their idiosyncrasies in your paintings. You need to know which pigments are opaque and which are transparent, as well as the relative tinting strength of the pigments. Many of the pigments in the expanded palettes will stain the support. In watercolor these new palettes are unforgiving of mistakes.

Continue to keep accurate notes in your journal to avoid confusing the two palettes. If you feel that one of your favorite pigments might be more effective on a color circle than the color listed here, use it. The pigments described are a point of departure for the development of your own expanded palettes. Alternative pigments are listed for several of the hues, allowing for personal preferences and availability of the pigments.

There is more freedom for you as an artist in this part of color exploration, both in the selection of pigments and in the execution of the exercises. You should be able to explore the pigments without step-by-step instruction, referring to the work you completed in previous exercises and adding the new pigments to your charts.

Turn on your imagination as you develop sketches using the new palettes. Let the colors suggest a subject or let the sketch have color as the subject. Subordinate the realistic subject to color dominance, disregarding local color. Be inventive. Let your color personality assert itself.

Fig. XI-5. Blue Ridge by Nita Leland. Acrylic collage. 15″ × 19″. Choosing colors for an analogous color scheme from the alternate palette liberates the artist from some of the local color associations of traditional pigments. Magenta is not found among the rocks, but it certainly makes a more lively painting.
Collection of Konrad Kuczak.

Traditional expanded palette

yellow—Winsor yellow

yellow-green—sap green
Thalo yellow green

green—Hooker's green light
Winsor green

blue-green—cobalt turquoise
Antwerp blue
manganese blue
cerulean blue
Winsor blue

blue—cobalt blue

blue-violet—French ultramarine

violet—Winsor violet
Thalo purple

red-violet—permanent magenta
Thio violet
Thalo red
alizarin crimson

red—Winsor red
Grumbacher red

red-orange—cadmium scarlet

orange—cadmium orange (Grumbacher)

yellow-orange—cadmium yellow deep
new gamboge

Alternate expanded palette

yellow—Winsor yellow

yellow-green—sap green
Thalo yellow-green

green—Hooker's green light
Winsor green

blue-green—Antwerp blue
Winsor blue
cerulean blue
cobalt turquoise

cyan—manganese blue
cerulean blue

blue-violet—French ultramarine

purple—Winsor violet
Thalo purple

red-violet—permanent magenta
Thio violet
alizarin crimson

magenta—permanent rose
rose madder genuine

red—Winsor red
Grumbacher red

orange—cadmium orange (Grumbacher)

yellow-orange—new gamboge
cadmium yellow deep

Using the expanded palettes

Exploration of pigments
Become familiar with the characteristics of the pigments that comprise the expanded palettes. You will need a color circle representing each palette for your reference in succeeding exercises. In order to select the pigments most suitable for each hue, you should explore them and reduce the number to twelve for each circle.

Exercise #59
Try out the pigments on the expanded palette list that are new to you, using the color exploration charts showing transparency, intensity, staining, tinting strength, etc. Familiarize yourself with their peculiarities. Review the properties of any pigments on the list that you tested previously, taking note of obvious differences in transparency, intensity or tinting strength between these and the new pigments.

Among the pigments on both of the expanded palettes there are greater variations in tinting strength and transparency than are found among the compatible pigments. The expanded palette pig-

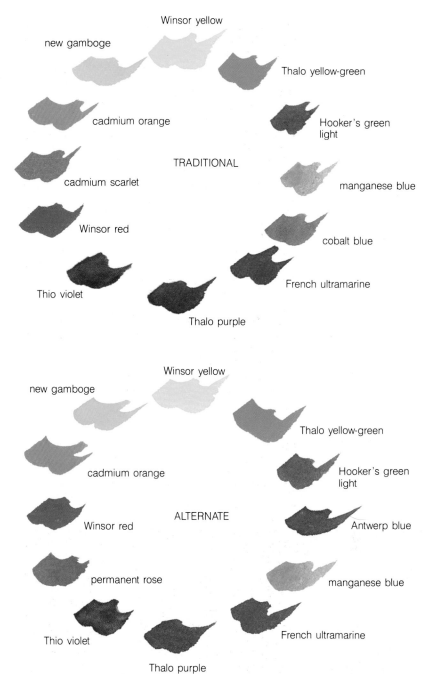

Fig. XI-6. The Expanded Palettes

ments share a small degree of compatibility; as long as you are aware of the differences that exist between them, you should be successful in using them.

Make a color circle for each palette, using highly saturated pigments with just enough thinner to make the paint flow. *(Fig. XI-6)* Select pigments having similar characteristics wherever possible, but be sure that each is a reasonable approximation of a spectral hue on the color circle.

Fig. XI-7. Alternate Primary Mixtures. *The alternate primaries mingle very beautifully. These distinctive mixtures are enriched by the settling property of manganese blue.*

Mixtures

Because a mixture of pigments is always less intense than the original colors, when mixing occurs in the expanded palettes the colors become less saturated; their intensity is considerably diminished. These mixtures are not to be scorned, however. Many are rich, vibrant, and unusual.

Exercise #60

With the alternate palètte, mix the pigments you have selected to represent magenta and yellow; magenta and cyan; cyan and yellow. *(Fig. XI-7)* What are the results? If, instead of pigments, these were the pure, transparent dyes and inks of photography or printing, the mixtures would be red, blue and green. With the ground pigments you are using, however, the results of mixtures are quite different. You are using tube pigments to represent the secondary and tertiary hues on the circle, because they are more saturated than the mixtures of these hues. The secondary colors of the alternate palette are the same as those on the traditional palette, and the pigments representing them are sometimes the same. The triads of tertiaries are different. These new relationships will provide some unique combinations.

Exercise #61

Find out how the colors on each of the expanded palettes interact with each other. Mingle four analogous colors from either palette and inject a color from the far side of the same circle. *(Fig. XI-8)* Do adjacent colors on the expanded palettes seem to remain relatively bright when they are mixed? What happens with colors located at a distance across the wheel? Do these modified mixtures have qualities that will be useful as contrasts to the brilliant, saturated pigments on the circle?

Note any color mixtures that are distinctive and especially attractive to you when you discover them. They may suggest a color composition one day.

Color Contrasts

All of the color contrasts are effective with the expanded palettes. This is undoubtedly the strongest

Fig. XI-8. Expanded Palette Mixtures. Mingle colors from the expanded palettes, starting with analogous colors. Add a touch of color from the opposite side of the circle. Many of the mixtures are distinctively beautiful—do some of them suggest paintings to you?

feature of the palettes. Contrasts of hue are extraordinary when the pigments are juxtaposed. The warm/cool contrast is equally noticeable. Complementary contrast is more powerful here than with the basic palette or with any of the compatible circle pigments, because the secondaries and tertiaries on those circles are mixtures. The simultaneous and successive contrast effects are pronounced, as well.

Exercise #62

Explore the pigments of the expanded palettes further, with the objective of acquiring the familiarity you achieved with the compatible pigments and your basic working palette. See how the color contrasts can be used with the expanded palettes in your paintings. The brilliant pigments bring explosive color contrasts within the realm of possibility. *(Fig. XI-9)*

Exercise #63

Experiment with the harmonies of light using the expanded palettes. Some of the pigments may be difficult to use for subtle effects. You will need considerable control over your medium as you tackle these more difficult challenges with colors. *(Fig. XI-10)* The brilliance of saturated pigments stretches your expressive powers and challenges your creativity. Effects requiring contrasts of hue, value and intensity are particularly interesting. Explore intense pigments against unsaturated complements. *(Fig. XI-11)*

Fig. XI-9. Maine Shorescape by Edward Betts, N.A., A.W.S. Acrylic. 22″ × 30″. Betts, an outstanding colorist, seems fearless in his contrast of pure hues. Each pigment is pure—no dull, adulterated mixtures—and is placed with conviction in the composition.
Courtesy of Midtown Galleries, New York.

Color Dominance

Having twelve pigments on each of the expanded palettes, you should be more careful than ever to plan color dominance and to control the number of pigments in the painting. The size of color areas and the frequency of their appearance also require special attention. Plan ahead. What do you wish the painting to express?

Selecting the colors for your paintings

Don't be tempted to use too many of the exquisite colors of the expanded palettes in a single painting. Begin with a limited palette. Prior to this exploration of expanded palettes, you used the primary triads of compatible pigments as the basis for color organization of your sketches. For the concluding exercise of this chapter use the primary triads of the expanded palettes. Remember that the alternate expanded palette has magenta, yellow and cyan as primaries.

Exercise #64

Paint sketches, either realistic or abstract representations of the four seasons or nonobjective compositions having colors suggestive of the seasons. Use the traditional primary triad first, then the alternate primary triad. Compare these sketches with those completed earlier in your color exploration, the first set using your original set of pigments, the second, your basic working palette. Has your ability to

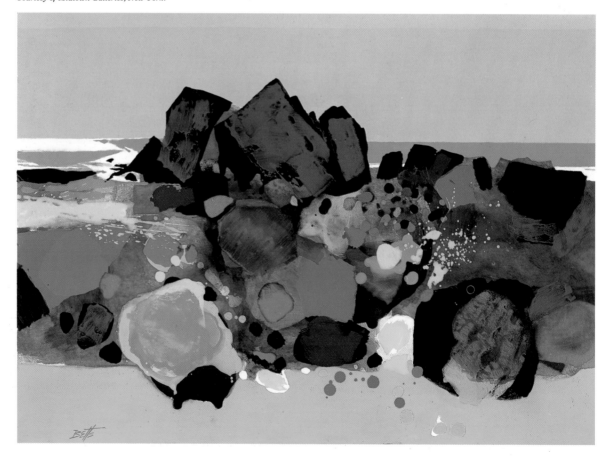

Fig. XI-10. Lady Jane by Paul Melia. Watermedia. 29″ × 40″. The colors of a full palette are evident everywhere in this painting. In the tradition of the Renaissance masters, Melia has placed the illuminated face against the intense darks, but, unlike many of those masters, has used richly colored darks.

express your color personality grown since you began color exploration? You should see less evident concern with the local colors of objects and more expression of the ambience of the scene through color.

Now that you have explored the compatible pigments and the expanded palettes, you have a wealth of colors to choose from. In actuality these pigments are a very limited number of the colors available from the manufacturers. Within this number you have probably found several that especially touch your sensibilities. Make a special effort to master these colors and to find places for them in your paintings. These are among the colors that are essential to your personal color expression.

You can never know all there is to know about color. However, through study and experience you can hope to develop awareness and self-confidence that will increase your color sensitivity and your ability to use color both knowledgeably and intuitively.

Fig. XI-11. Water Lilies by Betty Putnam Murray. Acrylics. 18″ × 26″. Turneresque tints dissolve into delicate neutrals in this luminous and expressive painting.
Collection of Mr. and Mrs. W. D. Coombs.

Fig. XII-1. Cabbage Fields *by Jeanne Dobie, A.W.S.*
Watercolor. 22″ × 30″. Invented color stimulates the
imagination of the viewer and makes him a participant in
the painting, rather than a bystander. Although this is a
realistic subject, the color is inventive and starts a chain
of thoughts in the viewer about what might be communi-
cated in the painting.

Chapter **XII**

Color Organization

Good visual order is the artist's objective in selecting a color scheme. Henri Matisse said that color reaches its expressive potential only when it is organized and when it reveals the emotional involvement of the artist. Organization and emotion—intellect and intuition—are two halves making an even greater whole.

No absolutes govern the use of color. Formulas are restrictive; rigid rules are inhibiting. Yet random selection may lead to confusion and the destruction of visual order. You should strike a balance, comprised of what you know and what you feel, to produce a successful color statement.

Expressive color schemes may be developed in many ways, but you should know first what you expect the color scheme to do in your painting and then how to select an appropriate scheme. It makes little difference what the color of the subject really is. Invented color gives the painting a life of its own, independent of the subject. *(Fig. XII-1)* When you paint, you are making visible on paper something of the artistic spirit that resides within you. You reveal your individuality through your painting. You tell us something about yourself. The color scheme you select should reflect this, regardless of the subject.

As you explored colors, you selected pigments that struck a responsive chord in you. Your reaction to these pigments was the first sign of your emotional response to color. These are *your* colors, and not the colors of a book or a teacher. The challenge now is to use these colors to gain the full benefit of their expressive meaning in communicating your ideas. The color scheme will help you to do this.

Developing a color concept

Logical organization and expressive communication should both be present in your painting. Organization without expression lacks its most vital collaborator, regardless of technical excellence. Expression without organization may lead to disorder, despite the sincerity of feeling apparent in the work.

Organization

Achieve organization by utilizing the *orderly relationships* of color schemes. Thus far, you have become familiar with one way to do this: using the primary triad. Many other logical arrangements reside on the color circle.

The rationale of the color schemes is simple: all are based upon the relative positions of colors on the color circle. Each discrete relationship has a specific effect on the hues combined. The predictability of the effect depends upon the purity of the hues. You will need to experiment a great deal to achieve consistent results, but as you become more and more familiar with the various arrangements of color schemes, locating the right color scheme for a particular painting becomes a real joy.

Once you understand how color schemes evolve, finding those that work best for *you* may take more effort. The array of colors on the traditional and alternate expanded palettes gives you many pigments for the exploration of color schemes. Keep in mind that there is no such thing as a perfect color scheme, nor are there perfect pigments for any one scheme.

Expression

Expressive personal communication is essential in a good color scheme. The *pigments* you choose should be your own selection, not someone else's. The *color scheme* you decide upon should be your personal choice as well.

Each color scheme has a different expressive potential. Some are rich and vibrant. Others are more subdued. One may seem perfect for an elusive, introspective mood you want to express. Another may be more appropriate for an extroverted feeling. Don't limit yourself to the same color scheme every time you paint. Let the mood of the subject dictate the colors of the painting; or let the colors you choose determine what you will paint. Both are valid approaches to getting started on a painting.

"Colors are not used because they are true to nature, but because they are necessary to the picture."
—Wassily Kandinsky

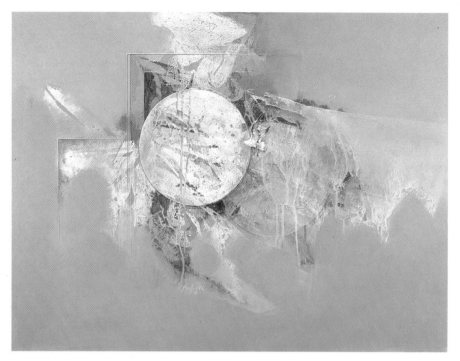

Fig. XII-2. Winter Thought *by Doug Pasek, A.W.S., O.W.S. Acrylics. 28″ × 38″. What is the message? This painting exists as a "spiritual reality," suggesting meaning beneath the surface of objects. Personal involvement is required of the viewer in order to discover the message conveyed by the subtle color and intriguing shapes.*

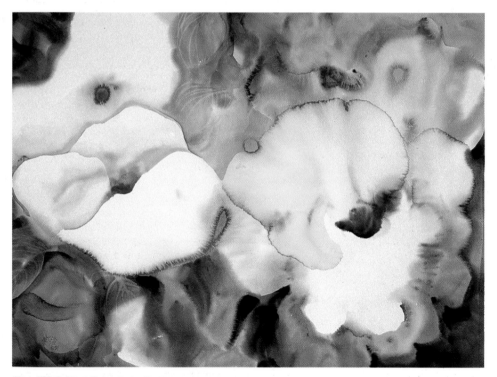

Fig. XII-3. Just Friends *by Barbara Nechis, A.W.S. Watercolor. 22″ × 30″. When the color scheme is consistent, everything works together in the painting. This watercolor has no discordant notes, partly because there has been no change in the artist's attitude or techniques as the painting progressed.*

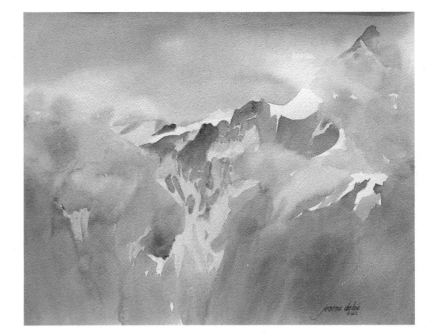

Fig. XII-4. Cloud Cauldron *by Jeanne Dobie, A.W.S. Watercolor. 12″ × 16″. Colorful neutrals dominate here, with wet-into-wet soft edges swirling around the sharper edges and value contrasts of the mountain peak. The painting is consistent throughout, and the viewer feels compelled to decipher its message.*

Characteristics of a good color scheme

A good color scheme reflects the planning required of all good design. Three factors should be included for a color scheme to be effective: communication, consistency and dominance.

Communication

First and foremost, the color plan should communicate an idea, your concept of the subject. Without the imprint of your mind and personality the color scheme becomes simply a reproduction of nature and gives no clues to your deeper understanding of the subject, whether realistic or abstract. What is your message? *(Fig. XII-2)* What technique or color scheme will say it best? Ask yourself these questions every time you paint.

Hans Hofmann wrote, "*. . . artistic creation is the metamorphosis of the external physical aspects of a thing into a self-sustaining spiritual reality.*" That spiritual reality is the message communicated in your painting.

A good color scheme must be relevant to the artist's concept of the subject, but not in a limited, literal sense. The local colors of objects need not be copied; they may be invented to contribute a color statement that gives the painting uniqueness. Many painters become so involved with reporting the facts of the subject that they lose sight of the painting as an expressive entity. For fuller expression, relate the color to what is happening in the *painting,* not in the subject. In contemporary art, the integrity of the subject is often subordinated to other considerations in much the same way.

Consistency

Consistency is apparent in a good color scheme. When you keep the color idea constant throughout the painting, you have more freedom to be creative with your subject. *(Fig. XII-3)*. Avoid discordant notes of color inappropriate to your color plan. Once you have decided upon your color scheme and selected your pigments, adhere firmly to your plan. If you find that the color scheme isn't achieving the desired result, instead of patching in other colors, choose a different scheme and begin again.

A number of twentieth century artists, from the Fauves to the Abstract Expressionists, used color without such restrictions. Kandinsky felt that whatever sprang from the inner spirit must be permitted. Without negating the contributions of these artists to the richness of modern art, you should follow a more conservative path and gain control of color before taking such liberties.

Dominance

A good color scheme features a dominant color, made expressive by contrast. Throughout the previous chapters the importance of the principle of color dominance has been emphasized. One color may dominate because of its value or intensity or because of the quantity of the color in the painting. *(Fig. XII-4)*

Use color intelligently, but first decide which colors are most revealing of your sentiments; then organize them in color schemes to accomplish your purpose. When you recorded your intuitive responses to pigments and mixtures of pigments, you created a valuable reference to guide you in developing color schemes. Now you will utilize the pigments that appealed to you in the earlier exploration, as you organize color and develop your composition.

Organizing color with color schemes

Some of the color relationships that result in harmony are based on similarities and others are founded on differences. The contrasts of importance in color design are those of hue, value, intensity, temperature, quantity, complements, and simultaneous and successive effects. The similarities include the use of a single hue, of analogous hues and of a dominant colored light. The harmony of color schemes is also achieved through a like/unlike division.

Relationships that are analogous, triadic, tetradic and complementary are all dependent upon the relative location of the hues on the wheel. *(Fig. XII-5)* Newton probably never suspected the potential of his little device when he shaped the light spectrum band into a circle and brought purple into the spectral family between red and violet.

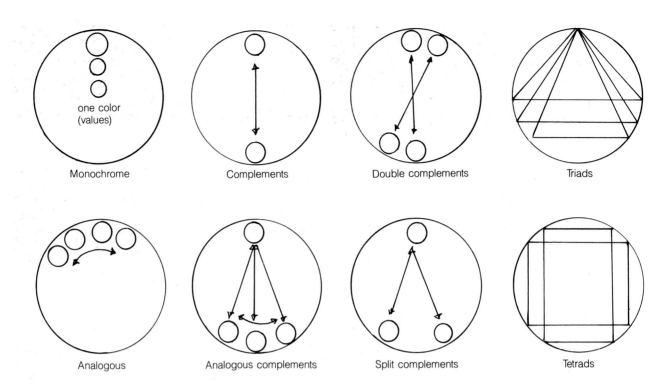

Fig. XII-5. Color Schemes

Fig. XII-6. Cathedral of Ruins *by Nita Leland. Water-color. 15" × 22". Monochromatic Color Scheme.*
Private collection.

Relationships of similarities of hues

Monochromatic color schemes

The monochromatic color scheme is the least complex color arrangement. *(Fig. XII-6)* One color alone is used. Disharmony is virtually impossible, because there is a complete absence of color conflict. You have seen in the study of contrasts that use of value contrast can result in a painting that is visually strong. Using close values will support harmony in the monochromatic color scheme.

Strong contrast gives greater emotional impact, but when values are close at either the high or low end of the scale, the expression is harmonious and subtle. An interesting effect of colored light may be suggested through the use of one color. The middle value range tends to lack impact in a monochromatic painting. When other colors are subtly suggested in the monochromatic scheme, the painting seems more lively, but, of course, it is no longer monochromatic!

Exercise #65

Mingle different values of one color. *(Fig. XII-7)* Paint several small, monochromatic sketches with a different color in each. Use close values in some, placing the stronger value contrasts near the center of interest. Create harmony without extremes of value contrast. In other sketches, use greater contrasts. Experiment with the chiaroscuro of the Renaissance masters to achieve effects of colored illumination.

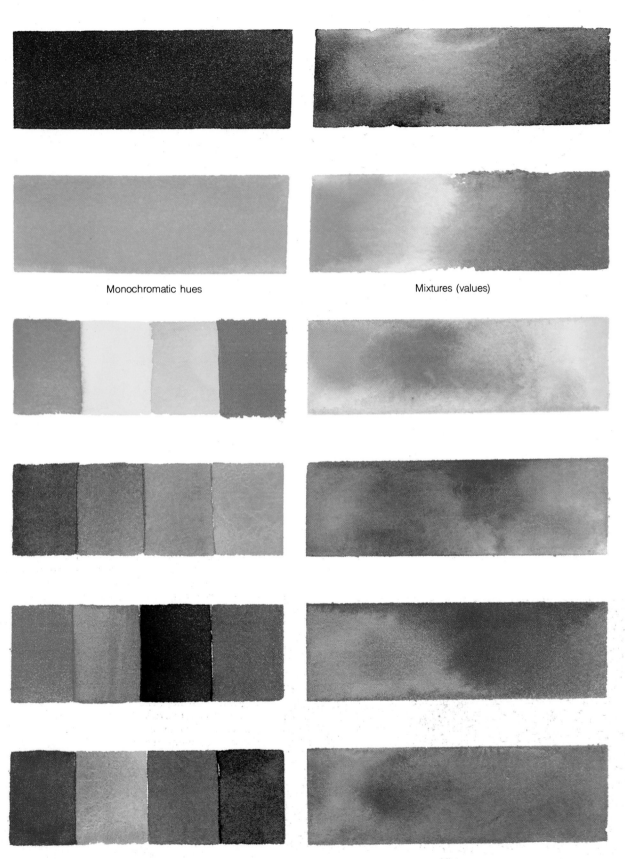

Monochromatic hues

Mixtures (values)

Analagous hues

Mixtures

Fig. XII-7. Monochromatic and Analogous Color Schemes

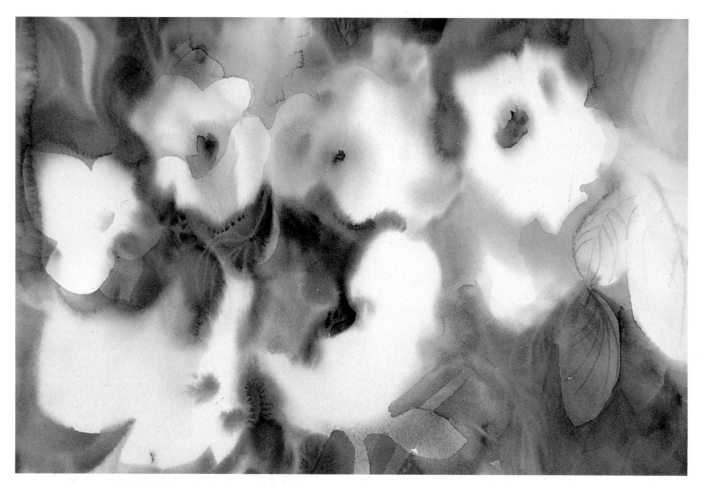

Fig. XII-8. Metamorphosis *by Barbara Nechis, A.W.S. Watercolor. 15" × 22". This analogous color scheme uses the hues from red-violet through blue.*

Analogous color schemes

The analogous color scheme consists of any three or four adjacent colors on the color circle. The colors enhance each other and contribute to brilliant color effects through gradation from one color to the next and through value contrast. *(Fig. XII-8)* Color mixtures of analogous colors are brighter than mixtures of colors somewhat removed from each other on the color circle.

The analogous scheme lacks sharp color contrast. This does not limit its capacity for full color expression. Value contrasts may be used throughout the full range to inject vitality into the color scheme. The close relationship of the colors readily suggests a dominant mood or idea. Their proximity on the color circle assures that analogous colors will contribute to a harmonious scheme, and where colors meet, they will blend beautifully.

Exercise #66

Select three or four colors on either expanded palette from the warm side of the color circle (yellow through red-violet). Mingle them on the support. *(Fig. XII-7)* Use them in a painting to suggest a bright mood characteristic of the warm colors. Repeat the exercise using several cool colors from the opposite side of the wheel (yellow-green through violet) to project a cool, serene feeling.

You may feel that the sketches need complementary contrast; perhaps they do. However, leave them for the time being. In your journal note your reactions to the analogous color schemes and any subjects you think might be appropriate for this treatment.

Fig. XII-9. Pure Hue Plus a Neutral. *The graphic image of pure, flat color against a neutral, such as black, is useful where instant recognition or attention is required of the viewer.*

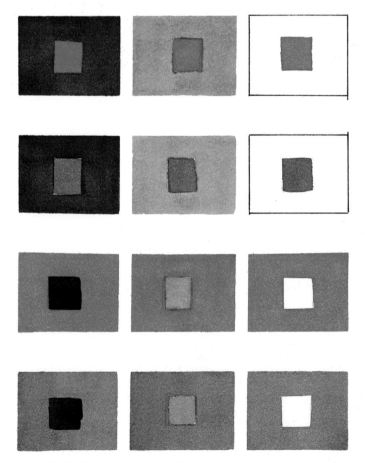

Fig. XII-10. Color Scheme Chart: *One color plus a neutral.*

Relationships of Differences of Hues

Dyads
The dyads are any two colors in a relationship of opposition. We will consider two: opposition of intensity (one color and a neutral) and opposition of complements (one color and its opposite on the color circle).

One color plus a neutral
Contrasting one hue with a neutral gray, black or white makes a simple, graphic statement of greater emphasis than a monochromatic scheme. *(Fig. XII-9)* Disharmony may occur if the neutral has a strong bias toward color that conflicts with the chromatic hue. The most familiar use of this combination is in posters and signs, where graded values are seldom used and the hue is sharply differentiated from the neutral. When value contrasts or gradation are introduced, the impact of the color contrast is somewhat diminished. Colors appear brighter when contrasted with black or gray and less so when contrasted with white.

Exercise #67
Explore the following contrasts in simple studies: the pure color against black; the pure color against gray; the pure color against white paper. Then, using black to modify the colors slightly, study these effects: the modified color against black; the modified color against gray; the modified color against white. *(Fig. XII-10)* Do colors seem brighter against neutrals, even when slightly modified?

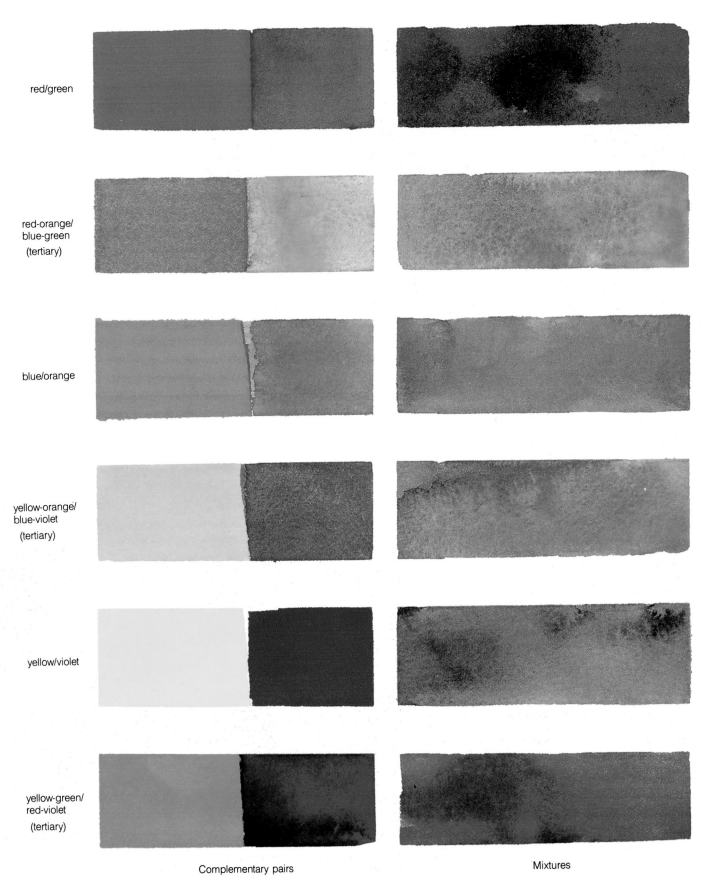

red/green

red-orange/
blue-green
(tertiary)

blue/orange

yellow-orange/
blue-violet
(tertiary)

yellow/violet

yellow-green/
red-violet
(tertiary)

Complementary pairs

Mixtures

Fig. XII-12. Color Schemes. *Complementary pairs.*

Fig. XII-11. British Series: Spectre by William D. Gorman, A.N.A., A.W.S. Casein. 22" × 30". Emily Lowe Memorial Award, American Watercolor Society Annual (1984). This provocative painting illustrates the powerful contrast of opposing colors. There is a warm dominance, with the whisper of graceful, cool passages for relief.

Complements

The dependable and wonderfully expressive complementary color scheme uses colors opposite each other on the color circle. As you know, complements enhance each other when they are adjacent, and neutralize each other when they are mixed. Complementary schemes possess the powerful contrast of opposing colors. *(Fig. XII-11)*

Exercise #68

Pair the complements of the expanded palettes and do sketches with the pigments. *(Fig. XII-12)* For extra punch juxtapose the pure hues in the area of greatest interest. Note the mixtures that interest you. Take a closer look now at the mixtures and contrasts of tertiary complements. Try one or two of these pairs in a painting. It's not likely that you would use these colors together without first being aware of their relationship on the color circle—do you find that combining them increases the range of possibilities for distinctive color? *(Fig. XII-13)*

Fig. XII-13. April's Green Endures by Nita Leland. Watercolor. 18½" × 29". This is a tertiary complementary color scheme based on red-violet and yellow-green. The colors are very evocative of a woods interior.

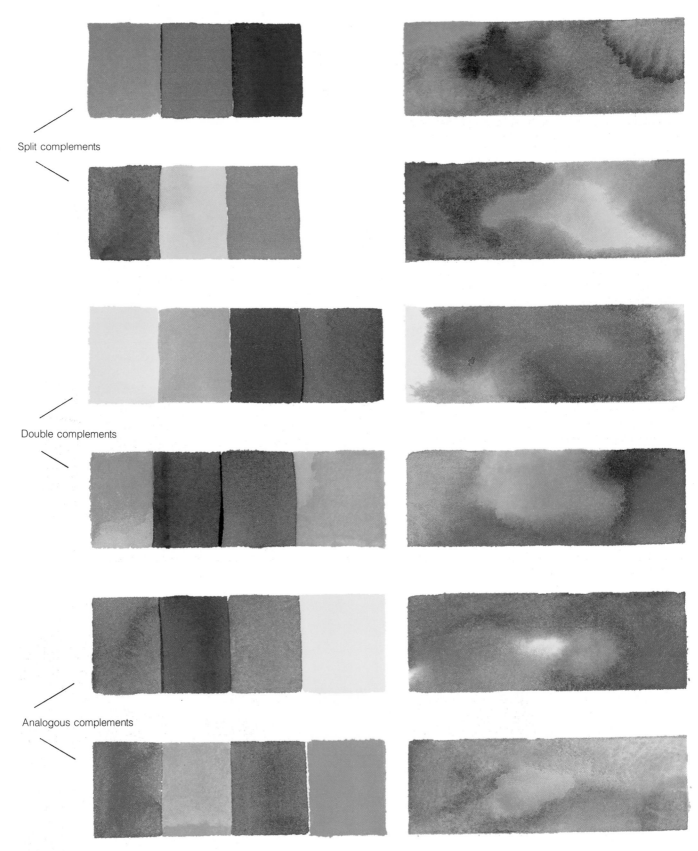

Split complements

Double complements

Analogous complements

Mixtures

Fig. XII-14. Color Schemes: *Complements.*

Double complements, split and analogous complements

The *double complement* is composed of any two adjacent colors and the two adjacent hues directly opposite them. The *split complement* is essentially a triadic relationship consisting of a color and the two hues on either side of its complement. If the complement itself is included in the split complementary color scheme, the combination becomes an *analogous complement,* providing complementary contrast to the analogous color schemes you explored earlier. *(Fig. XII-15)* All of these relationships increase the number of combinations available to you without violating the orderly relationships so important to color harmony.

Exercise #69

Explore the mixtures of double complements, split complements and analogous complements. *(Fig. XII-14)* Compare these mixtures to the many others you have discovered. Select several and do small sketches. Begin with an expressive idea that you feel is appropriate to the colors. Sometimes it is helpful to spend a little time playing with the colors you have selected to see just what kinds of mixtures you can expect from the pigments. Mingle the colors and then do a sketch. *(Fig. XII-16)*

Triads

The triads are any three colors having a triangular relationship on the color circle. The triangle does not have to be equilateral; at least two sides must have the same dimension. The split complement scheme just discussed is a triad.

An astonishing number of color schemes may be created with triads. The pigments on the two expanded palettes yield triads with distinctive mixtures. Powerful emotional statements are characteristic of the triads. Expanding your triadic choices beyond the primaries, which are the most commonly used triads, will permit you a wider range of expression, allowing interpretation of anything conceivable in nature or your imagination.

magenta yellow/green blue-green

Fig. XII-16A. Mingling Split Complements. *Alternate palette.*

Fig. XII-15. Nasturtiums *by Jean Luckman. Watercolor.* 13″ × 18½″.

Fig. XII-16B. Sketch from Split Complements.

159

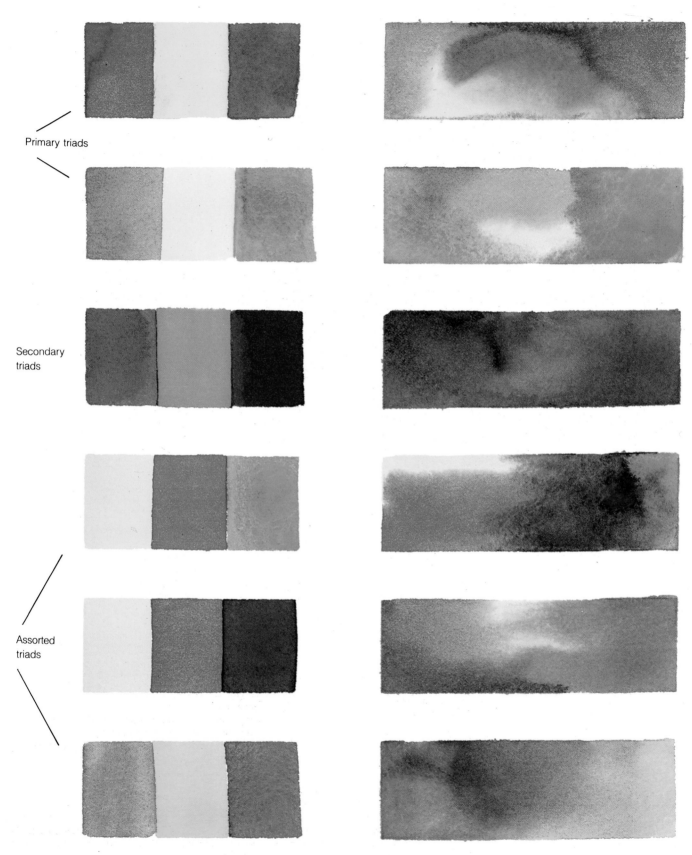

Primary triads

Secondary triads

Assorted triads

Mixtures

Fig. XII-17A. Color Schemes: *Triads*.

Fig. XII-17B. Sketch—Triads. Any triad in the proper relationships will yield a harmonious scheme.

Primary Triads

Most artists are comfortable with the primary triad.

The primary triad is bold and energetic. Its mixtures are purer than those of any other triad.

Magenta, yellow and cyan comprise the triad of the alternate expanded palette. These hues have attained an extraordinary popularity in contemporary art and fashion, but you may not have recognized that a primary triadic relationship exists between the colors. They are usually contrasted as pure hues and have a curiously exotic appearance. The characteristics attributed to primary triads—stability, boldness and intensity—apply to both the alternate and the traditional triads.

Exercise #70

Review the primary triads of both palettes *(Fig. XII-17)* Do small sketches with the triads, freely mingling the pigments. Take care not to mix too much. Do the triad mixtures suggest subjects or expressive moods to you? Take advantage of every opportunity to be more imaginative with color as you explore the relationships with pigments.

Secondary triads

The secondary triads are green, orange and violet on both palettes. Mixtures of secondaries may be less pure than mixtures of primaries, but are nevertheless surprisingly rich, possessing considerable unity. Since you are using individual pigments for each secondary hue, the mixtures will be quite different from those resulting when two primaries have been combined to make the secondary.

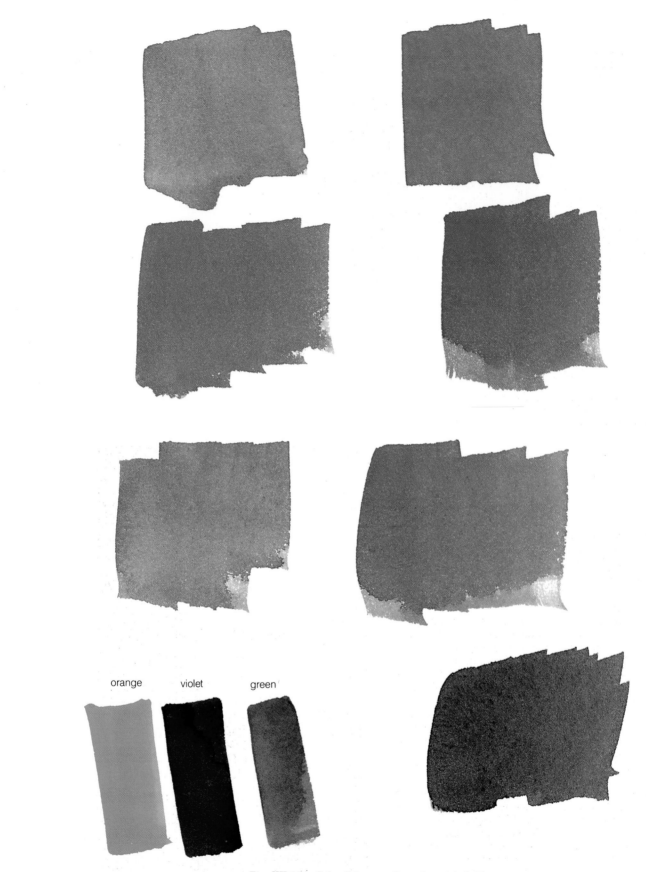

orange violet green

Fig. XII-18A. Color Schemes: *Secondary triad. The*
secondary triad is the same on both expanded palettes.
The mixtures seem more agreeable than the pure
pigments, although the hues may be used both ways.

Fig. XII-18B. Secondary Triad: *Pure hues. Colors are blended directly on wet paper. The distinctive contrasts may not be pleasing to every eye.*

Exercise #71

Mingle the pigments of the secondary triad. *(Fig. XII-18)* When you have an idea of what these colors will do, paint sketches with them. Do the secondary mixtures seem as powerful as primary mixtures? Which do you prefer?

Tertiary triads

Two sets of tertiary triads remain to be explored on each of the expanded palettes. These are the hues that appear between a primary and a secondary around the circle. One triad on the traditional palette is red-orange, yellow-green and blue-violet; the other is yellow-orange, red-violet and blue-green. The first set of hues (red-orange, yellow-green, blue-violet), although the contrast of pure hues may be somewhat disconcerting, can yield mixtures of extraordinary expression. *(Fig. XII-19)* The second set (yellow-orange, red-violet, blue-green) is also unusual, with mixtures that are provocative and challenging to the colorist.

The first tertiary triad of the alternate palette is red, yellow-green and blue-violet. The second is yellow-orange, red-violet and blue-green. This second triad is the same in both palettes, but the pigments representing them on the two expanded palettes may differ. Like the traditional tertiaries, these are best when modified in mixtures, rather than pure; the mixtures are subtler and less bold than those of primary and secondary combinations of hues.

Fig. XII-18C. Secondary Triad: *Mixed hues. The mixtures of the secondary triad are subtle and rich. A bright accent of pure hue will add interest to a focal point.*

Exercise #72

Mingle the pigments of each tertiary triad. *(Fig. XII-20)* Do color sketches with them. Continue to record your observations in your journal, with comments on subjects or compositions suitable for the colors and your reactions to the mixtures. You are a long way from color formulas now; expressive color—your *personal* color—is more and more accessible with every exercise.

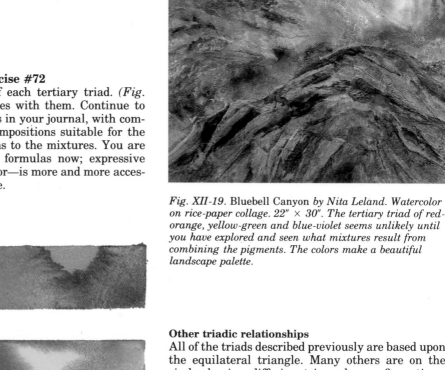

Fig. XII-19. Bluebell Canyon *by Nita Leland. Watercolor on rice-paper collage. 22″ × 30″. The tertiary triad of red-orange, yellow-green and blue-violet seems unlikely until you have explored and seen what mixtures result from combining the pigments. The colors make a beautiful landscape palette.*

Fig. XII-20. Color Schemes: *Tertiary Triads and Tetrads.*

Other triadic relationships

All of the triads described previously are based upon the equilateral triangle. Many others are on the circle, having differing triangular configurations. These will not be studied here. If you have a consuming curiosity about them, make prepared acetate overlays of assorted triangles to fit your expanded palette color circles. Mark the relationships in India ink on the overlays as shown in Figure XII-5 and you can find color relationships to your heart's content simply by rotating the overlay on either color circle.

Tetrads

With four colors harmony can still be achieved through logical relationships of the hues on the color circle. The tetrads may be square or rectangular. The double complement scheme is a tetrad. The acetate overlay described above proves useful here, as well, in discovering the colors that belong in the tetradic array. If you feel motivated to explore these color schemes, you should do so. The color relationships are striking and have innumerable possibilities for color expression. Any exploration of the color schemes is sure to be rewarded by the discovery of unique color combinations.

Exercise #73

Find several tetradic relationships on the color circles. Mingle the colors of each and study the mixtures. *(Fig. XII-21)* When you find a combination you like, do a sketch with it. Are your choices still expanding or have you reached a point of diminishing returns by now? You needn't feel you are limiting yourself seriously if you elect not to use the tetrads now. Complementary and triadic color schemes provide ample opportunities for a creative colorist.

Intellect and intuition

So many color schemes are possible; so many pigments are available. Choose both pigments and color schemes carefully, not simply because of your personal reaction to the pigments, but also because of your knowledge of their logical places in a color scheme. Try each color arrangement in several sketches or paintings, exploring the full range of possibilities of the pigments in the color scheme.

You probably are accustomed to deciding upon a subject first and then planning your color to suit the subject. As you begin to realize your preferences in colors and color relationships, you may want to select your colors first, and then develop a composition appropriate to the colors you have chosen. In this way, your reaction to an expressive color scheme provides you with the opportunity to be more inventive with color, rather than limiting yourself to local colors. Your paintings will begin to reveal what you see beneath the surface of objects, in the rhythms of nature.

If you understand the logic behind color schemes you are better able to express yourself through color by eliminating literal and extraneous colors. Knowledge and scholarship are the counterparts to emotion and intuition. All are necessary to color expression.

Distinguished color was no accident with the great colorists of the past. Delacroix was a diligent student of color theory and spent long hours at museums studying the colors of the masters. Van Gogh, a powerful and impulsive painter, was particularly taken with the effect of complementary contrast. Impressionists and Neo-Impressionists were cognizant of orderly relationships of colors. Beyond intuition, good visual order is essential to forceful expression.

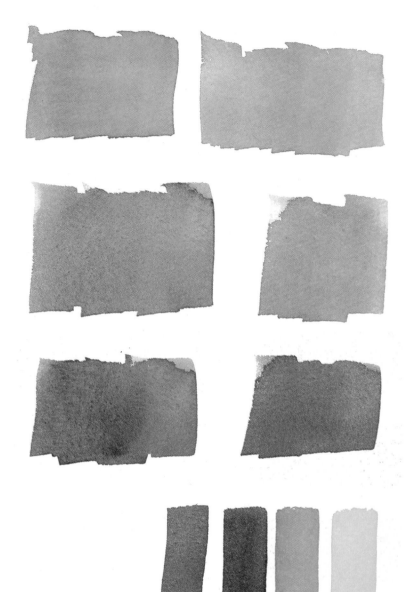

| blue-violet | red-violet | yellow-green | yellow-orange |

Tetrad and mixtures both palettes

Fig. XII-21a. Color Schemes: *Mingling Tetrads.*

Fig. XII-21b. Sketch—Tetrad. *From the colors discovered while mingling the tetrads comes an idea for a scheme for a sketch. These hues are not normally found in a painting of a marsh.*

"Work with expressive colors which are not necessarily descriptive colors.... It is the relationships which take charge of them.... It is not quantity which counts, but choice and organization."
—Henri Matisse

Fig. XIII-1. Only a Dream *by Joan Ashley Rothermel,
A.W.S., N.W.S. Watercolor. 29″ × 33″. Gold Medal, Georgia
Watercolor Society (1983). An appearance of spontaneous
emotional expression is achieved through the artist's
control over the elements of design. Knowledge of the craft
is as necessary as intuitive feeling in an expressive
painting such as this.*

Chapter **XIII**
Elements of Color Design

In painting, composition is the arrangement of lines, shapes, values and colors confined within prescribed limits on a two-dimensional surface. Composition helps to reinforce an expressive idea. Controlling the movement of the viewer's eye around the painting is important to both representational and nonobjective artists. Organization of the elements in a painting helps to prevent confusion and disorder, so that you can strike a visual balance, or unity, in the picture. When most of your major compositional decisions are made, you should be able to paint more creatively and intuitively, remaining open to changes in your plan whenever the work seems to call for it. *(Fig. XIII-1)*

When color is controlled and simplified, the limited number of relationships are more likely to be harmonious and easily perceived by the beholder. Chevreul asserted that too many colors and too much intricate detail distract the viewer and interfere with his concentration.

In *The Elements of Dynamic Symmetry* Jay Hambridge wrote,

"In art the control of reason means the rule of design. Without reason art becomes chaotic. Instinct and feeling must be directed by knowledge and judgment."

Personal expression can be *reinforced* by the rule of design, making color a significant *force* in the design. Use color so it contributes substantially to the unity and expression of the painting. Color is only one of the elements of design that need to be considered when you are planning your painting. Think of color as the keystone of personal expression as it interacts with the other design elements.

The ruling principle of artistic design is unity. The concept and the arrangement of design elements should form a harmonious whole—the finished painting. Ideally, when a painting is complete, nothing may be added or subtracted without destroying its unity. *(Fig. XIII-2)* Unity is the crowning achievement of the artist.

Planning a painting is a curious blend of knowledge and intuition, each dependent upon the other. Familiarity with the elements of color design and their application provides you with greater assurance of the development of a unified composition; but only intuition can tell you if your plan really works!

Yield to intuition in your color design when it finally "feels right." When intuition supersedes intellect, the artist's coloristic style and personality are revealed. Before that exchange takes place, however, you should have a firm grasp on the elements of color design and how to use them, so you can express yourself freely within the confines of a well-planned composition.

Fig. XIII-2. Michael Looney, Country Gentleman *by Homer O. Hacker, A.W.S. 17″ × 23½″. The compositional stability of a good painting is easily recognized. Imagine removing the figure, the fencepost or the large, green bush on the left. Each shape plays an important part in the balance, while areas of repeated colors help to keep the eye moving about the composition.*

black line

complementary line

analogous line

texture of lines

agressive

passive

Fig. XIII-3. Lines and Color Contrast

The elements of color design

When you plan a painting, determine first what constitutes the essential nature of your subject—the particular qualities you want to emphasize. Plan how color will help to make your statement: decide on a color scheme. Select the pigments you will use, then arrange the elements in the painting in such a way that the completed design reveals your expressive concept.

As you are developing your composition, keep in mind the location of every color relative to the edges of the painting. It is advisable not to place your important color effects too near the edges of the paper. The most striking color contrasts and color effects should enhance the center of interest, wherever it might be located. Arrange the colors to provide visual interest and movement leading the eye through the painting and back to the center of interest.

Color

You have seen how color is essential to the fullest expression of your artistic concepts. Color does not achieve this alone, however. Color needs the support of all of the elements of design.

Exercise #74

As a preparation for the study of color composition, look through the exercises from Part One and review the compatible pigment combinations and your basic palette. Check your journal for the pigment arrangements that you singled out for comment when you tested them. Select several color schemes for use in these exercises in color design.

Line

Lines have the power to reinforce or divide the design. Intersecting lines within the design help to locate a center of interest. The character of a line may be elegant or strident, lazy or energetic, qualities that can be interpreted in color, as seen in the lyrical lines of Kandinsky, Matisse and Dufy.

Line may be structural, confining shapes or showing the structure of a form; line may be descriptive, representing specific things that have linear characteristics, like the twigs on a tree branch; line may be decorative, lyrical, calligraphic strokes contributing lacy texture to the design. *(Fig. XIII-3)*

A colored line may also be symbolic, taking what is believed to be the meaning of the color and translating it into linear expression. If you think red denotes excitement, then a red line should have a sharp, aggressive thrust; if blue suggests tranquility to you, make a blue line that is serene. The effectiveness of a line will be influenced by its suitability to the subject and the mood and by the degree of its color contrast with intersected shapes.

Exercise #75

Do some sketches featuring lines. Try lines that are structural (lines around the shapes), descriptive (objects that are lines), decorative (lacy, calligraphic lines) or symbolic (lines representing a feeling or idea). Use black, complementary or analogous lines. Do not use all of these lines in the same painting. Vary the color contrasts between the line and the background and see if there is a change in expression.

Value

The contribution of value is unsurpassed by other elements of design. Color may be keyed with reference to value in ranges from high key to low key and full contrast. The nucleus of the expressive message of the painting is found in its values and colors. A gentle, atmospheric feeling can be expressed in light values. The contrary mood may be depicted with darker values.

Values and emotional impact are inseparable in a painting. When color is superimposed on the values, the impact is intensified. Like other elements of design, values are more successful when they are planned. When the greatest contrasts occur at a focal point, the viewer's eye is drawn to it.

Exercise #76

Choose several color schemes and pigments from the expanded palettes. Plan each to express a mood typical of various color keys. You will find that some color schemes are more suitable for high key and

others for low key. Once again, your color personality will be revealed by your choices, which will be increasingly individual as you explore color.

Shape

An object is recognized by its shape. When the color of the shape is related to the real color of the object, this helps to confirm the identification. Many of Georgia O'Keeffe's brilliant paintings have a clear color/shape identity. As the shapes become increasingly abstract and less suggestive of reality, the colors may become more inventive.

Ambiguity in the color/shape relationship invites the viewer's active participation, involving him in deciphering the anomalies in the relationship, thus enhancing the vitality of the work.

Shapes in a painting are not required to connote real objects. A successful arrangement of colorful nonobjective shapes can be a visual delight, as seen in the paintings of Robert Motherwell, Mark Rothko and Frank Stella. Twentieth century American art has been rich with paintings of this kind.

Some shapes are more visually interesting than others. Exciting shapes have varying dimensions and edges that interlock like the pieces of a jigsaw puzzle. *(Fig. XIII-4)* Plan the shapes in your composition first, and then reconcile the facts of nature to the designed shapes. Visualizing the subject as a few large shapes, instead of numerous small ones, enables you to simplify your composition and avoid the confusion of too many details. Often you will want to plan the shapes first, then the values, and finally, the colors of the shapes.

Exercise #77

Use black, gray and white construction paper to arrange several shapes within small rectangles (3″ × 5″ or 4″ × 6″) in your sketchbook-journal. *(Fig. XIII-5)* Collage studies help you to eliminate extraneous detail when you plan your painting. Include only essentials in the collage composition. Collage has advantages over paint at this stage of planning, because you can move the pieces of different values

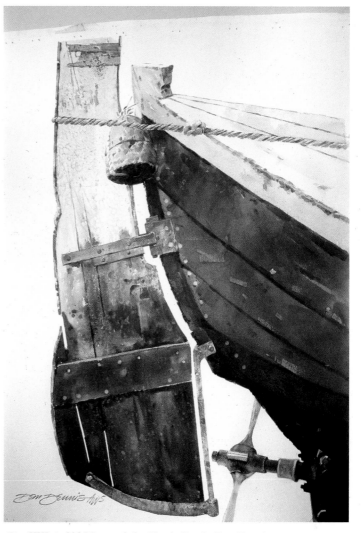

Fig. XIII-4. Old Man and the North Sea *by Don Dennis, A.N.A., A.W.S. Watercolor. 28″ × 22″. Strong shapes are characteristic of Dennis paintings. The dominant color reinforces the design, while complementary accents add color vibrations.*

Courtesy of the General Electric Company.

Fig. XIII-5. Shape: *Collage studies.*

Fig. XIII-6. Shapes: *Sketch from collage.*

Fig. XIII-7. The Flame by Al Brouillette, A.N.A., A.W.S. Acrylic. 21" × 30". Emily Lowe Memorial Award, American Watercolor Society Annual (1983). A network of intricate lines moves across a neutral background, beautifully energetic, but the brilliant, tiny spots of intense red capture the attention. Their small size and strong color contrast vividly with the neutrals.

around the page until you find a pleasing arrangement. Glue the pieces down when you are satisfied with the design. Trust your intuition to tell you when you have established a visual balance or unity of shapes. Do several small collages, either with reference to subject matter or wholly nonobjective.

Select a color scheme to strengthen the feeling projected by the shapes in each of the collage designs. What kinds of colors do aggressive shapes call for? Do sensuous shapes seem to require a different color emphasis? If you are interpreting a realistic subject, an inventive color/shape arrangement might be more expressive than the literal representation of local colors. Turn the collage upside down and do a non-objective painting from the design. Do several sketches based on the collages. *(Fig. XIII-6)*

Size

The size of the color areas has substantial impact upon the strength of the design. Generally, the larger the area of a color, the greater the color effect. Big, bold shapes tend to emphasize color, as seen in the color-field paintings of many twentieth century artists. Georgia O'Keeffe's extreme close-ups of flowers are so big in scale that the color impression frequently registers before the subject is recognized.

Small bits of color all over the surface lose their identity because of optical mixing. However, the contrast of a small, intense area against a large neutral area is one particularly effective way to use size and color contrast as significant elements of color design. *(Fig. XIII-7)* Several small color areas may be more effectively combined into a single larger shape. A variety of different-sized pieces of color is more interesting than several color/shapes of equal area.

Exercise #78

Complementary contrast of intense colors makes use of the effect of small, bright areas contrasted with larger areas. Paint three to five small shapes of any intense primary on a sheet of paper. Surround these areas with an intense field of the pure complementary color. Repeat the exercise with a field of the unsaturated complement around the small, intense shapes. *(Fig. XIII-8)* In both cases, the contrast of size adds emphasis to the color contrasts. The contrast of intensity establishes the importance of the small, bright bits against an unsaturated hue. When the areas are equal in size and are equally intense, color emphasis is uncertain and the expression in the painting becomes ambiguous.

Movement

The arrangement of colors on the paper can help to direct the viewer's eye around the painting. Color plays an active role in controlling the direction and speed of movement in a composition. Begin by thinking of directional movement as horizontal/static, vertical/ascending and oblique/dynamic. Could you suggest serenity by combining a blue hue and dominant horizontals? Yellows, browns and greens might suggest growth or stability in conjunction with verticals? Would red obliques in a zig-zag express action more effectively than blue ones? Think of other ways to use color as a reinforcement

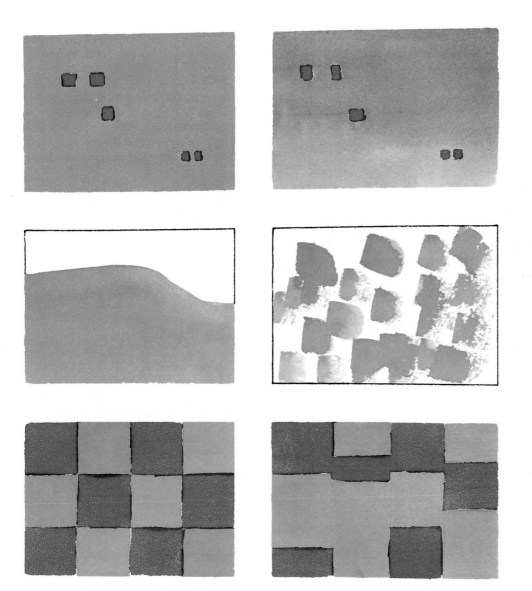

Fig. XIII-8. Size. Contrasts of size in the color areas, along with color contrast, can provide strong emphasis to the design in the painting.

for the horizontal, vertical and oblique movements in a composition.

Warm colors seem to move at a quicker pace than cool colors. Warm colors in the foreground hold attention there; a gradation of color from warm to cool draws the eye into the deep space of the painting. *(Fig. XIII-9)* Cézanne flattened the two-dimensional picture plane somewhat by warming the distant areas and preventing an impression of deep space from pulling the viewer too far into the painting.

Fig. XIII-9. Yellow Starland *by Lawrence Goldsmith, A.W.S. Watercolor. 18″ × 24″. Somehow this painting gives an impression of immense space and huge proportions to the shapes. The yellows appear throughout the painting, but they seem to fade to tints in the distance, as the forms also become less definite. The eye is irresistibly drawn through the composition.*

Fig. XIII-10. Tidal Rocks *by Carlton Plummer, A.W.S. Watercolor. 14½" × 21". The larger, colored shapes diminish in size and intensity as they move into the distance. There are fewer colors, as well. The figure is strategically located at an uncluttered spot in the composition.*
Collection of Mr. and Mrs. William Dempster.

Fig. XIII-11. Hollyhocks *by Betty Henderson. Watercolor. 22" × 30". Subtle color repeats of yellow centers, neutral greens, and shadowy, pale blue blossoms activate the entire surface of the painting.*

The viewer's journey through a painting may also be controlled by the size and intensity of color shapes. *(Fig. XIII-10)* Numerous small shapes can generate compositional movement across larger areas. The color of the shapes helps to determine the speed of movement and the direction. Alternating warm and cool shapes can be used to start and slow the journey of the eye through the composition.

Line is also used to establish directional movement. The colored line creates directional thrust across the painting surface and moves quickly or slowly according to its weight, gesture, intensity and temperature. Thin lines appear to move more rapidly than thick ones. A red line may seem to dart across the paper more quickly than a black line. The straight line is swift and direct; the curved line meanders. Tightening its curves into spirals may increase the velocity of movement of a line. If you want to slow down a too-active line of pure hue, modify the color with a complementary glaze.

Changes of color intensity or value are subtle and effective in suggesting movement. As a color is graded toward dark, it may seem to become heavier and less vigorous. The same is true of a gradation of pure hue toward a neutral tone.

Exercise #79
Paint two sketches. In the first, use the traditional movement into the distance with a warm foreground and cool background typical of atmospheric perspective. With the same colors, repeat the painting, enlarging the distant shapes and warming them in the manner of Cézanne. The eye may move more rapidly between the foreground and distance in the second painting because you have reduced the illusion of distance with the larger, warmer shapes. The illusion in the first painting, achieved by using cool colors to move into the distance, encourages a more leisurely movement.

Do several additional sketches varying the color schemes. Use warm/cool gradation to move across the painting, rather than into it; use small, intense shapes and changes of value to draw the eye around the painting; use the various qualities of colored line to create directional movement of different speeds across the painting.

Pattern
Similarities or repetitions of color, size, shape, value or line create patterns. *(Fig. XIII-11)* These may give texture to the surface of a nonobjective painting or to objects in a representational painting. They may contribute to the movement in the work. Pattern may also be purely decorative. The relative positions of colors strongly influence their interaction, as you have seen in the exploration of simultaneous and successive contrasts. This may be used either to emphasize or modify the pattern effect of the colors.

A color pattern within the painting should support the strength of the design. Select your colors and place them carefully. Don't let your color collapse into a busy, random semblance of jelly beans in a jar, with color scattered around the paper. Every color should be repeated, but its reappearance ought to have relevance to the design and the color expression. *(Fig. XIII-12)*

Exercise #80

Plan an arrangement of shapes and values with a small black-and-white collage. When you are satisfied with the design, choose a color scheme and decide upon the pigments you plan to use. Do a second collage in color. (*Fig. XIII-13*) Snip pieces of colored illustrations and advertisements in magazines or colored art papers to represent the colors in the painting. This will help you to visualize color patterns. Plan a focal point and locate the sharpest contrasts of intensity, color, and value there. Consider what other elements of design, for example, line, size, shape and movement, may add to the composition. The elements of design are not equally represented in every painting. The emphasis in this exercise is the effect of the pattern of colors. When you complete the collage, glue it down. Do a sketch based on the collage.

You have learned the elements of design; what remains now is to learn some of the many ways these elements can be applied to enhance the color expression in your paintings. When the elements of design support your intuitive feeling, you will have done all you can to unlock the viewer's imagination and permit him to share your emotional involvement in the painting.

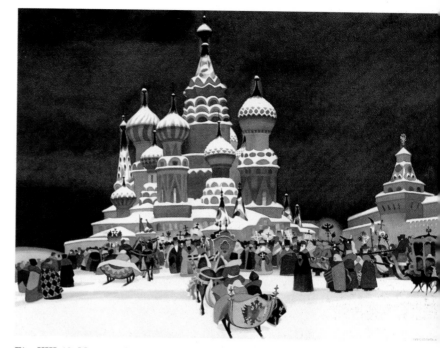

Fig. XIII-12. Moscow of Yesteryear *by Mario Cooper, N.A., A.W.S. Watercolor. 22″ × 30″. The rich variety of patterns in this complex painting has been carefully orchestrated—the white lace against the dark sky and the colored garments against the white snow. Planning is absolutely essential, in order to plot the progression of movement of the patterns throughout the painting.*
Collection of the Charles and Emma Frye Museum, Seattle, Washington.

Fig. XIII-13A. Color and Value Patterns: *Collage studies.*

Fig. XIII-13B. Color and Value Patterns: *Sketch from collage.*

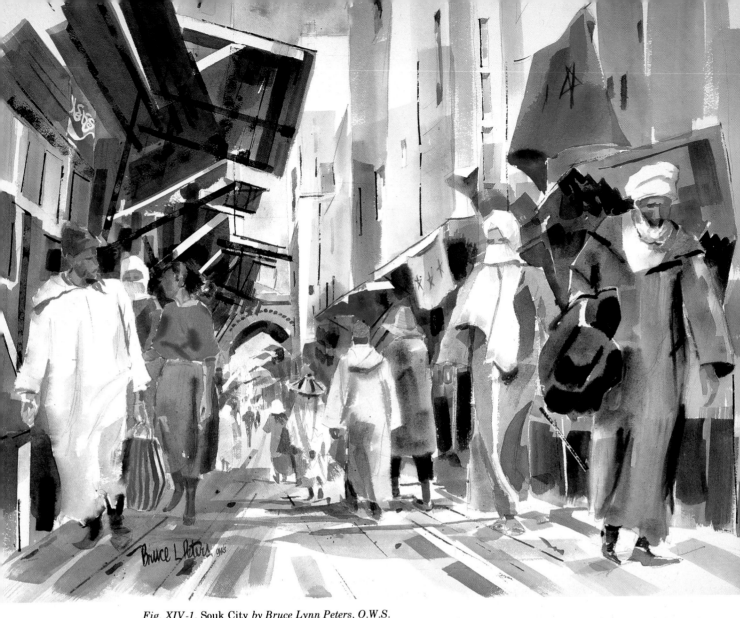

Fig. XIV-1. Souk City *by Bruce Lynn Peters, O.W.S.*
Watercolor. 21¼" × 29¼". A personal style is evident in
Peters's work. The subjects he selects are often busy
markets and harbors with crowds of people; his colors are
pure and bright; the brushstrokes are confident and
direct, with little wet-into-wet blending. The paintings are
full of color patterns and movement. All of these things
add up to instant recognition of a Bruce Peters painting.

Fig. XIV-2. On the Road to School *by Roger Haas.*
Watercolor. 11" × 15". The monochromatic color scheme,
close values and gently curving forms combine to achieve
a passive harmony that is appropriate to the subject.

174

Chapter XIV
Principles of Color Design

Style is the unique imprint of your personality on your paintings. Style should develop naturally, and not as an end in itself. When you trust yourself and develop your own subjects, colors, and compositions, based upon your experiences and your responses to them, rather than using source material created by other artists, your own style evolves. When you copy the style of another, the end result is frequently stiff and labored. After selecting a subject that interests you, carefully design the composition and choose the color scheme; then do what comes naturally. Style will take care of itself.

Style is partly how you handle the materials and your techniques with the medium. Another part of style, however, is how the painting is organized and how it communicates your message to the viewer.

A staccato rhythm established by short vertical lines of varying lengths creates an altogether different effect from a sensuous horizontal line or a dynamic oblique. Your decision to give emphasis to one or another of the design elements begins the development of your style. *(Fig. XIV-1)* Your selection of elements and preference for particular colors, as well, mark your work as clearly as distinctive handwriting, especially after the conscious planning is completed and intuition takes over.

The choice of subject is another imprint of yourself on the painting. You have the opportunity to share something with the viewer—your unique insight into a subject or the revelation of a concept that resides in your mind alone and in no one else's. You may be disguising yourself by painting only popular subjects that you believe are inherently picturesque and, therefore, ideal for paintings. If this is the case, you need to develop more confidence in your abilities, and your understanding of the complexities of color will certainly contribute to this.

The principles of color design

You have already applied several precepts of design in other contexts: harmony, contrast, gradation and dominance. You will see now how these principles unite with rhythm, repetition and balance in the imposing task of color design, helping to bring visual order to the painting. The rules of design are focused on the all-encompassing goal of *unity*, the organization of discrete elements into a harmonious whole, expressive of your picture concept.

Harmony

In the design context, harmony is the result of relationships that imply a sense of order. Similarities of elements in the design—restful lines, monochromatic or analogous color, similar shapes and sizes—contribute to harmony. *(Fig. XIV-2)* The movement in the painting may be serene, values may be close. A more energetic, dynamic harmony may be accomplished through manipulation of the proportions of opposing elements. *(Fig. XIV-3)*

The high key and low key value plans are usually harmonious. Extremes of contrast are likely to disturb that harmony. However, a painting completely lacking in contrasts may seem static, and will probably be a boring painting. You should seek a balance between serenity and boredom, if you want to express passive harmony in design. If serenity is the mood you want, use quiet colors and lines, and curving shapes. Gentle contrasts should provide enough visual activity to hold the viewer's interest.

Fig. XIV-3. Field Flowers by Dale Meyers, N.A., A.W.S. Watercolor. 22" × 29½". Gold Medal, National Arts Club Open Exhibition. The colors and values of this poetic piece are beautifully integrated into a harmonious work.

Fig. XIV-4a. Passive Harmony Sketch

Fig. XIV-4b. Active Harmony Sketch

Exercise #81

Paint a sketch expressing a quiet mood; use analogous colors, close values, restful horizontals, simple shapes. This should be a serene painting. If it seems too placid, introduce a little more contrast.

Paint another sketch using stronger colors and values and more energetic shapes and lines. Plan the arrangement of the elements so they support each other through repetition of patterns. Maintaining harmony becomes more difficult as you become bolder in using the elements of design; you will need to rely a good deal more on your intuition to achieve it. *(Fig. XIV-4)*

Fig. XIV-5. Midnight Sun *by Jeanne Dobie, A.W.S. Watercolor. 22″ × 30″. Strong contrasts define strong shapes; where the greatest contrast occurs, at the light area on the side, the eye is directed to the center of interest.*

Conflict

The dynamic aspect of color design is conflict. Color contrasts attract attention. Intense color is restive. A line in your painting may be alternately quick or slow. Symmetrical shapes may be contrasted with irregular ones. All of this activity generates excitement.

Contrasts can be used to draw attention to the most important area in a composition. *(Fig. XIV-5)* A judicious amount of conflict enlivens a harmonious painting: to the dominant horizontals add gentle obliques; to the analogous colors, a flicker of complementary contrast; to the high key value plan, a touch of value contrast, or saturated pigment. Opposition of colors and contrast of hues, shapes and sizes, in addition to value contrasts, create vibration on the surface of the painting. *(Fig. XIV-6)* Triads or tetrads may provide an opportunity to use opposition of colors, creating more energetic color than is found in a monochromatic or analogous color scheme.

Exercise #82

Paint a sketch using exciting colors and an unrealistic color scheme. *(Fig. XIV-7)* Simplify the elements of design to maintain a harmonious whole. Exaggerate the color expression and the direction and contrast of the line to give power to the feeling in the painting. Place contrasting colors where they will be noticed. If color areas become too jumpy or overly aggressive, restore order by applying unifying glazes to those areas.

Rhythm

Rhythm is established in the painting through the intervals at which related elements occur. *(Fig. XIV-8)* The eye is induced to move quickly across closely spaced elements, more slowly across larger intervals. The quality of line contributes to rhythm: the line may be a staccato zigzag or an elegant, sensuous flow. Patterns of colors can be rhythmically arranged with color repeats and gradation moving the eye

Fig. XIV-6. Buffalo Brother *by Morten E. Solberg, A.W.S.*
Watercolor/acrylic. 30" × 24". Intersecting lines and over-
lapping shapes, along with color contrasts, create activity
throughout the painting. All of these are carefully con-
trolled to direct the eye to the finely detailed face of the
central figure.

Fig. XIV-7. Conflict. *Exaggeration and vivid color*
contrasts create a lively painting; the rhythmic movement
of the repeated curves prevents the surface from becoming
fragmented and jumpy.

alternation

different rhythms

pulsing change

gradation

no variations—boring!

inconsistent rhythms

Fig. XIV-8. Rhythm

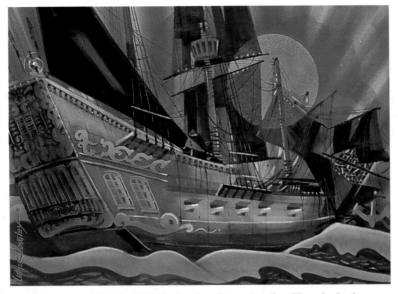

Fig. XIV-9. Another Time—Another Place *by Luther Longley. Watercolor. 22" × 28". Many curves of varying sizes are repeated through the painting, drawing the eye around the painting and evoking an almost-real sense of movement. The rhythms are consistent, but beautifully varied.*

across the painting. Pulsing changes of sizes and shapes will contribute to rhythm by alternation. *(Fig. XIV-9)*

Avoid interrupting a rhythmic progression unless conflict is the primary intent of the work. Conflicting rhythms make unity difficult to establish. The sequence of shapes and colors is important in rhythm. Variety in the intervals provides a necessary contrast. You have a great opportunity to control the viewer's sojourn in your painting by the astute use of rhythm.

Exercise #83

Cut narrow strips of black construction paper of assorted widths. Arrange and rearrange the strips on small rectangles drawn in your sketchbook, working out a predominantly vertical composition. Move the pieces around, first placing the strips close together, then far apart, then some near and others far. Vary the spaces between individual verticals and between groups of verticals. Rhythmic arrangements of the shapes need to be deliberately planned. *(Fig. XIV-10)*

Fig. XIV-10A. Rhythm: *Collage Studies.*

Would you place a center of interest where the eye is moving rapidly—or where it is moving at a leisurely pace? In a congested area or in an open area? When you are satisfied with your collage composition, glue it down.

Create a simple color collage based on this design. Use intervals of color to enhance the rhythmic movement of the composition. Paint a sketch from the second collage. You may also want to try horizontal or oblique rhythm movements using rhythmic lines and colors. Explore these other possibilities.

Gradation

Gradual changes in the elements of the painting are known as gradation. These changes indicate movement. They are the crescendo/decrescendo of color expression, providing graceful transitions from one color area to another. (Fig. XIV-11) The elements of design may be gradated in various ways to contribute to the rhythmic movement in the painting. Gradation provides a slower pace than sudden changes in intervals, and supports unity more firmly than abrupt and violent change.

Fig. XIV-10B. Rhythm: *Sketch from collage.*

Fig. XIV-11. Approach of Dawn *by Maxine Masterfield, A.W.S. Watermedia. 40" × 54". Gradation of color and values creates great depth. Note also the rhythmic forms and the repeated shapes that contribute to unity in the painting.*
Courtesy of C. G. Rein Galleries.

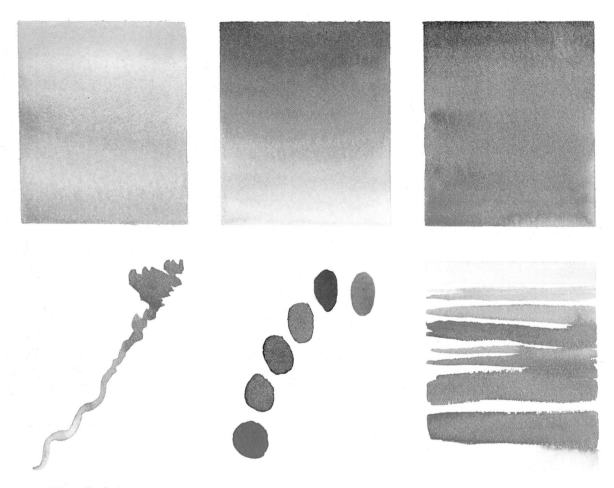

Fig. XIV-12. Gradation

Fig. XIV-13. Innerspace by Mary Beam, N.W.S. Acrylics. 30" × 40". Repetition of the colors in varied shapes and sizes keeps the eye moving throughout the painting and contributes to the feeling of a color theme in the work. Each repetition is calculated and carefully placed.

Exercise #84

You are already familiar with gradation of values. Consider how other design elements may be graded, including color. Doodle on a sheet of paper to see the effect of a cool, graceful line that changes gradually to become a warm, busy line; of a color that changes gradually from warm to cool, light to dark, bright to dull; of a red circle that evolves into a blue oval. Show how repeated color shapes may become gradually larger or smaller. (*Fig. XIV-12*) Elements that don't change may establish a somewhat static surface; those that evolve through gradation make a more energetic painting.

Do a sketch in which one or more of the elements is combined with color and gradated to move the eye around the painting.

Repetition

The viewer of a painting needs visual clues to help him interpret your message. Repetition of a familiar shape or color aids in this recognition and reinforces the idea of your picture. Repetition of color, line or value strengthens rhythm, movement and pattern. (*Fig. XIV-13*) In conjunction with repetition, variety is essential to relieve the boredom of *too much* similarity. Nearly identical units, gradated in size,

Fig. XIV-14. Blue Wall by Glenn Bradshaw, A.W.S. Casein on rice paper. 37" × 73". This painting is a long way from monochromatic, with many variations in the repeats of analogous colors and an infinite variety of shape repetitions. The eye is visually stirred from one end of this very large piece to the other, as it is drawn across by repetition of colors and shapes.

color, or values, planned in rhythmic sequences, make the whole greater than the parts. (*Fig. XIV-14*) Help the viewer to comprehend the meaning of your painting by repeating your color statement with variations.

Some painters place a color in three areas whenever they introduce a new color. The rationale behind this method is the importance of repetition; however, random placement of color is undesirable and may lead to a spotty appearance. There is no magic number for recurrences of a color in a composition. Planned placement of the color repeats provides unity in the painting.

Exercise #85

Develop a sketch exploring color repeats. (*Fig. XIV-15*) Give the repetitions variety and rhythm. Nature provides us with an endless variety of colors and shapes to choose from. Be selective. Find the important colors and place them strategically in the painting. Don't be satisfied with a careless reproduction of the facts of the subject. You may find it challenging to visualize this as a nonobjective exercise.

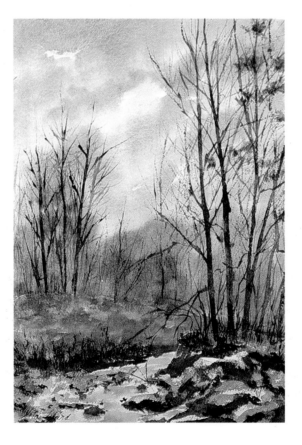

Fig. XIV-15. Color Repeats. Nature provided many greens, blues, grays and browns, but in order to establish the late fall ambience, the greens were eliminated and the browns were repeated throughout.

Asymmetrical (after Degas)

Symmetrical-informal
(after Cezanne)

Symmetrical-formal
(after Monet)

Fig. XIV-16. Balance

Balance

Balance results when opposing elements are distributed to produce an aesthetically pleasing whole. Symmetrical, or formal, balance occurs when colors of equal or similar values, shapes and sizes are used together in nearly equal proportions. Harmony can be achieved through symmetry, although the result might be somewhat static. Contrast is useful to add a spark of interest. (*Fig. XIV-16*)

Asymmetrical balance occurs when unlike or unequal elements are arranged to counterbalance each other, being brought into further accord by the temperature, intensity and weight of the colors. (*Fig. XIV-17*) The conflict inherent in asymmetrical balance lends vitality to a painting by giving the impression that change is imminent.

As the elements of design in your paintings become increasingly diverse, your balancing act tends to become more difficult. Color distribution, size, value and intensity are all to be considered in striving for balance. Do you think that a large, cool area should be balanced by a tiny "hot spot"? Does an intense passage have more weight than a neutral passage? Your expressive intention largely determines these things. If you wish to make a dignified statement, use strict, formal balance. The more emotional your message is, the more asymmetrical the balance should be and the greater the inequalities between the elements to be balanced.

When the elements of design are properly arranged, they stabilize one another in spite of differences between them. Intuitive choices need to be made often while the painting is in progress. Establishing equilibrium in the painting is a continuous effort. As the painting develops, each touch of color changes the relationships, while the next restores a balance. When the balance essential to unity is achieved, the painting is finished.

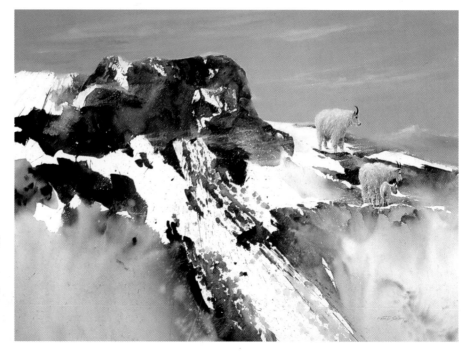

Fig. XIV-17. First Winter by Morten E. Solberg, A.W.S. Watercolor. 22" × 30". This is an excellent example of asymmetrical balance in several ways. The large, dark shapes are counterpoised against the small figures; the loosely painted background opposes the highly detailed center of interest; the warm color is reserved for small areas near the focal point.

Formal

◄— Imbalance

Informal

Fig. XIV-18. Balance. *Collage studies.*

Exercise #86

Paper collage can help you to balance your composition. (*Fig. XIV-18*) Choose your colors and color scheme. Cut assorted colored pieces to represent the major color shapes in your painting. Visualize the painting first as a formal, symmetrical design, placing equal amounts of the collage colors at equal intervals on each side of the composition. Vary the sizes and shapes and use different colors, but repeat each element on both sides of a vertical axis. Glue the pieces down.

Repeat the subject with another collage. First, exaggerate imbalance by placing all of the elements to one side. Begin to move the collage pieces around. Repeat the shapes and colors most essential to the content of the painting. When you feel that the relationships of the pieces on the page are stable, glue down the collage and paint a sketch from it. (*Fig. XIV-19*) Unity is achieved through balance, whether formal or informal, and you can become more conscious of how color balance works in design by doing collage exercises.

Fig. XIV-19. Balance: *Sketch from collage.*

Dominance

Dominance is a principle of color design of great importance. Other principles are present in every painting to varying degrees, but dominance nearly always plays a central role in the design. When elements are in conflict (light vs. dark, bright vs. dull) one of these should dominate. Dominance resolves conflict between the elements, restoring unity to the painting.

Achieve dominance by repetition of lines, values, colors, shapes, sizes, movement and patterns. (*Fig. XIV-20*) Emphasize important elements and diminish lesser elements. Plan a dominant light effect. A painting having equal light and dark areas has contrast, but until one or the other is made dominant, the expressive idea is unclear. Equal quantities of intensity contrasts can have the same effect. Contrast several small shapes of different colors with a large shape of a single color. The large quantity of a single color dominates the picture. Small areas of a single color of great intensity contrasted with a large neutral area may dominate by reason of their great brilliance.

Dominance makes the color statement more coherent and helps to keep the painting from acquiring a busy, fragmented appearance. Dominance can help you to focus attention on your expressive intent. When you use dominant blues and greens, you suggest a cool, serene atmosphere; dominant reds and oranges are warmer and more aggressive. Reinforcement of the aesthetic principle of unity should be the outcome.

Exercise #87

Select colors and color schemes for several paintings. Plan temperature dominance (warm or cool), value dominance (dark or light), shape dominance (curved or angular), intensity dominance (bright or neutral), dominant light. Resolve the conflict of varying elements by giving one element greater importance in some way, through repetition of color areas, for example. Paint sketches concentrating on color dominance in each sketch.

Think continually in terms of a dominant idea, value, line or shape. Bring all of these elements together to support your color idea.

There are no hard and fast rules for color composition. The elements and principles of design described here are offered only as guidelines. Art of the twentieth century has often repudiated rules of design, in favor of the expression of the innermost feelings of the artist, unhampered by a plan or organization. However, many artists feel the need for a rational order based on proven principles of color and design. If you share this point of view, the ideas stressed here should prove useful in your development as an artist.

It is better to know the rules and deliberately break them than to diminish the power of color by a careless and casual attitude. You won't need to consult a list of rules every time you paint. What you have done in your color exploration will remain with you, guiding your intuition to produce works of finer color than you have ever achieved. You have developed color awareness, color sensitivity and a logical means for constructing color composition.

Fig. XIV-20. Sunkissed Peach *by Nita Leland. Watercolor. 22″ × 18″. Color dominance is important to the expression in this painting. Artists run the risk of being too literal with portraits in the hope of getting a likeness. Unless you are painting commissioned portraits, you will be more successful if you develop a portrait like any other design, deciding what you want to say about the subject and then incorporating the design elements and principles that best express your idea.*

Collection of the artist.

Fig. C-1. Undergrowth *by Carole D. Barnes, A.W.S.*
Acrylic on paper. 21" × 27". A unified painting is a
successful blend of the elements and principles of design.

Conclusion

Most of us who love to paint wish to express ourselves and to communicate our feelings to others. These final suggestions about using color are worth your consideration.

Every time you do a painting, ask yourself these questions and be objective in your answers. What have I tried to say? Have I utilized the best means of saying it? The true subject of every painting you do, is . . . *you:* how you see and feel; your personal vision revealed.

Color exploration will help you to accomplish your goal of self expression and communication. The pigments you choose for each painting will enable you to express your color personality and your reactions to the subject. The color schemes offer a wide selection of color relationships to enhance your color design. Your selection of colors will begin to affect your choice of subject matter. You can paint effects now that you never believed you would be able to do. You'll find yourself ignoring local color in order to impart a higher meaning to the subject, a more emotional expression. You'll sometimes want to bypass realism and let the colors speak for you as the subject of your design.

Don't stop your color exploration! The potentialities of color expression are inexhaustible. But now you know how to test pigments and color schemes, giving you the capability of tapping this huge resource.

Awareness of color as a vital part of the structure of a painting is essential to the development of the work as an organized entity. Plan the hue, value and intensity of every color area, its temperature, size and placement, so the painting will be a unified composition. *(Fig. C-1)*

Your ability to communicate is enriched by everything you experience. Visit museums and galleries. Learn to appreciate how artists for centuries have used color to express themselves and to communicate with their contemporaries. They still have something to say to you today. Read fine literature, poetry, history; listen to music. Try to envision in all of the arts the parallels with painting that many writers find fascinating. There is color in music, poetry, in life. You are the sum of all that you see and hear and experience. These things are stored within you, to be made visible through your art. Enrich yourself, so the richness of your life may be revealed when you paint.

As you discipline yourself to analyze color and understand what color can contribute to your painting, you will no longer be limited in your expression by your untutored intuition alone. Color can be the force that communicates your deepest feelings to the eye and heart of the beholder.

"Color is a power which directly influences the soul."—Wassily Kandinsky

Selected Bibliography

Albers, Josef. *The Interaction of Colors*. New Haven: Yale University Press, 1975.

Arnheim, Rudolph. *Art and Visual Perception*. Berkeley and Los Angeles: University of California Press, 1954.

Birren, Faber. *Color and Human Response*. New York: Van Nostrand Reinhold, 1978.

———— *Color: A Survey in Words and Pictures*. New Hyde Park, New York: University Books, 1963.

———— *Creative Color*. New York: Van Nostrand Reinhold Company, 1961.

———— *History of Color in Painting*. New York: Van Nostrand Reinhold Company, 1965.

Bradley, Milton. *Elementary Color*. Springfield, Massachusetts: Milton Bradley Company, 1895.

Brotherton, Naomi and Lois Marshall. *Variations in Watercolor*. Westport: North Light Publishers, 1981.

Chevreul, M.E. *The Principles of Harmony and Contrast of Colors*. New York: Van Nostrand Reinhold, 1981.

Clay, Jean. *From Impressionism to Modern Art*. Secaucus, N.J.: Chartwell Books, Inc., 1978.

Delacroix, Eugène. *The Journal of Eugène Delacroix*. tr. W. Pach. New York: Hacker Art Books, 1980.

Flam, Jack D. *Matisse on Art*. New York: E. P. Dutton, 1978.

Graves, Maitland. *The Art of Color and Design*. New York: McGraw-Hill, 1951.

Hill, Tom. *Color for the Watercolor Painter*. New York: Watson-Guptill Publications, 1975.

Hofmann, Hans. *Search for the Real*. ed. S. T. Weeks and B. H. Hayes, Jr. Cambridge, Massachusetts: The M. I. T. Press, 1979.

Itten, Johannes. *The Art of Color*. New York: Van Nostrand Reinhold Company, 1973.

Kandinsky, Wassily. *Concerning the Spiritual in Art*. New York: Dover Publications, 1977.

Mayer, Ralph. *Artist's Handbook of Materials and Techniques—4th Ed*. New York: Viking Press, 1981.

Sargent, Walter. *The Enjoyment and Use of Color*. New York: Dover Publications, 1964.

Schink, Christopher. *Mastering Color and Design in Watercolor*. New York: Watson-Guptill Publications, 1981.

Smith, Janet K. *A Manual of Design*. New York: Reinhold, 1950.

Van Gogh, Vincent. *The Letters of Vincent van Gogh*. Boston: New York Graphic Society, 1981.

Verity, Enid. *Color Observed*. New York: Van Nostrand Reinhold, 1980.

Winsor and Newton Co. *Notes on the Composition and Permanence of Artists' Colours*. London, England.

Glossary

achromatic — lacking color; black, gray or white

additive color — derived from light mixtures reflecting from a white surface

balance — distribution of opposing elements to produce a harmonious whole

balanced pigments — see *compatible pigments*

blossom — the feathered edge that occurs when a wash creeps into a damp area on the paper

chiaroscuro — principle of light and dark contrast

chroma — see *intensity*

chromatic — having color

color — the design element of greatest importance in expressive painting

color circle — a circular arrangement of the colors of the spectrum

color constancy — the adaptation of the eye to changes in illumination

color identity — an obvious color bias in a neutral mixture

color key — relationships established through color values:
—high key: medium to light values
—low key: medium to dark values
—full contrast: light, medium and dark values

color personality — individual preferences for particular hues or pigments displayed in the artist's work

color scheme — orderly selection of colors according to relationships on the color wheel

color solid — a three-dimensional construction showing the properties of color

color wheel — see *color circle*

colorant — coloring matter, such as pigment or dye

colorist — a painter who stresses color relationships in his work

compatible pigments — pigments matched for similarities of transparency or opacity, intensity and tinting strength

complement, complementary — opposites on the color wheel; the relationship of any two colors opposite on the color wheel

composition — the arrangement of the elements of design to create a unified, artistic whole

conflict — opposition; a dynamic element of contrast

design — see *composition*

direction — horizontal, vertical or oblique movement into the space and across the surface of a painting

dominance — having one element of greater importance than another in the composition

dominant light — representation of lighting effects or changing light of season or time of day

dyad — color scheme having two colors

dye — a transparent colorant absorbed by the surface it colors

fugitive color — a pigment that fades or changes noticeably under normal conditions of light or storage

glaze — a transparent veil of color that modifies an underlying color

gradation — gradual change

harmony — pleasing result of balanced relationships

hue — the name of a color

illumination — an effect caused by a light source

intensity — the purity of a color; saturation; chroma

limited palette — selection of a small number of colors for a specific painting

line — structural, descriptive or symbolic force in the composition, having little volume

local color — the natural or painted color of an object

luminosity — a radiance or glow in the painting

mingle — to blend pigments without excessive mixing

monochromatic	having a single color
movement	see *direction*
opaque	having covering power; not permitting paper or other color to show through
optical mixing	occurs when small areas of color are juxtaposed and are perceived by the eye as a mixture
palette	the white surface on which colors are mixed; also, the colors selected by the artist for his painting
pattern	planned placement of repeated color areas contributing to the strength of the design
pigment	powdered coloring matter; coloring matter suspended in a liquid; colorant applied to the surface of an object
primary color	a color that cannot be mixed from other colors: for example, red, yellow and blue
properties of color	hue, value, intensity, temperature
reflected color	color on an object that bounces off adjacent objects
repetition	recurrence of near-identical units to enhance the composition
rhythm	sequence of elements to control speed of movement through the painting
saturation	see *intensity*
secondary color	a color resulting from the mixture of two primary colors: for example, orange, green and violet
sedimentary color	pigment that settles in granular washes
semi-transparent	slightly transparent
shade	a medium to dark value of a color
shape	a form having importance in compositional arrangement and object recognition
simultaneous contrast	any one of several effects colors have upon each other when juxtaposed and viewed at the same time
spectrum	the band of colors produced when white light passes through a prism: red, orange, yellow, green, blue, violet
stain	see *dye*
style	the imprint of the artist's personality on his paintings
subtractive color	derived from pigment mixtures that absorb all color except the local color of the object, which is reflected
successive contrast	the afterimage of a complementary color seen after viewing a color
temperature	the relative warmth or coolness of hues or pigments
tertiary colors	mixtures of a primary and its adjacent secondary: for example, red-orange or blue-green; intermediate colors
tetrad	a color scheme having four colors with some logical relationship on the color wheel
tint	a light value of a color
tinting strength	the power of a pigment to influence mixtures
tone	a color modified by gray
toned support	paper or canvas having a preliminary wash that influences the colors placed over it
transparent	permitting light to penetrate and reflect off the white surface of the support or allowing another color to show through, as in a glaze
triad	a color scheme having three colors with a logical relationship on the color wheel
underpainting	see *toned support*
unity	the ruling principle of artistic design, in which all elements contribute to a harmonious whole
value	the degree of light or dark of a color
wash	a thin layer of paint covering a large area of paper or canvas

Index